New Museums

New Museums

Josep M.ª Montaner

Architecture Design and Technology Press
London

Published in Great Britain in 1990 by
Architecture Design and Technology Press
128 Long Acre
London WC2E 9AN

© 1990 Longman Group UK Limited

British Library Cataloguing in Publication Data
A CIP catalogue record for this book is available from the British
Library

ISBN 1 85454 600 7

First published in Spain by Editorial Gustavo Gili, S.A., Barcelona
Original title *Nuevos Museos, Espacios para el arte y la cultura*

Printed in Spain

Contents

Introduction

In an earlier book, entitled *The Museums of the Last Generation,* the present author defined the most significant characteristics of those museums designed at the end of the seventies and the beginning of the eighties as: the complexity of the programme; the substitution of flexible space for traditional rooms and galleries; improved methods of conserving, exhibiting and lighting the objects; and the urban role of the museum as a monument and as a repository of art.

This present book, devoted to the new museums designed and built during the eighties, especially during the second half of the decade, adopts a different approach, more technical and more specialized. Our intention here is to address the most important architectural questions raised in the design of this architectural type, analysing the relationships set up in the interior of each museum between the architectonic form and the discourse of the exhibition; between the container, the shell, and its content. For this reason, the examples in this book have been organized in terms of functional complexity – from large-scale museums with an extensive range of uses, to smaller, more specialized examples. Both the introduction, and the structure of the book itself, therefore bring groups of museums together in terms of programme, size, form and complexity.

The key to this classification is the relationship between the architecture and the museum's programme, between the space and the works of art, between science and culture. In other words, that set of architectonic characteristics – for instance size, spatial structure and lighting system – which have an intimate relationship with the interior discourse. This analysis led us to establish six main categories of museum: large-scale cultural centres, in which the museum is accompanied by a number of other cultural facilities; major art galleries; museums of modern art; museums of science, technology and industry; civic or municipal museums; and galleries and centres of contemporary arts.

We should clearly recognize that the museum building derives from a variety of origins, with varying histories – treasure chamber, exhibition of art and of curiosities, natural history collection, picture gallery, archaeological garden, grand state museum, museum of science, social museum, and so on.

We must recognize too, that contemporary museums are moving simultaneously in two opposite directions. On the one hand, the number of great cultural complexes is growing, with museums and exhibition areas playing an important part in their composition. There is a similar increase in the number of great national museums, many of them in need of remodelling.

On the other hand, small, specialized museums devoted to a single theme are becoming increasingly prevalent. Such a museum may be dedicated to a particular artist, or to an individual collection (either public or private); to industrial archaeology or objects from the world of work; or to one of a diverse range of aspects of contemporary culture – cinema, industrial design, psychoanalysis, women artists, childhood, and many others.

Thus we are witnessing the simultaneous evolution of two contrary tendencies: the multifunctional and the specialized.

From the point of view of programme, there is no doubt that museums have become more complex over the last few decades. While the museums of the 19th century were expected simply to provide spaces for the permanent exhibition of works of art, those of the last part of the 20th century must carry out a wide variety of functions. In addition to displaying works of art they require considerable space for the storage, conservation and restoration of the works. With the increase in the number of visitors to cultural buildings – conceived as centres of activity and consumption – comes the need for vestibules, shops, restaurants, auditoria and spaces for temporary exhibitions. Moreover, the sophistication of the running of such institutions means that much of the building must be dedicated to administration.

1 GREAT CULTURAL COMPLEXES

One of the most marked tendencies of the final years of the 20th century has been the creation of great cultural and civic complexes, of which museums and exhibition spaces are a major, but not the only, element. They form part of a more extensive whole which includes libraries, mediathèques, auditoria, theatres, administrative centres, cultural foundations, research centres, and educational entities such as art schools and the like; in addition to restaurants, shops, and other commercial functions.

To some degree, the Pompidou Centre on the Plateau Beaubourg, designed by Renzo Piano and Richard Rogers (1972–7) could be taken as the present-day paradigm of these great centres dedicated

to culture and leisure – an enormous shell (which in this case has adopted the aesthetic of the petrochemical refinery and the typology of the multi-storey open-plan factory). It offers a great variety of cultural activities and facilities: temporary exhibition galleries, library and mediathèque, museum of contemporary art, centre for industrial creation, restaurant, shops and more. It also has an annexe dedicated to the Institute for Research and Co-ordination of Accoustics and Music (IRCAM).

The cultural complex is not actually a recent invention. In Greece and in Rome, for instance, the beginnings of the library, the museum and the academy are to be found in the same group of spaces; and to one side of the library in Alexandria an academy was later built, in which the leading scholars of the time would gather to pursue the study and understanding of the phenomena of nature. Examples of great libraries and museums within the same building occur throughout history, for example the British Museum in London. Indeed, from the Renaissance to the Enlightenment, it was quite usual for curiosities, works of art, books and scientific instruments to coexist in the palace of the collector. Even the Museum of the Prado in Madrid, designed by Juan de Villanueva, was originally intended – before its definitive conversion to an art gallery in 1819 – to be an Academy of Sciences and Natural History Museum, with collections of mineralogy, botany and zoology, a chemistry laboratory, an astronomical observatory, a hall for mechanical devices, a library, and the academy of the three arts, as well as accommodating the meetings of the academics.

It would therefore seem that the contemporary museum has recovered one of its ancient meanings and roles, and made these the emblem of its future. The idea of the museum as a place of classification and specialization (the product of the scientific and positivist thought of the 19th century) having been transcended, it has once again become a great centre, bringing together cultural activities of many kinds, as had been the case with the first museums, libraries and academies, and the museums of the Enlightenment.

In this group of great complexes, of which the museum is one element, we can find examples of different typological and morphological solutions.

First, following the precedent of the Pompidou Centre, we have the

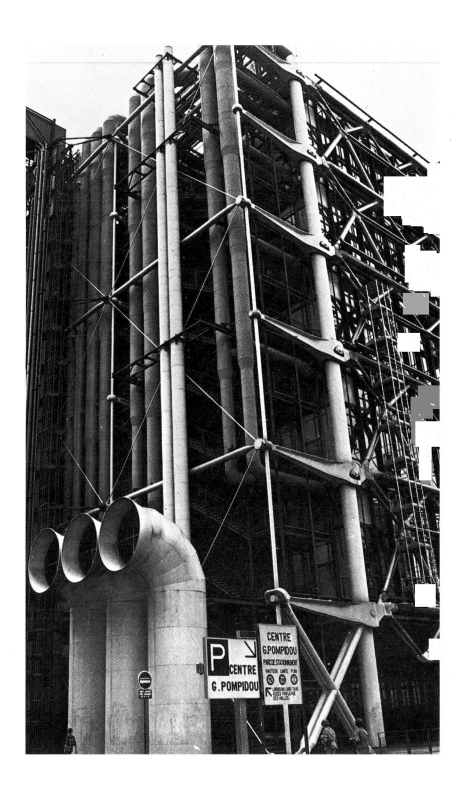

8

2. Institute of the Arab World,
 Paris (France),
 Jean Nouvel. (1981–1987)
3. Mediathèque and Centre for
 Contemporary Art,
 Nîmes (France),
 Norman Foster. (1984)

solution of the great urban repository, prismatic in form, with all its many functions installed in a homogeneous interior. There are two clear examples of this approach among recent museum projects: First, the Institute of the Arab World, designed by a team led by Jean Nouvel (1981–7). This is a great architectonic shell containing a variety of cultural options, of which two components are essential: the Museum of Arab Culture and the Library. It is also equipped with a media library, spaces for temporary exhibitions, an auditorium, research facilities, and shops.

Then there is the Nîmes Mediathèque and Centre for Contemporary Art, designed by Norman Foster's office in 1984 and presently nearing completion. This similarly consists of a single great prismatic container, housing a variety of spaces and facilities to serve the mediathèques and centre for contemporary art.

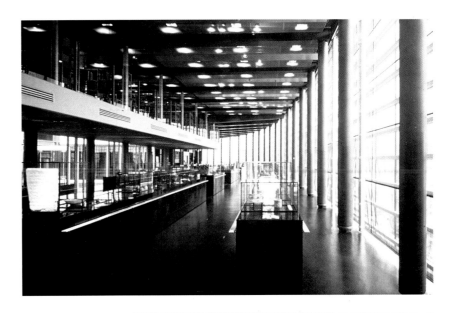

It emerges, then, that one of the approaches which can be adopted in the metropolitan context is that of the high-technology container, with a precisely designed, neutral cuboid enclosing and defining interior spaces of great flexibility. Following the vein of careful architectural design already explored in the Sainsbury Centre in Norwich (1974–7), Foster's team has proposed, in the Nîmes Mediathèque, a reformulation of the aggressive megastructues of the seventies, transforming them into delicate, carefully designed and highly technological containers, skilfully integrated into the urban fabric. The interior spaces, too, have evolved. From being radically multifunctional, they have progressed to being more singular and defined. In these buildings the level of technology is at its highest, with computerized monitoring and control of lighting and humidity conditions, and of the state of conservation of the works of art. This intensive application of high technology is one of the definitive characteristics of the contemporary museum.

A second possible approach is to articulate all these diverse elements more clearly, though still within a unified whole. A number of the new German museums are, in effect, great cultural complexes of this kind. The Wallraf–Richartz Museum, the Ludwig Museum, and Busmann & Haberer's Philharmonica in Cologne (1975–86); the Nordrhein Westfallen Art Collection in Dusseldorf by Dissing & Weitling (1975–86); and James Stirling's project for the extension to the Staatsgalerie in Stuggart (1977–84), all develop a much more complex functional programme than that of the museum in the strict sense. Even the Exhibition and Meeting Centre in Ulm, by Richard

Meier (1986) is, on a smaller scale, a cultural complex (with much care devoted to its integration into the urban setting).

What is required of buildings such as these is that they are sufficiently clear, in terms of volumetric form, typology and symbolism, for visitors to easily orient themselves and clearly identify the different parts of the building. These buildings must cater for many different types of visitor – tourists, school students, specialists, etc – and should orient people unmistakably by means of clear vestibules, distribution spaces, and so on. From this point of view, buildings with a dispersed form are likely to be much clearer than the simple, single-volume containers. The extension to the Staatsgalerie in Stuttgart (with museum, theatre, school of music and other volumes articulated around a circular piazza) identifies each of its parts much more clearly than the Institute of the Arab World, which houses various heterogeneous services within a single large and essentially homogeneous shell, with repetitive glass partitions and high-tech ceilings defining identical spaces on every floor.

The Cultural Centre in Brisbane, Australia, designed by Robin Gibson (1984–7) is an intermediary case, its approach being something midway between a clear articulation of the different elements, and the giant single container. Buildings of this differentiated kind favour multifunctionalism, and allow for easier adaptation to the interior layout in response to changes in the cultural content.

A third option, related typologically to the articulated solution, might be that of the re-use of an area of the old city, with the rehabilitation of various historic buildings to create a system of museums, libraries, exhibition galleries, cultural institutions and so on. Examples within this category include the Centre for Contemporary Culture in the old Casa de la Caritat in Barcelona, with its Museum of Contemporary Art designed by Richard Meier in 1967, plus a wealth of other cultural facilities and services. It also includes Vigevano's Sforzesco castle; the 'Museopolis' and 'Bicocca' projects in Milan; and the Manchester Museum of Science and Industry.

Lastly, in those instances where the buildings are situated in a rural context we find great landscaped complexes consisting of scattered historic buildings, as is the case with the group of old factories at Ironbridge, in Great Britain; or the International Centre for Reflection on the Future, the International Centre for Architecture, and the Claude-Nicolas Ledoux Museum, all in the old Saline Royal at Arc-et-Senans in France.

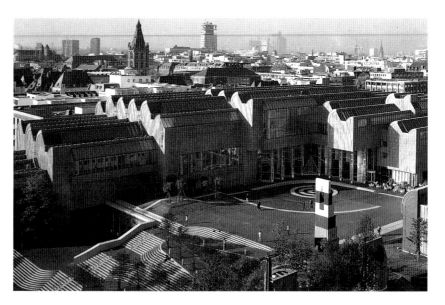

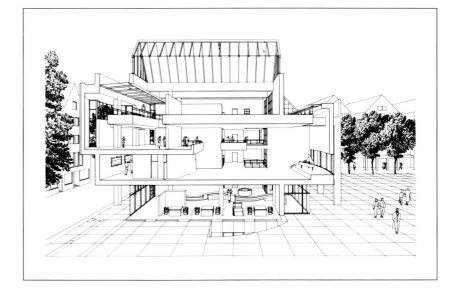

Richard Meier's scheme for the Getty Center in Brentwood, Los
Angeles (1987), planned on the basis of the open articulation of seven
cultural centres distributed over three hills, is comparable with the
above-mentioned museums in its dispersal across the landscape.

2 GREAT NATIONAL ART GALLERIES

This second major group of museums takes its definition from the
museum's purpose – to house a great national art collection: in other
words, to preserve the artistic memory of the country. We are dealing
here with museums built in the great capital cities, state-run, and
having to confront the problems created by enormous volumes of
visitors and by the constant obligation to add to and renew the
collection, and to update the system of presentation.

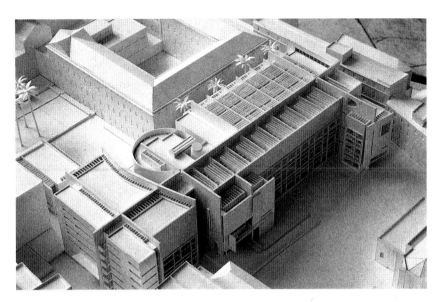

These great buildings express the idea of a national museum, and as
such are charged with a high degree of political and ideological
significance. They address this message to their visitors in two ways:
by presenting the art of the nation to its own citizens as an element of
cultural cohesion, and by showing this art to outsiders.

This explains the need for monumental, 'stage-set' architecture,
housing immense collections under the supervision of a complex
administrative structure.The principal architectural characteristics of
these great museums derive from their scale. They must be
sufficiently spacious, and sufficiently theatrical, to draw in a large
number of visitors – colossal entrance halls, noble flights of stairs,
wide galleries for circulation, grand spaces and long vistas, and
impressive lounge areas.

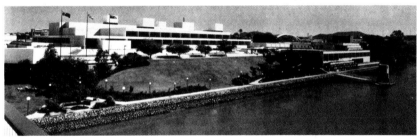

The monumentality of the entrance porticoes and the size of the
interior spaces provide the typological definition of these buildings.
By the same token, their complexity means that they need great
spaces to articulate them and allow the hundreds of visitors to orient
themselves within the building: classical vestibules, spacious central
courtyards, impressive salons and long galleries. Therefore, such
buildings tend to be 'show' museums, based on the hugeness of their
interiors, their wealth of ornament, and even on the impressive flow of
people.

Their origins are to be found in the first public and state museums of
the end of the 18th century, with the first initiatives being the British

747.876

1854546007l002

Museum in London (1753) and the Central Museum of Arts of the Republic in Paris (1793) which was soon to become the Napoleon Museum in the Louvre. This genesis continued into the early 19th century – the National Gallery in London, the Hermitage in St Petersburg, the National Gallery and Altes Museum in Berlin, and others.

Every one of these museums, first conceived against the criteria of the 19th century, have since needed some modernization and, in some cases, extension. Two types of solution have emerged in response to this problem of whether to modernize, remodel, reorganize or extend.

The first consists of a restructuring of a great existing museum. This is what has been done in I.M. Pei's scheme for the Great Louvre in Paris (1983–9). The same process is underway in the extension to the National Gallery in London (Robert Venturi, 1985), and is planned for the Brooklyn Museum in New York, following Arata Isozaki's project (of 1987). Even some middle-sized, non-State-directed art museums of our own time have reached the point of needing extension: this was done at the Museum of Modern Art (Cesar Pelli, 1977–84); has been started at the Guggenheim (Gwathmey & Siegel, 1984); and was foreseen at the Whitney (Michael Graves, 1985) – all of these in New York. In Barcelona, the Joan Miró Foundation, designed by Josep Lluis Sert in 1972, has been extended by his former collaborator Jaume Freixa (1984–8). In all of these last-mentioned cases, a particular problem had to be faced – that of treating masterpieces of modern architecture as if they were 'old' architecture in need of extension. This will be discussed more thoroughly in the next section.

The alternative approach is to gather the collections together in one large building. One of the options is to choose a great urban shell, an old and significant edifice, as was done in Paris with the creation of the Museum of 19th Century Art by bringing together various museums and collections (the Impressionists from the Jeu de Paume, the Walter-Guillaume from L'Orangerie, the collections from the Palais de Tokio etc) and installing them in the former railway station of Orsay as adapted by the architect Gae Aulenti (1980–6). Alternatively there is the Museum of the Art of Catalonia created inside the old Palau Nacional, in Barcelona. The most colossal and representative of the buildings constructed for the International Exhibition of 1929, this project too is by Gae Aulenti (1985).

The third option is to build something new from the ground up. This was the case with the new Munich Art Gallery, designed by Alexander F. von Branca (1974–81). It is a magnificent example, with its open form and clear spatial structure. Thanks to its great central hall and its two itineraries, routed around the courtyards, this building affords the visitor a clear understanding of the spatial layout of the museum.

The architectural problems presented by the modernization of these museums are extremely complex. It may be necessary to modernize the way in which the works of art are presented; to rationalize and signpost long visitors' routes; to restructure circulation and rest spaces; to improve access from the exterior for large numbers of tourists; to develop appropriate forms of lighting in buildings in which it is difficult to provide natural illumination in all rooms; and to find a unified solution to the problems inherent to the museum itself – adding new rooms; and introducing the services which a modern-day museum requires.

The outcome of all this is that in many cases – as has happened with differing degrees of good fortune in the Gare d'Orsay in Paris and the Metropolitan Museum of Art in New York – these great buildings end up becoming a conglomerate of separate small museums and galleries. The complex of galleries in the Gare d'Orsay, for instance, is articulated in a labyrinthine and vertical manner around the great central and linear space of the old railway station. In New York's Metropolitan Museum of Art this sense of the addition of museum upon museum is intensified by the new galleries designed by Kevin Roche between 1969 and 1989, which extend horizontally and have the character of large rooms filled with attractive natural light.

In planning extensions to these great national museums, there are three types of problem which have to be solved: strictly functional problems, urban problems and symbolic–formal problems.

With regards to the first, all of the internal circulation must be interrelated, the location of the works of art must be thought out anew, and all the services associated with a contemporary museum must be introduced. In the second place, the problems of urban context have to be tackled; problems created by the restructuring of a monumental building occupying a central position in a capital city, resolving problems of access, of connections with public transport and with parking facilities. Thirdly, there is the problem of formal and symbolic character: the bestowing of a new image on a monumental

11. Extension of the Brooklyn Museum, New York (USA), Arata Isozaki. (1986)
12. Extension of the Museum of Modern Art, New York (USA), Cesar Pelli. (1977–1984)
13. Extension of the Guggenheim Museum, New York (USA), Gwatmey & Siegel. (1984)
14. Museum of the Nineteenth Century in the Gare d'Orsay, Paris (France), Gae Aulenti. (1980–1986)
15. New Munich Art Gallery (West Germany), Alexander F. von Branca. (1974–1981)
16. National Museum of Catalan Art, Barcelona (Spain), Gae Aulenti. (1985)
17. National Gallery of Canada, Ottawa (Canada), Moshe Safdie. (1988)

	11	
12	13	14
15	16	17

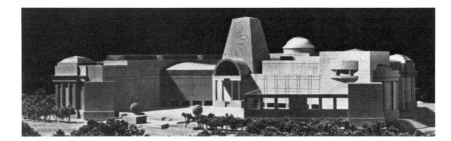

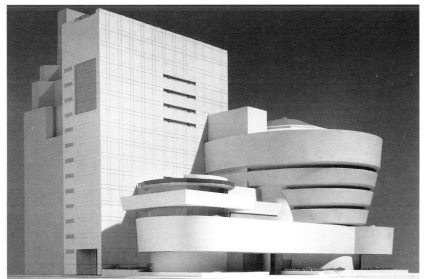

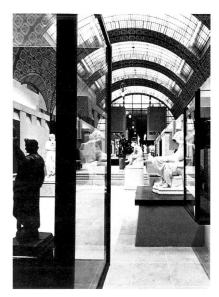

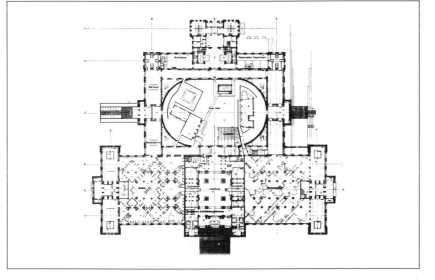

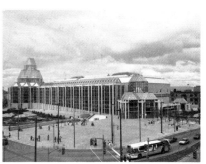

and historic building; the introduction of new forms alongside a monumental architecture, forms which should be capable of giving expression to the memory of the old building and at the same time express the modern quality of the extension – in short, provide the museum with a new image without slighting its traditional character.

There is no doubt that the project which has most perfectly succeeded in simultaneously resolving all of these challenges is the extension to the Louvre. By means of the great pyramid and the new underground corridors it has simultaneously resolved urban character, formal restructuring, and definition of a new and contemporary image in keeping with the historic entity. The pyramid, in the centre of the Louvre courtyard, relates the building with the monumental city, recreating the axis of the Arc de Triomphe. It provides much-needed new access, reorganizing at the same time the entire internal functioning of the different parts of the museum; and it gives to the museum a new image, pure and transparent, which is integrated into the urban context.

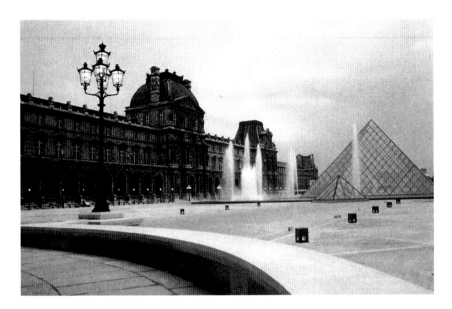

By contrast, the most pessimistic project is the extension to the National Gallery in London. With his customary irony, Robert Venturi has presented a scheme whose façade is an imitation and echo of the existing building. What we have here is a sophisticated, urbane 'decorated warehouse'. The interior is functional; its exterior is an imitation of its surroundings, making of it a mere reflection.

In other instances, the extension to a great museum is carried out with the addition of an independently functioning element or elements. This is the approach adopted by James Stirling and Michael Wilford in the two phases of the Tate Gallery extension – the Clore Gallery (1980–6) and the Library and Sculpture Room (1986). The Clore Gallery, in fact, should be understood as a little museum of art in its own right, independent of the great museum.

3 MUSEUMS OF CONTEMPORARY ART

Contemporary art museums effectively adhere to the same logic as the art galleries and museums of art of the 19th century, such as the Dulwich Gallery in London (1811–14) or the old Art Gallery in Munich (1826–36), in that each has been established in a medium-sized space for the purpose of housing a collection of contemporary art.

With the passage of time, there have been two essential changes in

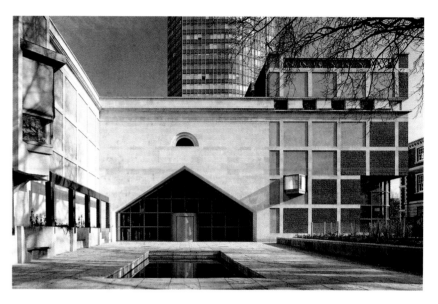

21/23. Extension to the Tate Gallery,
London (GB),
James Stirling, Clore Gallery (1980–1986);
later phases (1986)

the field of the museum of contemporary art. First, the idea of the museum has evolved: nowadays the museum tends to have a programme of much greater complexity and is conceived as a centre of activity. Secondly the characteristics of, particularly, late 20th century art are radically different from those of the conventional pictures of 19th century painting. As a result, there exists a problem of the remodelling of these old, medium-sized art galleries as well as a need to create new museums of contemporary art.

While it is true that the changes brought about by the avant-garde movements at the turn of the century were radical and qualitative, only a small part of their work – that of Dadaists, surrealists, constructivists, Soviet futurists – broke with the traditional relationship between painting and space. The greater part of the work of Mondrian, Kandinsky, Klee, Picasso and the rest remained within the conventional canons which determine what a picture is. The most radical changes have been produced by the avant-gardes of more recent times. Their size, form and characteristics have required a transformation of exhibition space. Art brut, pop art, body art, land art, minimalism, video art, happenings, performance, installations and many other more or less interactive or ephemeral artistic modes have set about writing their own laws which should govern their display in a museum. Sometimes, a particular display demands a specially constituted space. In others, the size and weight of the work obliges the building to meet certain special infrastructural conditions. Almost invariably a space with sophisticated technological provision is called for. In short, spaces intended for housing of contemporary works of art must possess certain very carefully defined qualities, probably including flexibility, versatility, and a high level of technology.

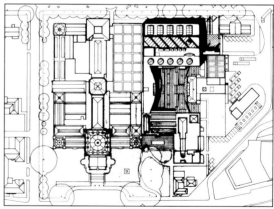

The impossibility of a modern collection ever being complete and closed makes it essential to think in terms of adaptable buildings with some potential for further growth. The tremendous diversity of sizes and characteristics of these works of art – from tiny, intensely concentrated pieces to gigantic compositions extending into space – requires that the space be capable of giving definition to small environments as well as of opening up large volumes and areas.

The new museum of contemporary art may well be housed in an entirely new building. A model example of this is Arata Isozaki's Museum of Contemporary Art in Los Angeles (1982–6). This is a low building, shaped by entrance courtyards and defined by a series of rooms with pure volumetric forms – prisms, pyramids, cylinders – lit

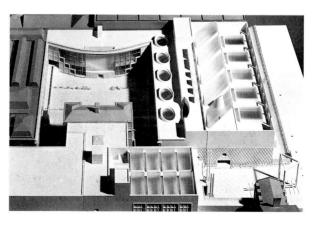

from above. The building is a paradigm of the museum of contemporary art: of medium size, composed of rooms which are simple in form and neutral in character, with a high proportion of natural light.

Another model instance is that of the Menil Collection in Houston (1981–7), designed by Renzo Piano. When the museum in question is to be built entirely from scratch, it is possible to find a perfect solution to one of the central issues for a building housing an art collection: natural illumination. We have already considered the Dulwich Gallery in London, with its adroit use of skylights providing ideal overhead lighting. In the case of the Menil Collection, the use of fibre laminates, which can be angled according to the strength and position of the sun, has made it possible to ignore the traditional maximum of 200 lux illumination in an art gallery. Here the works on show are exposed to 2000 lux. This provided an exceptional clarity inside the museum, in which every detail of each individual piece can be seen.

Considered in terms of this model, that of the wholly new museum of contemporary art, defined by examples such as the MOCA and the Menil Collection – buildings, we have noted, of medium size, composed of rooms with simple forms and overhead lighting in which the works of art are placed in a neutral and flexible manner – the Municipal Museum in Mönchengladbach (1972–82), by Hans Hollein, is an exceptional case. It conforms broadly to this typology yet, in adapting each individual room to a specific collection, it tends in the direction of the municipal and civic museums which we will discuss in the next section. The extension to Stirling's Staatsgalerie in Stuttgart, on the other hand, strikes a significant divergent note. The new part of the museum exhibits contemporary works of art in a classical system of rooms laid out in sequence. The reason is that, although originally meant to house 18th and 19th century paintings, the great popular success of the new building has now led to its being used for exhibitions of contemporary art for which it had not been intended.

In Japan we have seen the creation over the last few years of a whole new generation of new municipal museums of contemporary art, such as the Municipal Museum of Gunma (Arata Isozaki, 1972–4), the Museum of Modern Art in Saitama (1981–2) and the Municipal Museum of Modern Art in Nagoya (1983–7) – both of these by Kisho Kurokawa – and the National Museum of Modern Art in Kyoto (Fumihiko Maki, 1985–7). The majority of these are laid out on the basis of the articulation or linking together of a series of pure

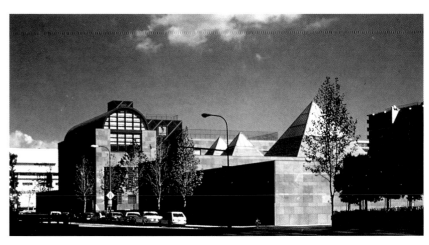

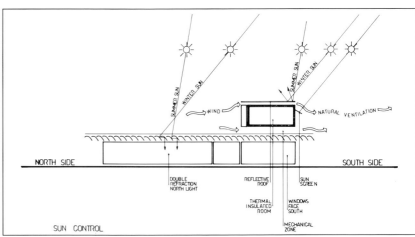

SUN CONTROL

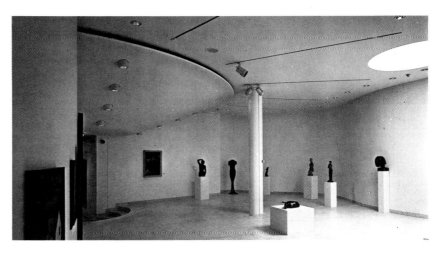

volumes: cubes, prisms and pyramids which combine with one another in accordance with axial and rotational laws and are constructed of noble and brilliant materials – stone, plates of polished steel, and great glazed surfaces – which give them the appearance of cold, gigantic, polished sculptures.

We must of course bear in mind that in many cases, at the time of planning these museums of modern art, those involved could not be completely sure which works of art would be exhibited in them. This was the case with the Museum of Contemporary Art in Frankfurt, designed by Hans Hollein (1983), as well as Richard Meier's Museum of Contemporary Art in Barcelona (1987). What the architecture has contributed in these instances is a setting of great rooms with perfect volumetric definition and overhead lighting.

In concluding with these instances of entirely new museums of contemporary art, there remain a few cases which should not be overlooked.

A not very recent example is the Van Gogh Museum in Amsterdam (1973) by Gerrit Rietveld. This is a tall building organized around a great unifying space containing the stairs, which makes it an ideal example of an internally structured museum, its layout allowing a clarity of orientation and perception to the visitors inside. The Valencian Institute of Contemporary Art in Valencia (1984–8), designed by a large team headed by Emilio Giménez, corresponds to this same typology: medium size, good natural lighting, and rooms with pure volumetric forms. By constrast, Italo Gamberini's new museum of contemporary art in Prato (1988) has opted for the industrial aesthetic of great horizontally extended containers. The new Northern Museum of Modern Art in Villeneuve d'Asq, designed by Roland Simounet (1983), is an obvious example of a museum with a labyrinthine internal organization, resulting in difficulty of orientation for the visitor.

In other cases there may be a return to the reuse of a great building such as a palace, a market, a hospital, a customs house or the like: some great architectonic shell whose clarity of structure and large multifunctional spaces might make it particularly suitable for the installation of a diverse collection of works of art. Such is the case with the Temporary Contemporary in Los Angeles (1983), an old warehouse, transformed into a museum of contemporary art by Frank Gehry. This is true of many museums of contemporary art and art

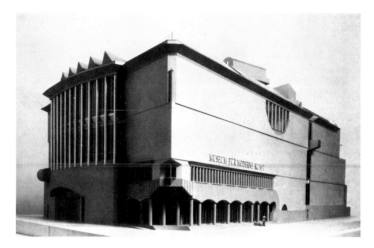

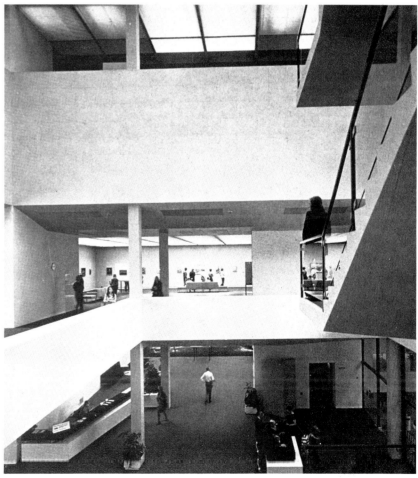

galleries in the industrialized world. As we shall see in the sixth section, if a relationship has been established between the characteristics of contemporary art and a certain type of architectonic space, this relationship has been developed by way of the reutilization of industrial buildings.

There is a great variety of different examples of museums of contemporary art – or museums devoted to the work of one particular contemporary artist – installed in old buildings. Foremost are the two Picasso museums. The one in Paris is located in an old baroque palace, the Hôtel Salé, remodelled after a scheme by Roland Simounet (1976–84); the Barcelona museum, designed by Jordi Garcés and Enric Sòria, has been installed in a series of renaissance palaces (1981–6). In the Museum of Contemporary Art in the Rivoli castle at Turin, designed by Andrea Bruno (1986), the works of art are set in a relationship of point and counterpoint with the baroque space and forms. The new Tate Gallery in Liverpool, designed by James Stirling and Michael Wilford, makes use of the ground floor of an old dock building (1988); while the Antoni Tapies Foundation has established itself in what was originally a *Moderniste* printworks in Barcelona, transformed by the architects Lluis Doménech and Roser Amadó (1985). The new Tate Gallery in Liverpool, designed by Stirling and Wilford, makes use of the ground floor of an old dockside warehouse (1988). It was Stirling and Wilford too, who won the limited competition to design a new gallery in the gardens of the Villa Favorita (Lugano, 1986) to house the Tyssen–Bornemisza collection.

4 MUSEUMS OF SCIENCE, TECHNOLOGY AND INDUSTRY

In these museums there is a continuation, to some degree, of the late Renaissance tradition of collections of curiosities and exhibits of the natural sciences. This tradition was continued in the museums of Natural Sciences promoted by the scientistic, positivist and classificatory culture of the post-Enlightenment 19th century. Now, in the second half of the 20th century, these museums see themselves as educational centres. This results from our new understanding of the museum as a centre of activities intimately related to its context, itself the outcome of the socialization of science and of culture in general which has taken place during the 20th century. These museums tend to be interactive, based on intervention and 'hands on' participation by their visitors, and centred on essentially experimental and educational objectives. They aim to exercise an influence over the community; to be places for the transmission and acquisition of knowledge; centres for the encouragement of cultural and social cohesion.

In contradistinction to museums of art, in which the interior is based on the direct visual relationship between the visitor and the work on show, what predominates in these museums is not the direct perceptual relationship between subject and object, but rather the observer's intellectual efforts to follow the syllabus set out in the different parts of the museum as if it were a discourse.

In marked constrast to the world of art, the material exhibited in these museums will not, in many cases, have great economic value; nor will they display unique, or artistic, or irreplaceable pieces. Scientific museums are stocked essentially with objects from two worlds: the natural and organic, and the artificial and industrial. Alongside these objects the whole explanatory underpinning, the didactic apparatus, takes on a hugh importance: panels, displays, series of objects, photographs, diagrams, dioramas, slides, audiovisual presentations, games, demonstration apparatus, models, and reproductions. In the most recent examples, the fundamentals of the whole building are present in every tiny space in which the visitor gets 'hands on' experience of some apparatus, to experiment with light, or sound, or mechanics, or optics, or whatever. Just as with the automata, the scientific instruments and the chambers of baroque curiosity museums, the museum in these recent examples is intrinsically present at the level of the mechanism itself, in the fascination of every apparatus and contraption.

These museums are generally places capable of accommodating, perhaps even in a single building, objects of greatly different scales – from skeletons of dinosaurs down to explanations of the microcellular world; from huge spacecraft to tiny instruments and tools. As a result, these museums tend to be great containers, hangars in which to deposit an infinite variety of objects and display cases, great spaces in which the exhibits are scattered wide.

Museums dealing with man and nature have undergone a process of development and organization in line with that of the advance in scientific knowledge – Linnaeus (*Systema Naturae*, 1735), Darwin (*The Origin of Species*, 1859), etc.

In keeping with this continual transformation of the world of science and industry, any museum of science needs to have a provisional

29. Antoni Tapies Foundation,
Barcelona (Spain),
Ll. Domanech/R. Amadó.
(1985–1990)
30. Picasso Museum in the Hotel Salé,
Paris (France),
R. Simounet. (1976–1984)
31. Museum of Contemporary Art
in the Rivoli Castle, Turin (Italy),
Andrea Bruno. (1986)

32. Valencian Institute of Modern Art
(IVAM), Valencia (Spain),
E. Gimenez, V. Garcia, J. Murcia,
C. Salvadores, Ch. Sanchis
33. Tate Gallery, Liverpool (GB),
James Stirling. (1985–1988)

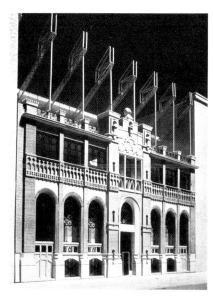

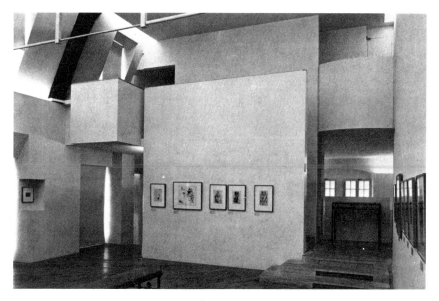

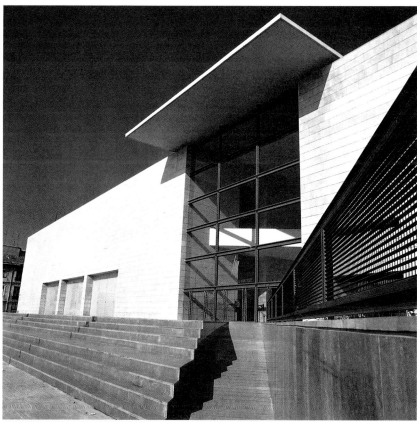

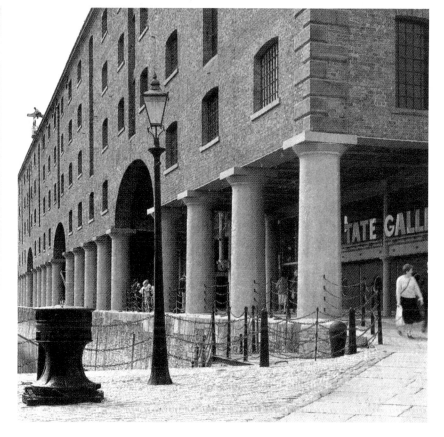

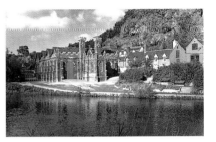

internal arrangement, and even a form, which allows for growth. New interpretations and inventions will call for future reorganization and extra space. These museums should be constantly rearranging themselves and putting on exhibitions on new themes.

From the Oxford University Museum (designed by Benjamin Woodward between 1855 and 1860) or the Natural History Museum in London (designed by Alfred Waterhouse between 1871 and 1881) up to Museum of Science and Technology at La Villette in Paris (by the team led by Adrien Fainsilber between 1980 and 1986) they have all adopted the architectonic solution of the great shell or container. The first two examples express themselves in a neo-gothic language relating to their use of stone, while the last sets out from the late modern language of high technology. The first two literally adopt the spatial structure of the gothic cathedral, while the last follows the typological lead of the great industrial buildings. The diversity of scale of the exhibited objects makes it necessary, in the majority of cases, to propose a building with a large central hall of considerable height flanked by wings of several storeys. This probably explains the ecclesiastic typology of the 19th century and the industrial model of the large central space, surrounded by various floors, in the case of La Villette.

In addition to those already mentioned, the following museums have all been of seminal significance in this century. The Noorder Animal Park in Enmen, Holland, a largely open-air zoological and ethnological museum, was inaugurated in 1935 and remodelled in 1970. The 'Deutsches Museum' technical museum in Munich, with an extension by the architect Paolo Nestler added in 1957–61, is a building given over to the exhibition of key pieces and periods in the history of science and technology, with a collection of objects of every conceivable type – mills, locomotives, ships, aircraft etc. There are many more: the Swiss Transport Museum in Lucerne, by the architects O. Dreyer, H. Käpeli and J. Huber (1956–9); the Palais de la Découverte in Paris, dating from 1937, devoted to scientific exhibitions; the Gorge Museum in Ironbridge, England (Telford) where in 1777 the first really large scale smelting of iron (for the construction of the iron bridge itself) took place, with a variety of different factories and workshops – all on their original sites – now converted into working museums; the Ecomuseum of Man and Industry in Le Creusot, installed in an old industrial mining settlement; the International Centre for Reflection on the Future and the International Centre for Architecture in the old Saline Royal, designed by Claude-

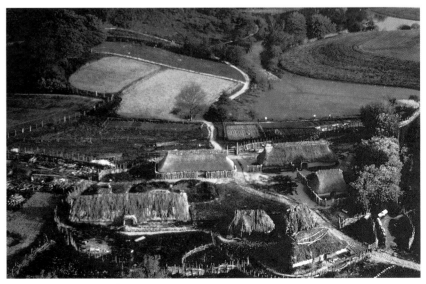

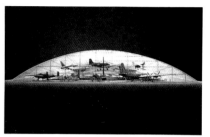

Nicolas Ledoux in Arc-et-Senans; the Wasa Museum in Stockholm, given over to the exhibition of a full-size Viking longboat; the Museum of Childhood in Brooklyn, New York, the first in the world, opened in 1899 and modernized in 1976 by the team of Hardy, Holzman and Pfeiffer; and many other highly successful and popular museums, such as the Exploratorium in San Francisco, the Air Museum in Washington, the Air Museum in Los Angeles and the Museum of Cinema in Frankfurt. In many of these museums the architectural contribution is not the most striking feature, preferring to stay out of the limelight. In some cases – Ironbridge, Le Creusot, Saline Royal in Arc-et-Senans, the Manchester Museum of Science and Industry, etc – these are restorations of historic sites or, as at Lejre, near Roskilde (Denmark; developed from 1954 on), the recreation of a primitive settlement.

In other cases the architectural contribution takes the form of a large, neutral, flexible container which houses the collection – a container which may well possess a high architectural quality, such as the Museum of Science and Industry in Manheim (1986–90) by Ingeborg Kuhler; which might be quite literally an aircraft hangar, as in the scheme for the American Air Museum in Cambridge, Great Britain, by Norman Foster (1988); which might be a lesson in how to convert an old building into a new space, like the Museum of Science in Barcelona (1979–88) by Garcés and Sòria; or which might set out to achieve an exaggerated expressiveness in its own right, like the Museum of Canadian Civilisation, in Ottawa (1989).

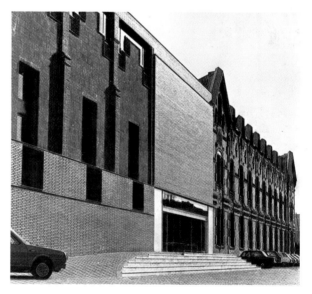

We have already remarked on the fact that the predominance of the educational element, and the participation and interactive involvement of the visitor are definitive characteristics of these museums of science, and that the architecture should provide the container in which the whole museological system is to be installed. It ought to take second place to the pieces it houses. We can go further, and say that, beyond the cult of the valuable object, the predominant element in these museums, much more than the object in itself, is the discourse – the logical sequence, the syllogistic chain, the reasoning process which each individual display and the overall script of the exhibition as a whole seek to expound.

The recent examples of such museums present an extremely high level of technology: from the technical support of the building and the sophistication of its equipment, to the range of information retrieval technology available to the visitor. The Museum of Science and

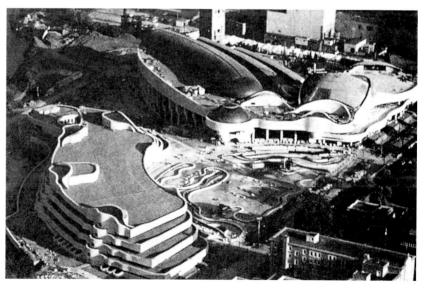

Technology at La Villette, Paris, is an ideal example of this, offering temporary scientific exhibitions of all kinds, and providing every type of peripheral service: mediathèque, information centres, conference and lecture rooms, and more.

Logically enough, then, the greatest innovations have been introduced into this type of museum, gradually extending the boundaries of what can be exhibited, and how, over the last quarter century or so, experimenting with alternative techniques for presentation and exploring this conception of the museum as an open and active place, a source of education and understanding, a point of influence in its social setting. The ecomuseums (that is, museum complexes which take a specific territory as their subject, such as prehistoric settlements, industrial communities, etc) are another recent contribution to this field – one which has brought with it, as an innovation, a type of museum which is not urban, but adapted to the countryside, with the same origins and the same physical context as that which it exhibits.

5 CIVIC AND SINGLE-THEME MUSEUMS

If what is important in the museums of science, technology and industry, is the discourse, over and above the objects themselves and the architectonic container, then in this extremely heterogeneous group of museums the absolute essence of the museum is its collection of pieces. Here, the architectonic space should be a function of the nature, size and characteristics of each displayed object. The architecture proceeds by defining the most appropriate settings for the contemplation of these pieces: the form of the room, the lighting system, the texture of the walls, the mounting of the piece itself. Glass cases, pedestals, stands, displays and lamps need to be carefully thought out and, very often, determined piece by piece, case by case. The objects of particular interest must be presented in some special way. As a result, the architectural project will find itself evolving by means of close engagement with design of each individual mount and display.

In a museum, the dialectic relating to the exhibition of the objects operates on three levels: the piece to be shown, its mount and the surrounding space. In classical museums these three factors were developed in a conventional fashion, without conferring any special significance on this intermediary element, the mount or support. Guides, stands, supports for sculptures and paintings were considered to be neutral, fixed elements; they were executed in a style in keeping with the ornamentation and decoration of the interior itself. But with the Italian museums of the fifties and sixties, in which designers such as Franco Albini, Carlo Scarpa and the BBPR team worked with complete collections of the very highest value, usually in buildings of unique historical significance, extreme emphasis began to be placed on the mounting of every piece. These supports and displays, each of which is treated individually, are an attempt to highlight the presence and value of the objects they serve, but end up by taking the dominant role for themselves, trying to be objects of artistic value in their own right, situated on an intermediary stratum between the architecture of the building and the artistic identity of the displayed pieces.

There is a close relationship between this type of museum and the project which bases itself exclusively on the design of the system of mounts and supports and the treatment of the spaces, room by room. This is an architecture of interiors, of fragments, rather than of global intervention in the building as a whole. In the case of Arrigo Rudi's contribution to the Maffeiano Lapidary Museum in Verona (1976–82), it is quite apparent that the remodelling project, in addition to restoring the neoclassical building itself, consists of the reorganization of the system by which the pieces are exhibited according to modern museographic criteria. A modular metallic system has been created which serves as support for the stones installed in the courtyard, and many kinds of glass display cases, plinths, tables and stands have been designed for the interior, following the same modular principle and the same objective of ensuring the legibility of all of the displayed material.

This tradition in Italian museum design is continued in the work of Marco Albini, Franca Helg and Antonio Piva. The Civic Museum in the church of the Hermits of Padua (1969–86) houses a series of collections of the most varied typologies. After duly considering the materials, weight and form of each collection, the designers came up with an assortment of glass cases, stands and supports which follow a modular system. The idea was to obtain the maximum flexibility and, at the same time, the most painstaking precision in the presentation of each piece. The most important pieces stand out, not only on account of their privileged position, but also thanks to special lighting which highlights their formal and chromatic characteristics. This team adopted the same approach – studying each piece and

42. Museum of Prehistory and
 Ancient History,
 Frankfurt (West Germany),
 J.P. Kleihues. (1980–1988)
43. Maffeiano Lapidary Museum,
 Verona (Italy),
 Arrigo Rudi. (1976–1982)
44. Museum of Roman Art,
 Mérida (Spain),
 Rafael Moneo. (1980–1985)
45. Civic Museum in the Church
 of the Hermits,
 Padua (Italy),
 Albini, Helg, Piva. (1969–1986)
46/47. Marini Marine Museum,
 Milan (Italy),
 Albini, Helg, Piva
48. National Gallery of Parma (Italy),
 Guido Canali. (1970–1986)

	43	
42		44
45		
46	47	48

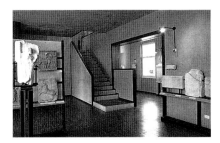

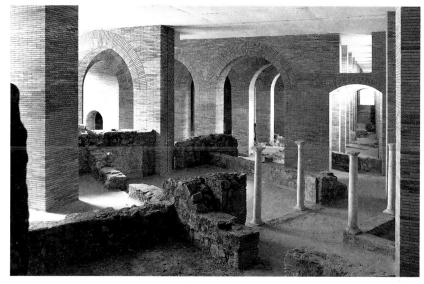

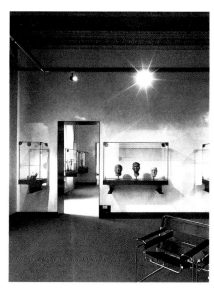

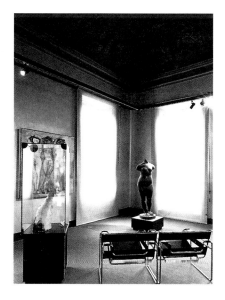

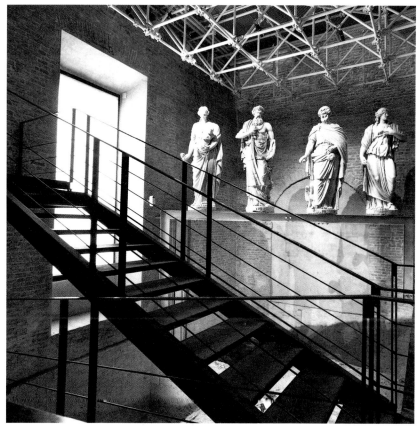

each room individually, giving consideration to the ease and informativeness of the exhibition itinerary – in their scheme for the installation of a single-subject collection, the work of the artist Marino Marini, on the first floor of the Villa Reale in Milan.

The National Gallery in the Palazzo della Pilotta in Parma, designed by Guido Canali (1970–86), is located inside the great historic complex made up of the Teatro Farnese, the Museum of Antiquity, the Palatina Library and the National Gallery. The introduction of architectonic interventions – corridors, bridges, platforms, stairs – was of fundamental importance in articulating the long itineraries and the diversity of spaces of the historic complex and in making the installation of the various pieces and collections. The court-like space of the Teatro Farnese, on the first floor, serves as entrance to the long itinerary through the many galleries. The Museum of Prehistory and Ancient History in Frankfurt (1980–8), by Josef Paul Kleihues, is an example of a combination of different solutions: the glass cases and the mounting of the archaeological exhibits have been installed in the interior of the late-Gothic church of the Carmelite convent, while all of the other facilities – vestibules, libraries, lecture halls, workshops and offices – are situated in a new annexe, a low building with a linear form.

In other archaeological museums the emphasis given to the object has met with a different type of interpretation. In the Museum of Roman Art in Mérida, designed by Rafael Moneo between 1980 and 1985, the system of construction of the entirely new building, using 'Roman' brick walls, expresses (in line with Robert Venturi's ideas) the actual content of the museum – original pieces of Roman art. In this instance the relationship with the object operates on the semantic level. In the case of the remodelling of the Museum of Archaeology in Barcelona (1986–9), carried out by Josep Llinàs, the most important element is the rethinking of the building's spatial structure, with its restoration of the dominant role to the vestibule and hexagonal central distribution area.

A perfect example of a project for this kind of museum is the remodelling of the Museum of Navarra in Pamplona (1986–9). Garcés and Sòria's scheme resolves the problem of the treatment of each piece by concentrating on its characteristics, its size, form, texture. The designers have therefore approached the definition of each of the rooms separately and individually. The Ukiyo-E museum in Matsumoto, designed by Kazuo Shinohara (1982) and the Museum of

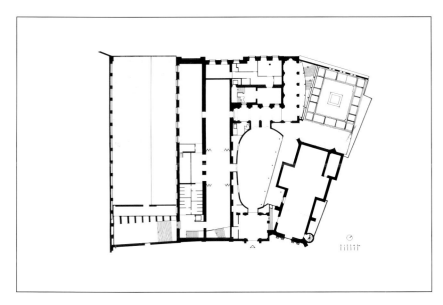

Decorative Arts in Frankfurt, by Richard Meier (1979–85), are two quite architectonically different solutions to the problem of defining the containing form as repository for a collection.

Museums of Ethnology, Anthropology, and Arts and Crafts, have something in common with both of the types or groups defined here. In terms of the artistic value of the collections exhibited and the individual treatment of each object, they can be located within the field of the civic and single-theme museums, while the importance they accord to discourse and the emphasis they place on their didactic function (by means of panels, dioramas and other communications techniques) would entitle them to a place in the section dealing with museums of science, technology and industry.

The truly definitive characteristic of the museums we have looked at in this section, however, must be the dependence of the space and the display system on the nature of the individual objects – the emphasis placed on the presentation of each piece, whether this be determined by the logic of the collection itself, by its heterogeneity, by the size and uniqueness of particular pieces, or whatever. In certain extreme cases, such as the already-mentioned Wasa Museum in Stockholm, the exhibition of Pablo Picasso's *Guernica* in Madrid, or the Hydraulics Museum in Murcia, the definitive element is the emphasis on showing a single, unique object: a Viking longboat, a painting or a water mill. In the case of the single-subject or single-theme museum, an extremely close and intimate relationship is established between container and content.

This monograph quality in a museum is well illustrated by a minimal, almost miniature, example, four metres by eight. This is the Museum of the Collegiate Church of Santa Maria in La Coruña, a scheme by Manolo Gallego Jorreto (1982–6), skilfully integrated into the city's historic centre and devoted to the exhibition of pieces which are themselves small: the jewels of the adjoining church.

In some cases this monograph quality, this closeness of the relationship between building and object, can go so far as to enter into crisis: the architecture becomes the sole objective of its own narcissistic mechanism. This has happened with the Museum of Architecture in Frankfurt (1980–5), designed by Oswald Mathias Ungers. The itinerary around the perimeter provides the opportunity to admire the turn-of-the-century villa, now rehabilitated as a museum; while the interior itinerary leads to the discovery of the allegory of the

primitive hut which is housed at the heart of the building, on the first floor – the house within a house. Beyond this, there is nothing; there is no space left over to exhibit or even preserve the house's treasures.

6 GALLERIES AND CENTRES OF CONTEMPORARY ART

There remains one last group, once again with similarities to museums of contemporary art, but clearly differentiated from them – privately-run commercial art galleries and the publicly-owned centres of contemporary art. Although it has been our intention in this book to scale the peaks of complexity and representative significance, looking at the great national museums and cultural complexes, we must take in the opposite extreme as well: those lesser spaces which offer contact with the most recent art, which is not yet 'museum material'.

While such spaces are not quite museums, they are only one step removed, and make it possible to experiment with solutions and to propose spatial relationships with much greater freedom than in a museum; solutions which, in the long term, may be applied to the museum proper. In these places the work of art is in free play with the space, interpreting it, overflowing and transcending it. These galleries and art centres offer us a glimpse of what the museums of the future will be like, because they display an open, active and tense relationship between work of art and space.

The objects exhibited in museums of contemporary art and galleries are the same – modern-day works of art. Nevertheless, there is a difference in the way they are exhibited. In the museum, the objects tend to be installed in a definitive fashion; even the space and the lighting may be individually thought out for each separate piece. In galleries and art centres there are, by definition, no permanent collections. They are centres for the promotion or development of the artist. Every exhibition is temporary, situating itself provisionally in a particular space, on an already determined support structure. More important still, in many cases the artists actually conceive their ephemeral, non-permanent contributions – paintings, sculpture, installations, machines, etc – on the basis of that space, the space of that particular gallery. Each intervention transforms the perception of the space. Also, we must not forget that the relationship between architectonic space (with its forms, its technological support, its lighting systems, and so on) and the work of art (with its plastic, its

textural, its symbolic and other values) is an aspect of the very essence of the art museum.

The most emblemetic example to be found in this field is 'Le Magasin' in Grenoble (Patrick Bouchain, 1985–6). This was originally a coppersmith's workshop, roofed with a metal structure designed by Eiffel, which now houses a National Centre for Contemporary Art with work spaces, classrooms, studios, a library, an auditorium and a large exhibition space in the middle. The artists who set up in the place offer, with every piece of work, an individual plastic interpretation of the space they occupy. In such cases the work overflows the architecture, appearing with astonishing force inside the space.

For this to be possible, these centres and galleries have to offer extremely flexible, highly-technologized spaces capable of allowing the installation of work of a great variety of types, bringing together interdisciplinary experiments of every kind and all the diversity of approaches which art promotes.

At this point in our investigations we must formulate a certain question: if the end of the 18th century saw the creation of those fashionable salons where the new enlightened taste could present itself to the public; and if, during the period of the avant-garde movements in art, architecture – directly or indirectly – conceived spaces capable of providing appropriate accommodation for the singular works of modern art (for example the proposals of Mies van der Rohe, from the German Pavilion to the National Gallery in Berlin, by way of the Museum for a small town; or the pavilions by other architects, such as the one by Meinikov in 1925, or Sert and Lacasa's of 1937, both in Paris) then what spaces have been proposed by present-day architecture for the housing of the exhibitions, installations and montages of the most recent art? It would seem that the response made by our post-modern condition has consisted of the recovery of industrial and metropolitan spaces now in disuse which, thanks to their typological characteristics – flexible spaces, with plenty of height and volume, wide angles of vision, ease of lighting installation, rationally laid out nuclei of access and vertical circulation, moderate conversion and reuse costs, adequate loading facilities, etc – have emerged, in numerous instances, as the containers of art galleries in many of the world's great capitals. Precisely those typologies – multi-storey factories, warehouses, etc – which were once dedicated to industrial production are now being converted for use in the service of artistic activity. The industrial

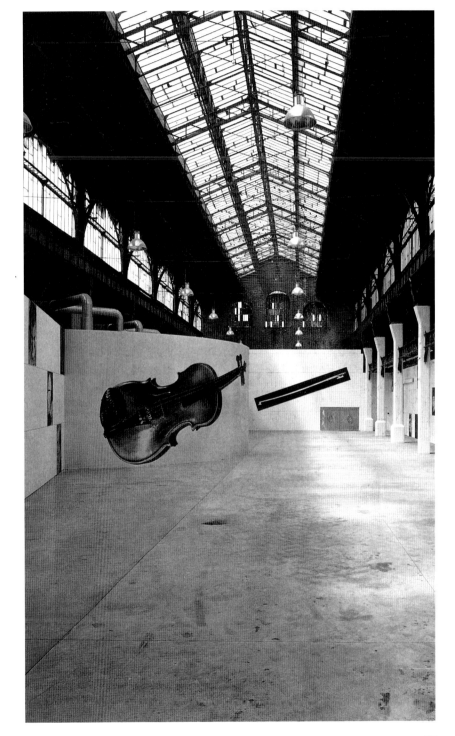

space, with its rows of cast-iron columns and its steel frame roofs, has become the most common repository for recent artistic production. Indeed, there are certain parallels between the activity of industrial production, its mechanisms and movements, and the processes of contemporary artistic creation – the transporting of pieces, the manufacture of prototypes, the use of welds and solders, the importance of technology and computerization, the interdisciplinary approach, of montage, installation, and so on.

The evidence is there to see in most of the world's major capitals: art centres, galleries both large and small, even the artists' own studios and workshops. In New York there are dozens of examples, perhaps the most outstanding being the New Museum of Modern Art, the Artists' Space and the complex of art galleries which takes up the building at number 640 Brooklyn Avenue – all of which occupy old warehouses in SoHo. In Paris we find the space of the Grande Halle de La Villette, an old market converted into a gigantic temporary exhibition area. There are two exemplary instances in London: the remodelled Whitechapel Gallery, a conversion of a former church carried out between 1982 and 1985 by Alan Colquhoun and John Miller; and the Saatchi Art Collection, installed in an old car repair workshop redesigned by Max Gordon (1983–4). Even an institution with a considerably higher public profile, such as the already mentioned Temporary Contemporary in Los Angeles, designed by Frank Gehry (1983), acknowledges this temporary quality so prevalent amongst contemporary art galleries and centres, and is installed in what were formerly warehouse premises.

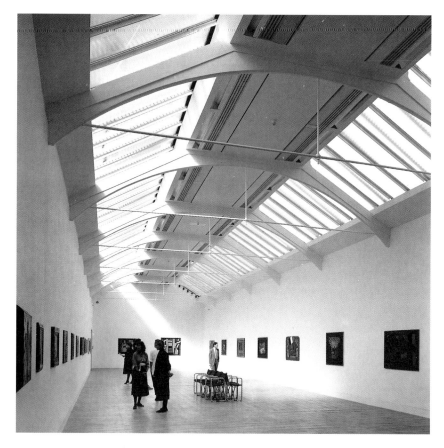

Some of these centres of contemporary art have now reached a point where a certain logical difficulty presents itself: the accumulation of works of art and the impetus to develop into a museum. With the passages of time these centres have been acquiring and amassing collections of their own, the product of workshops, their exchanges and their temporary exhibitions. Such is the case of the Centre for the Contemporary Plastic Arts in Bordeaux, installed in an old dockside customs house dating from the beginning of the 19th century, remodelled by Denis Valode and Jean Pistre (1978). Gradually this great centre, which is also provided with theatres and other cultural facilities, has come to find itself in possession of pieces which amount to a permanent collection. This has accordingly created a need for new spaces in which to install this collection.

With the overall category of 'centres of contemporary art' there are

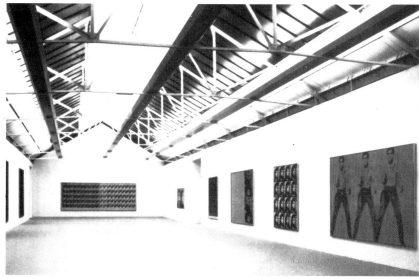

institutions which are exclusively devoted to encouraging creativity –
by means of workshop, seminars, courses, etc – and there are
buildings conceived with the aim of providing the spatial and
technological framework for temporary artistic installations of every
imaginable character. The Multimedia Space for Contemporary Art in
Palermo, designed by Mario Botta (1988) consists of a building in the
form of a cube with a cylindrical central courtyard (which gives it its
structure) and a roof garden; it is provided with multifunctional
spaces, and galleries around the periphery to accommodate artistic
events, exhibitions and performances of all kinds. The brief for the
Galician Centre for Contemporary Art in Santiago de Compostela
(1988), designed by Alvaro Siza Viera, has essentially addressed itself
to providing services and spaces for temporary exhibitions.

There is, finally, another type of provision closely comparable to the
museum, to which we have already implicitly referred, and which also
raises questions concerning the temporal relationship between space
and discourse: the exhibition. Once again, successes and mistakes,
the appropriate or inappropriate choice of a space and the
development of a given expository option will depend on a proper
understanding of the relationships which must be established
between the various kinds of space available (open, linear, bordering
a courtyard, labyrinthine, compartmentalized, etc) and the logic
inherent in the discourse of each exhibition (unitary, dispersed,
subdivided in orderly fasion, etc).

In every period, architecture had been called on to find appropriate
spaces for the presentation of contemporary works of art: the
neoclassical galleries of the early 19th century which followed
classical taste, like John Soane's Dulwich Gallery; the open plan,
flexible museums for the art of the first decades of the 20th century,
like Mies van der Rohe's National Gallery in Berlin; the coolly
indifferent industrial containers for the art of the late 20th century. As
time passes, provisional installations become more set and solid, new
parameters appear to delimit the work of art, other solutions pass
away to take their place in history; the art gallery turns into a museum
and the task must be taken up anew.

Finally, Aldo Rossi's scheme for the Museum of German History in
Berlin (1988) is a synthesis of certain.characteristics of the different
types of museum we have looked at. In terms of its programme, it lies
somewhere between a science museum – given the museum's
insistence on its didactic value – and a civic museum – in the special

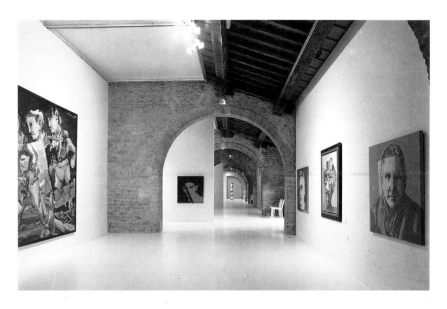

interest which surrounds the pieces exhibited. As far as form is concerned, there is an explicit wish to refer back to the typology of the great national museums of the 19th century, such as the British Museum or the Louvre. Rossi's museum is to be understood as a great hangar, attempting, in its volumes and its elements, to establish a relationship with the monumental tradition of the museums of the European Enlightenment. The cylinder housing the entrance represents the classical rotunda; the great exhibition space is open plan, and recalls the classical German architecture of the first part of the 19th century; the roofs seek to integrate themselves into the morphology of the medieval city; the decorative glazing pays homage to the German Rationalism apparent in the work of Gropius and Mies; and the L-shaped part which houses the administrative services takes the form of a colonnade in white stone, similar to the one designed by Schinkel for the Altes Museum in Berlin. Understood, above all, as an urban monument, what Rossi has put forward here is a proposal which acknowledges its debt to the modern tradition of the European museum.

CONCLUSION

Ranging from instances of the greatest complexity and the widest public significance, to the smallest and most ephemeral examples, we have tried to offer an orderly and intelligible review of the great diversity of approaches, solutions and qualified experiences to be found in the architecture of the new museums. The criterion which has served at once as guideline and pattern in grouping the examples chosen, has been the point, deep in the interior of the museum, where the confrontation between space and discourse is enacted, where museum and architecture come face to face. We have, accordingly, considered several different groups: those buildings defined by their formal complexity – whether they be containers, articulated buildings, dispersed complexes or ecomuseums – within which the museum may be a central, but not a unique, cultural facility; the great national museums of art, with their problems of scale; the museums of contemporary art; the museums of science, technology and industry – great containers with their heterogeneous collections and innovative discourses spread through their spaces; the civic and municipal museums based on the compartmentalization of space and the design of the supporting elements specifically for each individual collection or piece; and the centres and galleries of contemporary art, in most cases installed in what where once utilitarian buildings on the fringes of the old city centres. Above all, we have tried to show that in every one of these cases there are certain key relationships which hold for the adaptation of the architectonic space to the museographic programme.

Josep Maria Montaner

Examples

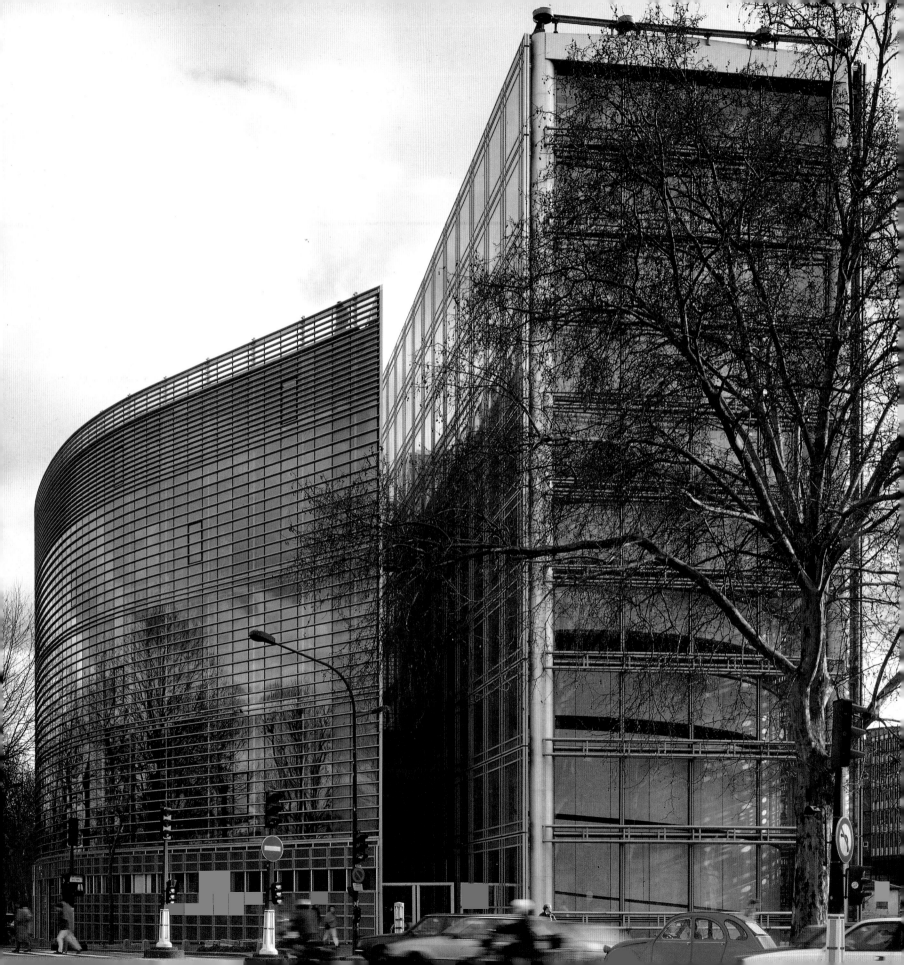

Architect: Jean Nouvel

Collaborators: Gilbert Lézénès, Pierre Soria
Architecture Studio (M. Robain, J. F. Galmiche,
R. Tisnado, J. F. Bonne)

The Institute of the Arab World

1981-1987 Paris (France)

On the banks of the Seine, next to the Faculty of Sciences and the point at which the Boulevard Saint-Germain and the Quai Sant Bernard meet, is the Institute of the Arab World. It is an international organization representing the Arab world in Europe. A huge glass repository in two parts, with a central divide and a courtyard inside, the two main uses of the building are as museum and library, and to a large extent these correspond with the two main volumes of the building. The museum is on five levels. Taking up three levels of double height, the library is located in the prismatic section. The three levels of reading space are vertically connected by a helical tower, reminiscent of oriental minarets, which also doubles as a book stack.

Although the main entrance is on the platform opposite the south facade, the volume-defining divide is also used as the entrance to the single-theme exhibition room. The two vertical spaces forming the interior are the nucleus of the vertical entrances, consisting of a large technological display with a view of the service installations and transparent lifts, and the aforementioned courtyard which illuminates the interior of the museum.

Besides these facilities, there is a series of spaces for single-theme exhibitions. There is a large auditorium in the basement, under the large entrance platform, next to the underground car park. In this basement, between the bottom of the emerging building – devoted to contemporary work – and the auditorium, is a large hipostila, formed by four rows of columns in a cylindrical shape. This space can be used for exhibitions and acts as a foyer to the auditorium. Most of the facilities – auditorium, meeting rooms and so on, are designed to be hired out.

These diverse functions are held within a large container of simple forms. To achieve the most attractive formal solution, the whole structure of the facade is independent of the structure of the building. The various components and details bring together Islamic culture and the world of high technology.

The south facade is shaped from diaphragms which, in a tight geometric and repetitive composition, allow continual control of natural light in the interior of the building. In the courtyard, a sensitive system of supports allows the composition of delicate square marble panels which filter light and at the same time invoke the idea of an oriental courtyard.

The space of the museum resembles that of a large office building. Occasionally this results in objects of identical size being displayed in double-height spaces and cramped single-height spaces. The stands and display cabinets, showing pieces relating to Arab history, art and culture are composed of metal structures, struts and sheets of glazed ceramic.

Having such a large variety of facilities within one homogeneous building has presented a series of problems. First, confusion as regards the entrances, since the entrance through the divide of the building is much more expressive than the main entrance on the south facade. Second, there is confusion with interior traffic – routes to the library, museum, shops, exhibition rooms and so on, all cross each other. Neither is it clear from their character which spaces are public, semi-public and which strictly private.

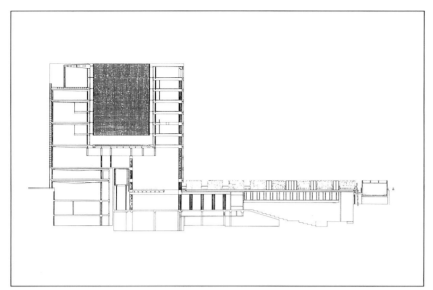

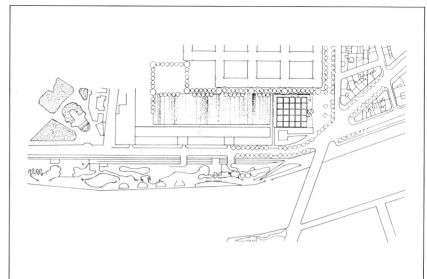

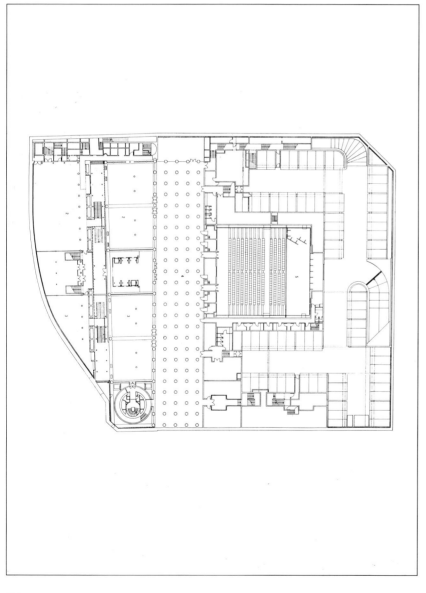

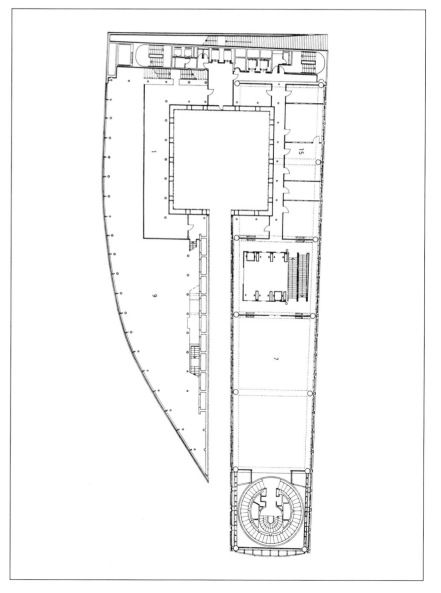

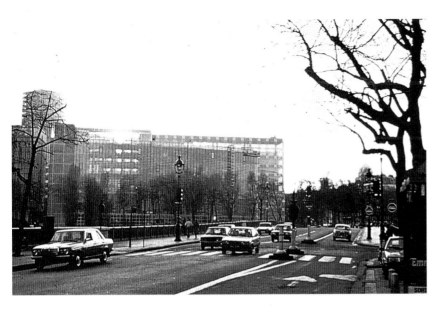
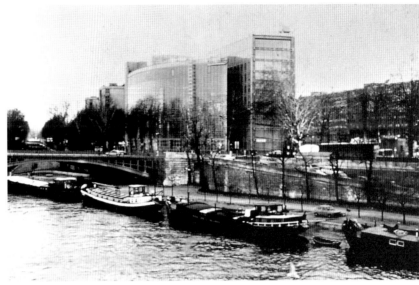
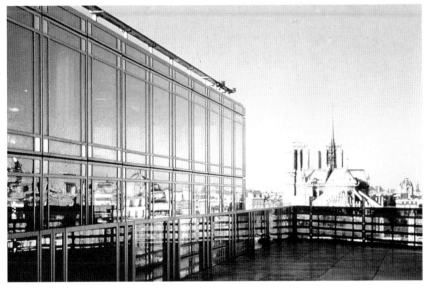

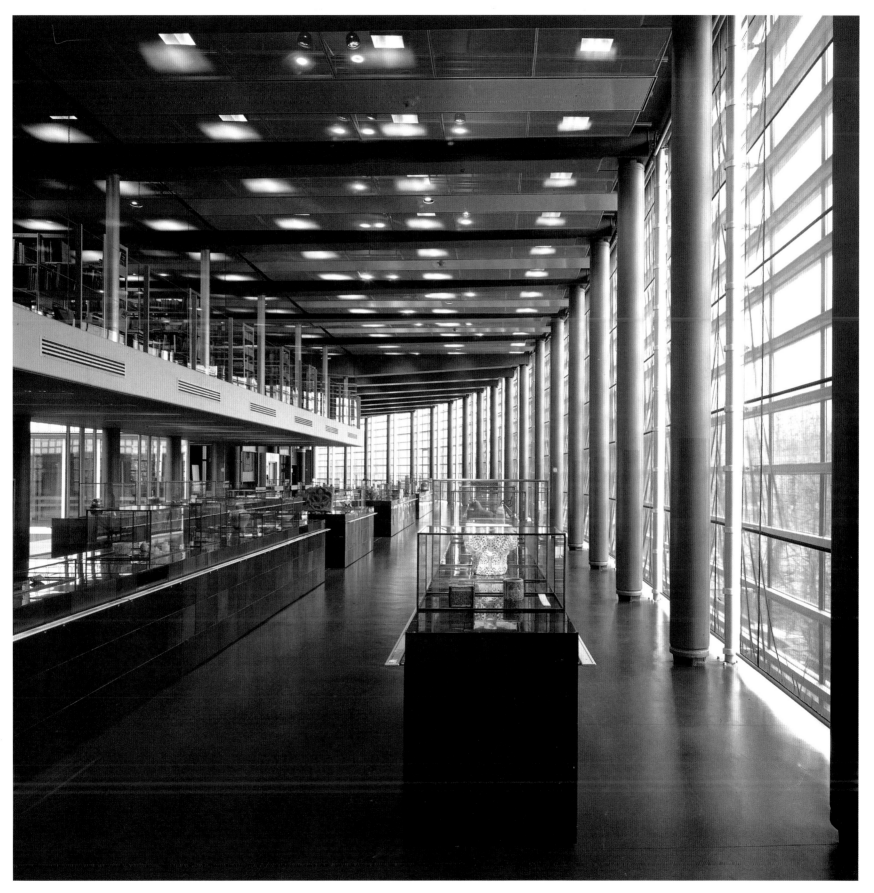

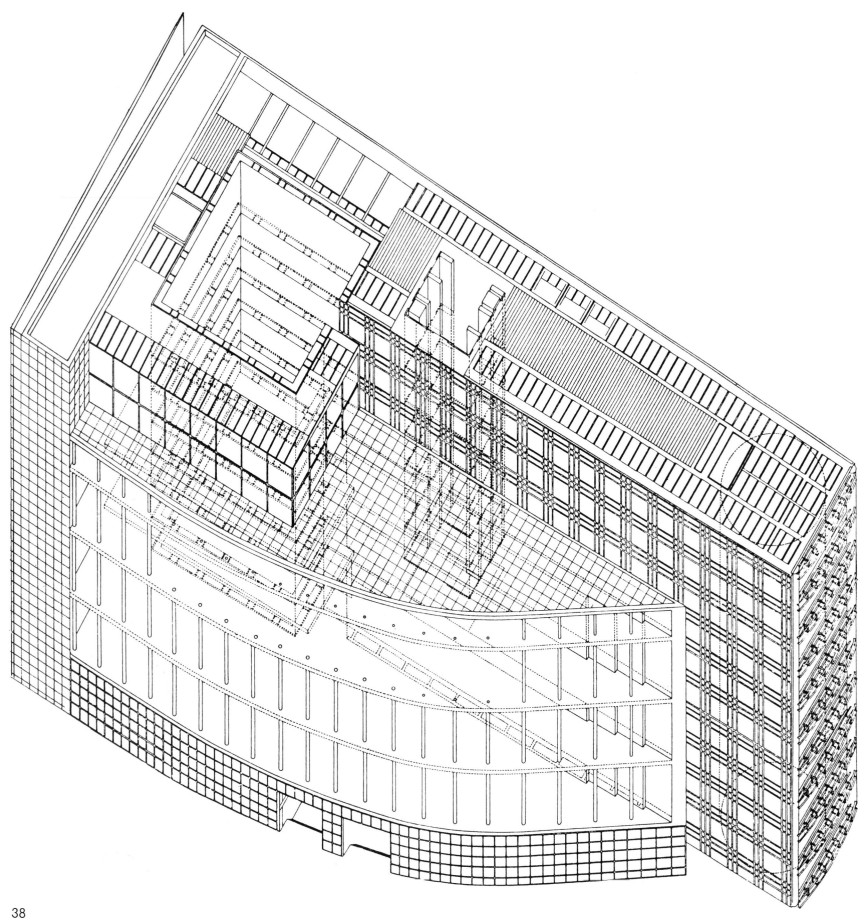

38

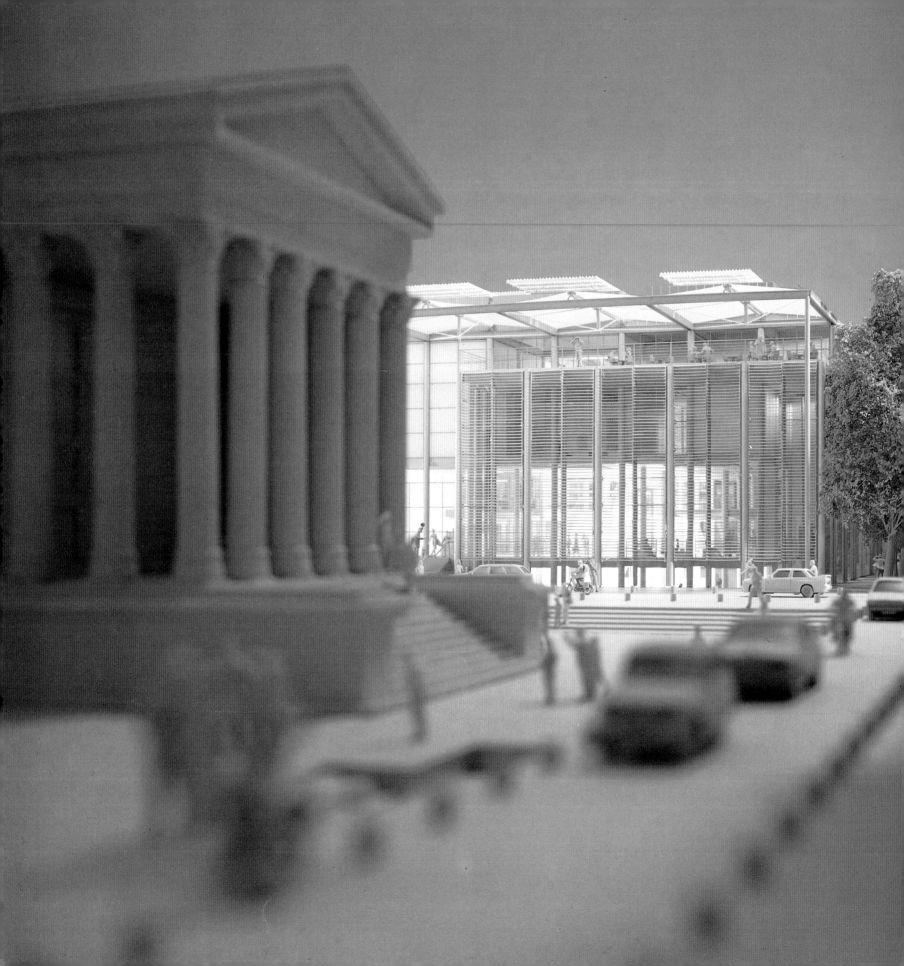

Architects: Norman Foster Associates

Collaborators: Ove Arup and Partners

The Nîmes Mediathèque and Centre for Contemporary Art

1984- Nîmes (France)

This building is strategically positioned opposite the Maison Carée, Nîmes' most famous Roman monument. The new Mediathèque and Centre for Contemporary Art is on the old site of the neo-classical theatre which was damaged by fire in 1951. Its role will be to enrich the city's network of artistic and cultural facilities, offering an information centre, a large Mediathèque and space to house contemporary works of art.

Twelve prestigious architectural practices participated in the international open competition, organized in 1984, to select a design. The finalists were Frank Gehry, Jean Nouvel and Norman Foster. Foster won with a proposal along the same lines as his previous work: a large prismatic repository, carefully designed to accommodate diverse functions and facilities. It has an obvious relationship to the Pompidou Centre in Paris in that they both take the shape of a delicate crystalline container, with the flexibility and order of materials found in the work of Mies van der Rohe.

Norman Foster's office worked on ten consecutive designs, modifying and making models before reaching the definitive solution. In the series of possible solutions which were eventually discarded, there were various options: to keep the neoclassical colonnade of the old theatre; to construct a completely transparent and open building; or a cultural centre with defined forms. Its relationship with the urban surroundings, particularly the Maison Carrée, was an important consideration. The eventual choice was a prism-like glass container supported by a light structure and protected by huge shutters. It has a large portico and the exhibition rooms have overhead skylights.

The building is organized on different levels. The ground floor is the public reception area and has a large entrance at one end. It houses administration, shops and other facilities and all other spaces lead from it. The various facilities are reached by taking lifts to different floors. One elevator goes to the first floor where the mediathèque can be found; another to the second floor which is made up of exhibition rooms; a third goes to a terrace with a bar. The ground floor and the mediathèque are connected by a large empty space in between the mediathèque and the glass portico which overlooks the square. The exhibition rooms are logically situated on the two upper floors to take advantage of natural light. The building has all the necessary administrative services and enough space for loading, unloading and storage. Various basement floors were designed for this purpose.

The spatial structure of the building consists of a central corridor, with stairs, lifts and two lateral borders consisting of services, offices, and service lifts. In the two intermediate borders which are between the facilities at the front and the central traffic corridor are the spaces for traffic on the ground floor, Mediathèque reference rooms and the exhibition rooms on the upper floors.

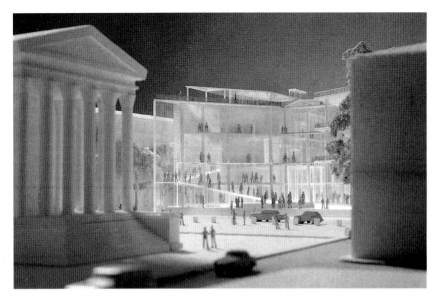

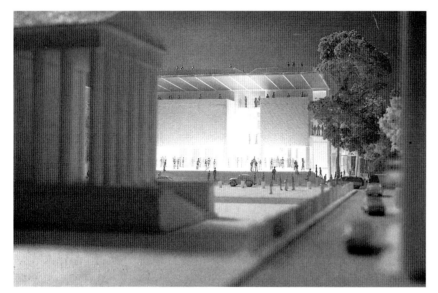

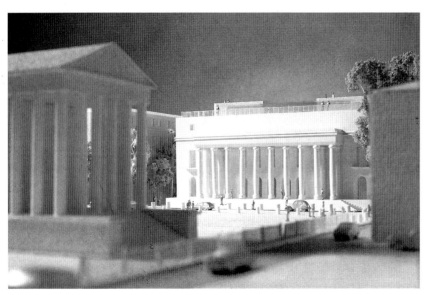

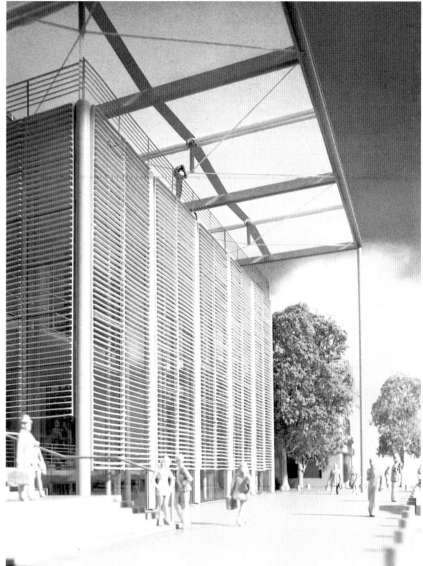

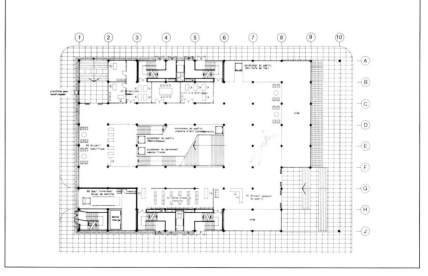

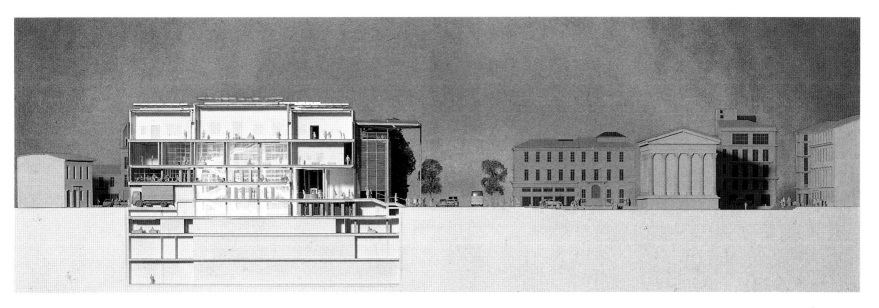

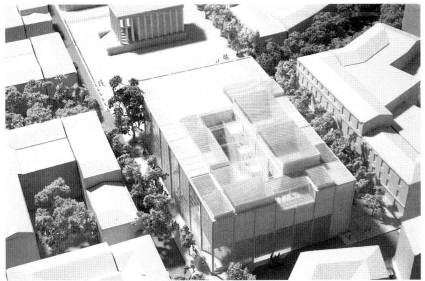

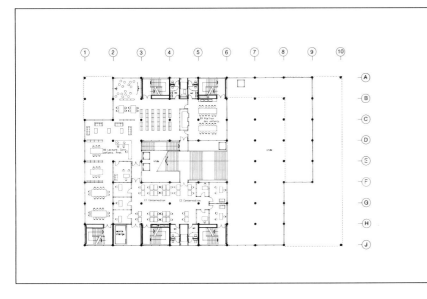

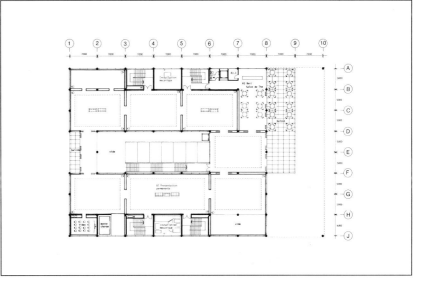

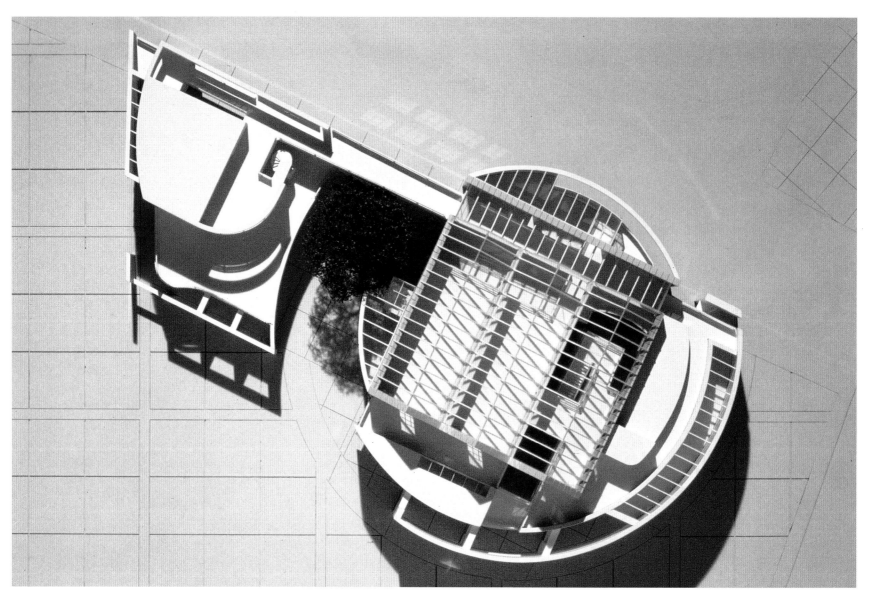

Architects: Richard Meier & Partners

Collaborators: M. Buttrick, D. Ling, B. Lutz, J. Marvel, S. McInerney, R. Scholl, G. Standke, W. Wohr

The Exhibition and Meeting Centre

1986- **Ulm (West Germany)**

The plan and form of the building derive from its urban context. The architects have made a modern public building which can be used both as a gallery and as meeting rooms. It is situated opposite the gothic cathedral. The proposal was intimately connected with the plan to redesign open spaces: the space opposite the cathedral was rethought and two rows of sycamore trees were planted at the side of the abbey. There was also a proposal to extend the Deutsche Bank, which is in the same urban boundary.

On the ground floor of the building are a restaurant and municipal tourism office, as well as various temporary exhibition rooms on the second floor, spaces for municipal meetings and so on. The creation of this building is closely connected to its situation in a tourist spot.

The architecture of the building seeks to express its public function. With its open forms, based on the linking of differing fragments and volumes, it exists as a huge urban sculpture, like an entrance door to the age-old foyer of the monumental cathedral. With its construction of curved forms it integrates into a context defined by the flow of pedestrian traffic. The form is fragmented, transparent and totally white. The building is made of reinforced concrete, the central cube being covered with natural stone; the curved parts are stucco; the restaurant and interiors are also totally white. The skylights in the exhibition rooms form a sloped transparent roof to relate visually to the surrounding medieval architecture.

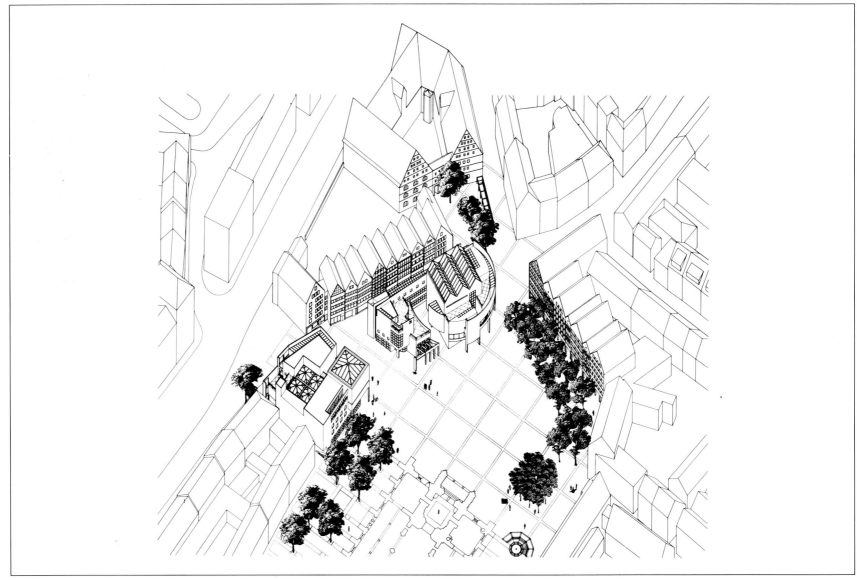

46

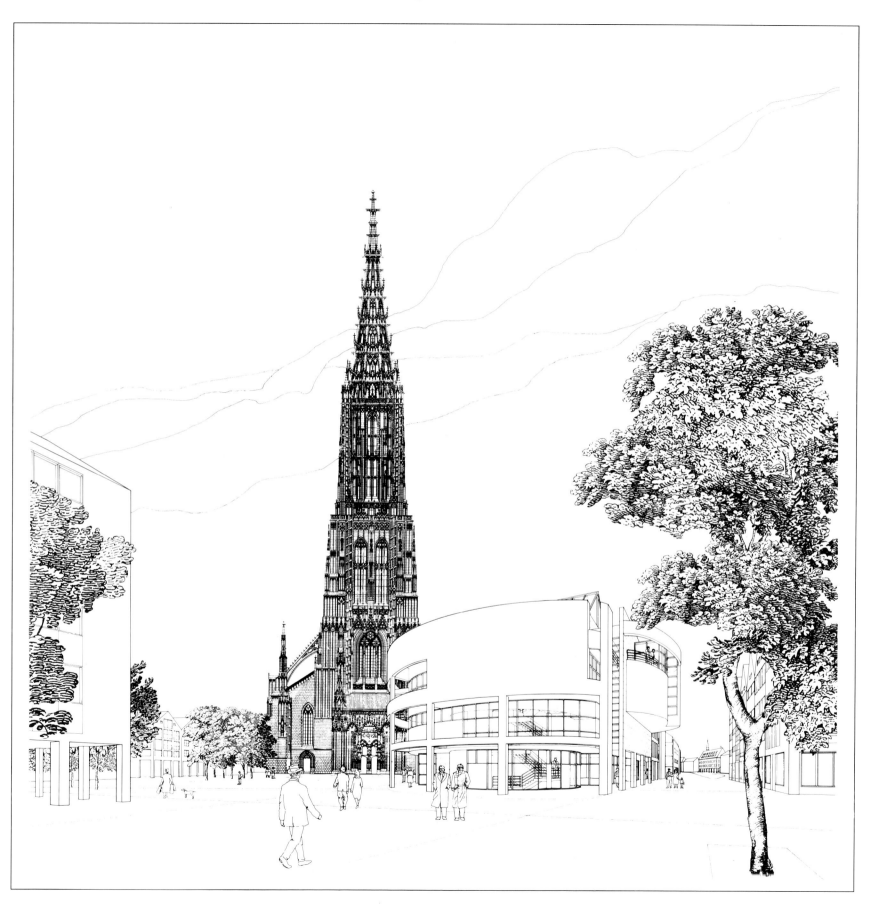

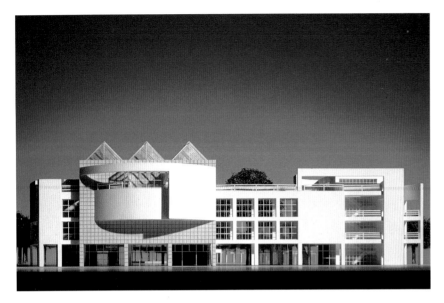
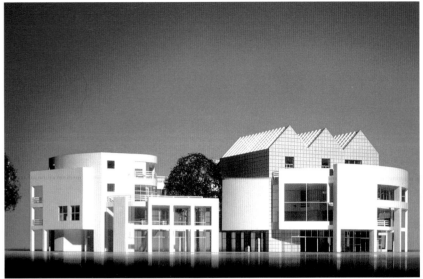
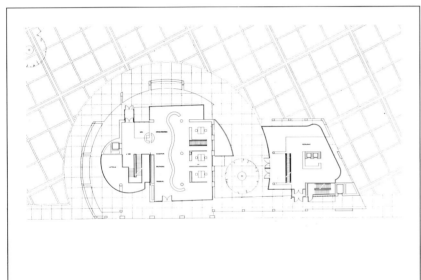
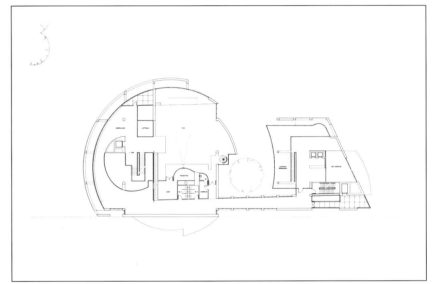
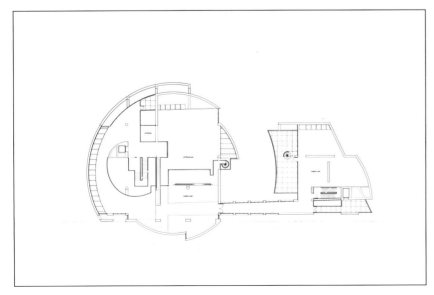
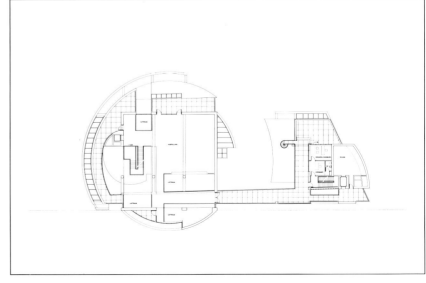

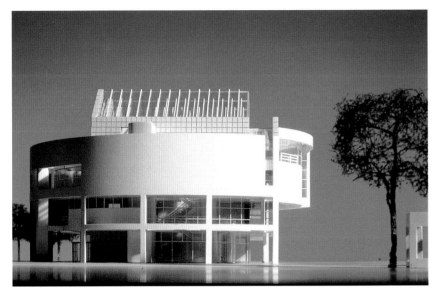

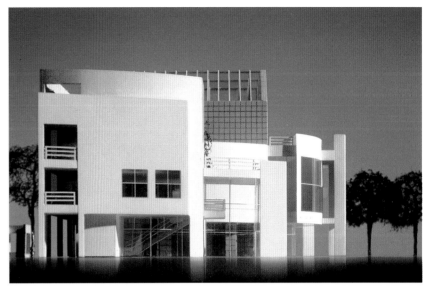

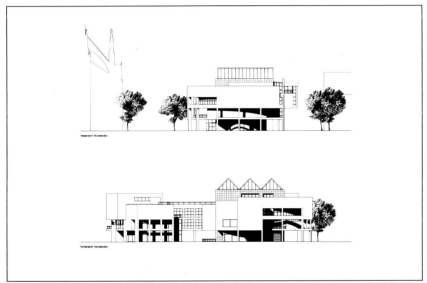

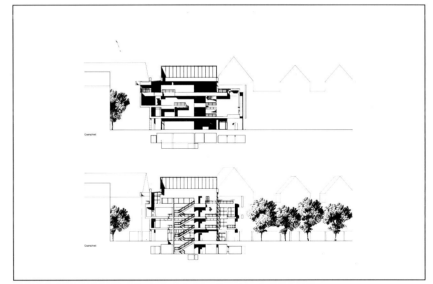

Architects: Peter Busmann & Godfrid Haberer

Collaborators: A. Bohl, U. Kuhn, V. Shrivanek, Hans Luz and Partner, U. Coersmeier

The Wallraf-Richartz Museum and Ludwig Museum

1975-1986 Cologne (West Germany)

The design is from Bussmann and Haberer's winning proposal for the 1975 competition, in which Oswald Martin Ungers, Godfried Bohm and James Stirling also participated. Situated in the most monumental part of the city, on the pedestrian route which goes from the banks of the Rhine to the gothic cathedral, the railway station and Hohenzollern Bridge are also nearby. Housing both the collections of the Wallraf-Richartz and the Ludwig necessitated a fairly complicated layout. There is space for everything: information services, teaching rooms, administration offices, a large multi-purpose hall and a restaurant, as well as a two thousand seat concert hall. The remaining space is used as a foyer. The braked form of the skylights, covered with metal sheets on a stone base, dominates the mass of the building. The complex is organized round urban platforms as two buildings of different sizes. All reception areas and the large café/restaurant are on the ground floor. The same exterior platform leads to the circular concert hall, which is exactly below the circular space defining the two buildings of the museum, below ground level. Entry is via a flight of steps which bridge the gap between the bank of the Rhine and the cathedral. The environs of the museum were designed by Dani Karavan with a balanced use of geometric motifs. There is a need to make this complex understandable to visitors entering its monumental space. The interior spaces of the building have a striking roominess dominated by a grand, monumental stairway which gives access to the top floor where the collections are kept. The system of glass 'sheds', resulting from the combination of circular room and slanting windows, brings a high quality of natural light into the interiors and is the building's main characteristic. In the city's urban landscape the huge, metallic and braked roof acts as a counterpoint to the towers, pinnacles and flying buttresses of the gothic cathedral.

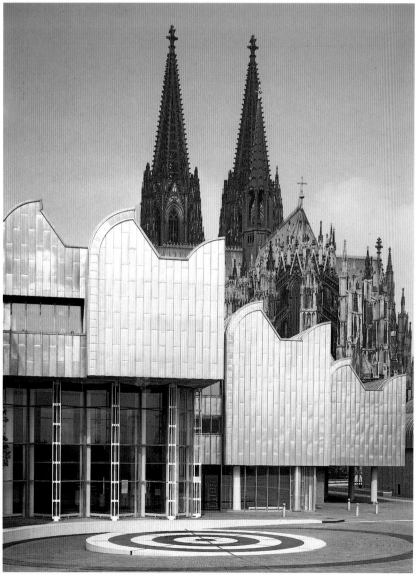

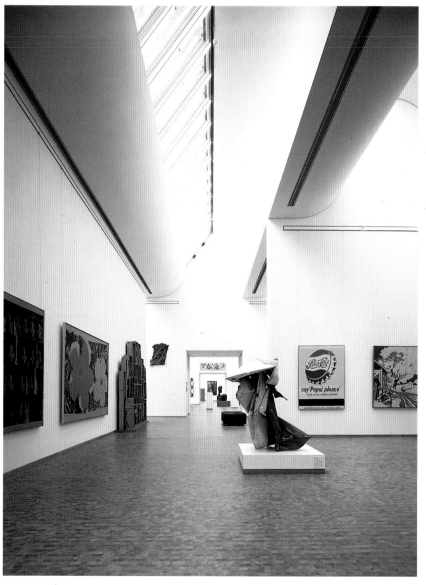

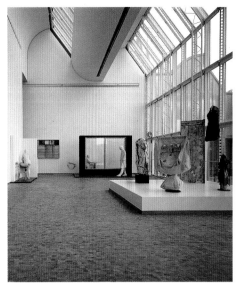

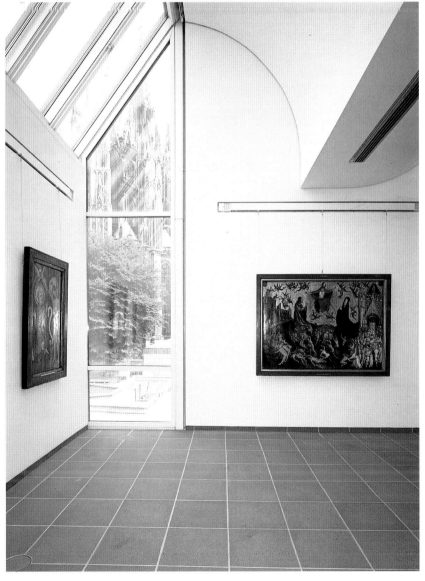

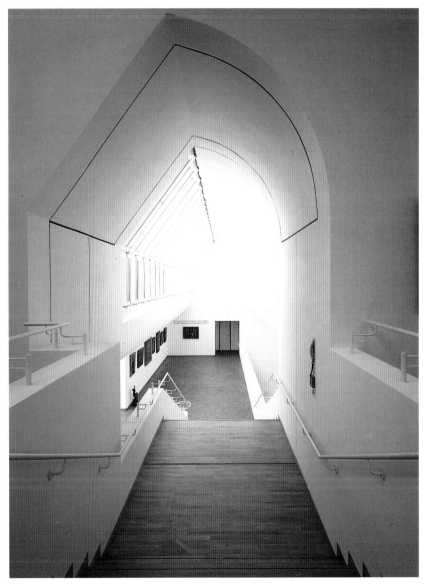

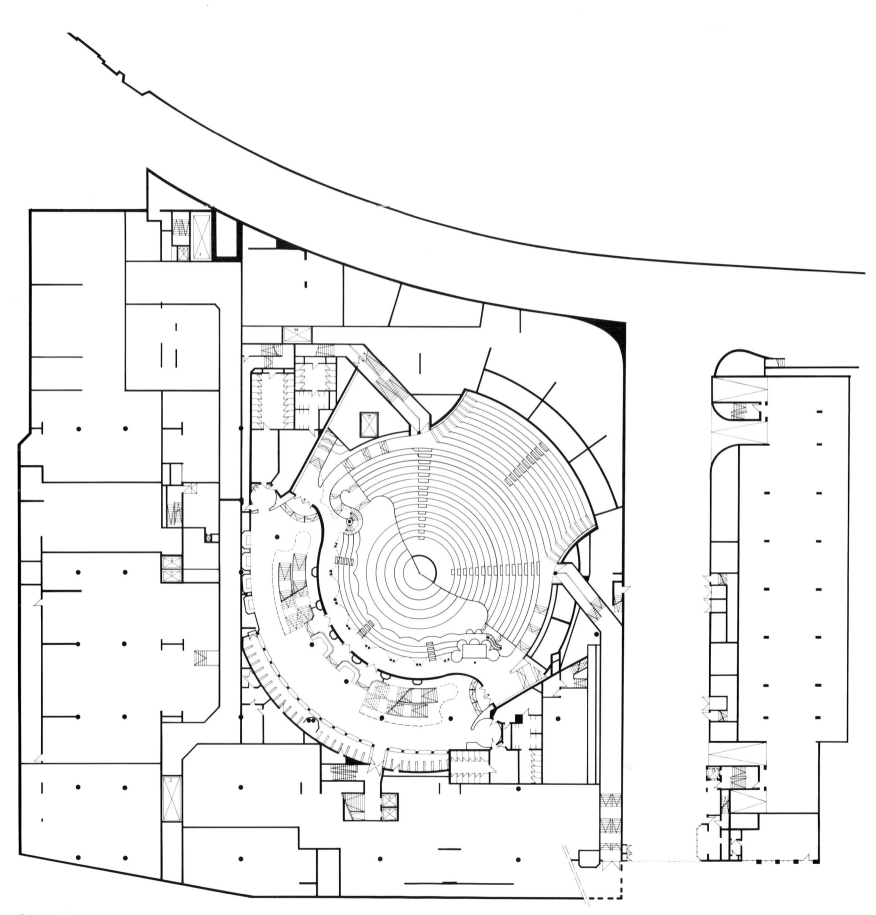

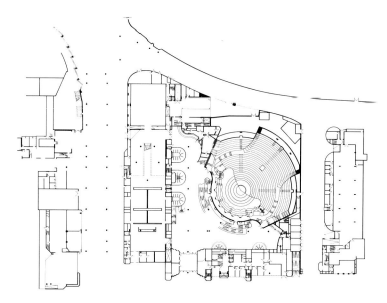

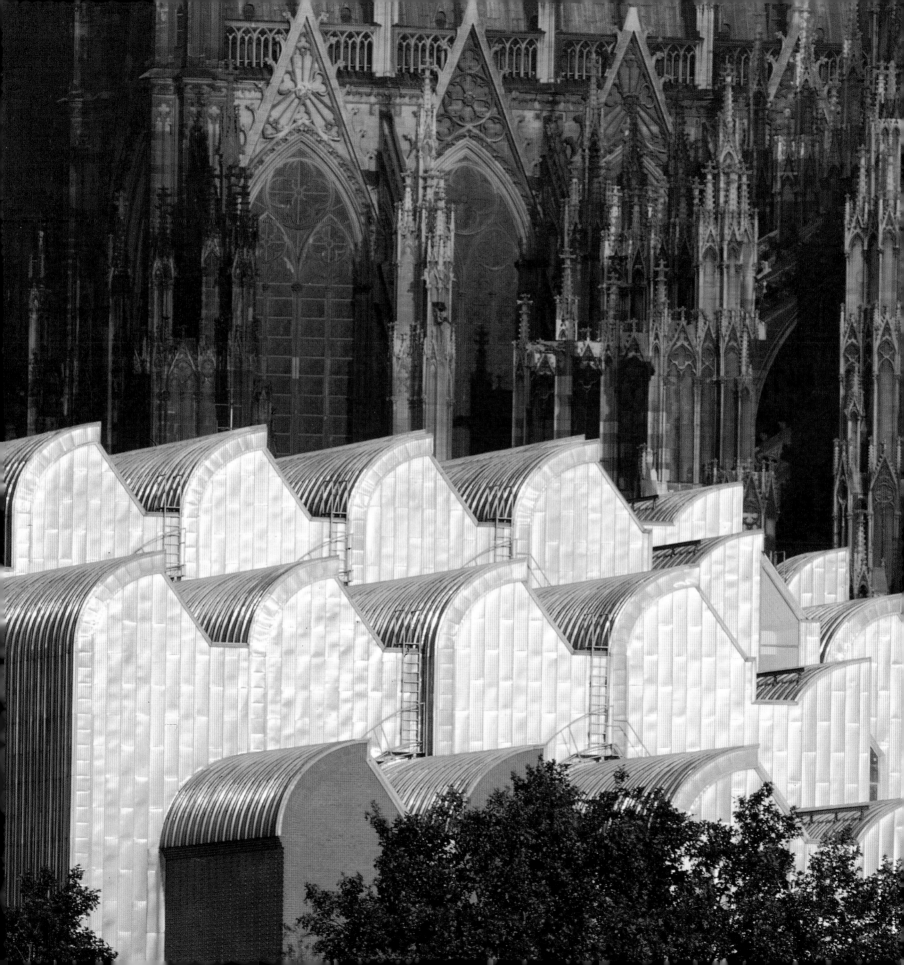

Architects: Hans Dissing, Otto Weitling

Collaborators: D. Fremerey, R. Tolke, J. Roschmann, U. Christiansen, H. Ingvarsen

The Renania Museum of North Westphalia

1975-1986 Dusseldorf (West Germany)

The origin of this building goes back to 1960, with the donation of 88 paintings, drawings and watercolours by Paul Klee (who worked in Dusseldorf before emigrating to Switzerland) from part of a private collection in the United States. This collection was enlarged with works by Picasso, Braque, Miro, Kandinsky, Pollock and many other 20th century masters. A competition for the design of the new museum was held in 1975 in which, as well as the winners, Marcel Breuer, Kenzo Tange and James Stirling participated. The initiative of the director, Werner Schmalenbach has been crucial in the promotion of this museum.

The main feature of the building is its urban location. It has been put up on the site of the old library, where the historic northern quarters and the new centre of the city meet. It is also situated between two landscaped areas: Grabbe Square and a large park. Having a delicately curved facade, the building adopts a linear form. Inside, the longitudinal axis of the main stairs gives access to two parallel wings which are used as exhibition rooms. At the other end of this same axis, on the ground floor, is the conference hall. The pedestrian axis is perpendicular to the building's central axis. The main entrance is at the point where the pedestrian axis and the interior axis of the flight of stairs meet. The large central stairway has a narrow and braked overhead opening, of debatable taste. The facade, smooth and rigidly curved, is dark granite, with only a few glass ornaments protruding. The exhibition rooms are on the two upper floors, and space has also been reserved for administration, a library and a large multi-purpose room which can also be used for temporary exhibitions, theatre and so on. A system of movable partitions which hang from the metallic structure of the ceiling is used in the exhibition rooms, which allows space to be modified and platforms to be created according to the type of exhibition. The system of overhead illumination has been designed to create optimum lighting in a way that seems to stress continuity of space. Beneath the 'sheds', protected by lacquered aluminium laminates, Lexan diffusers distribute light. Intermediate spaces have been designed along the imagined route of the visitor –

the lobby and the stairs – which have a low lighting; in this way, when the visitor goes into the fairly highly lit exhibition rooms (300 lux), there is an even greater clarity and brightness. Thus the main objective of the museum, the omnipresence of natural light, is achieved.

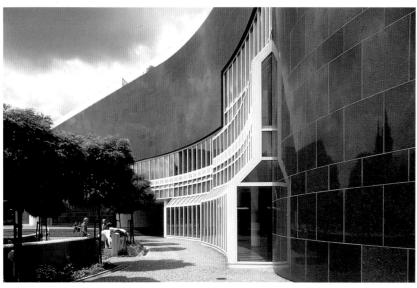

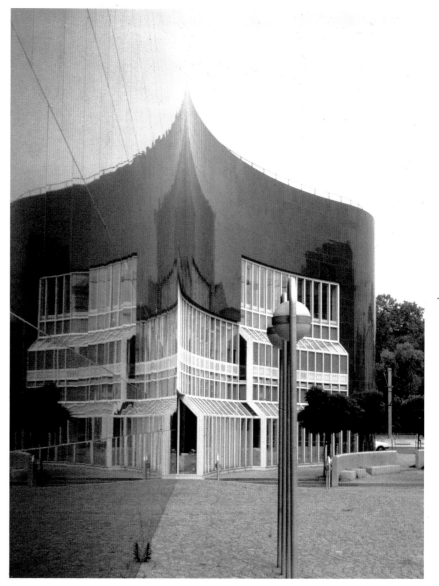

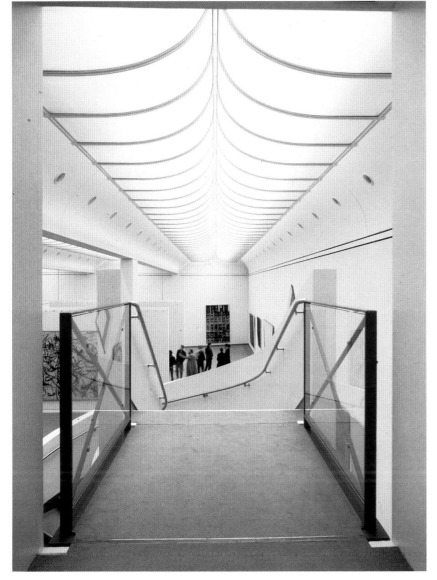

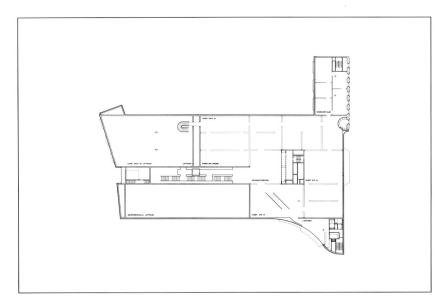

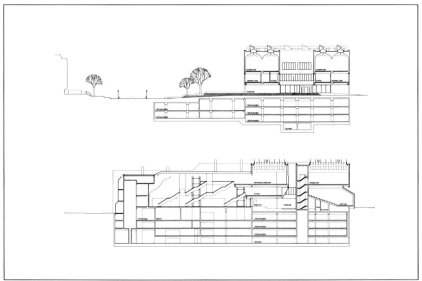

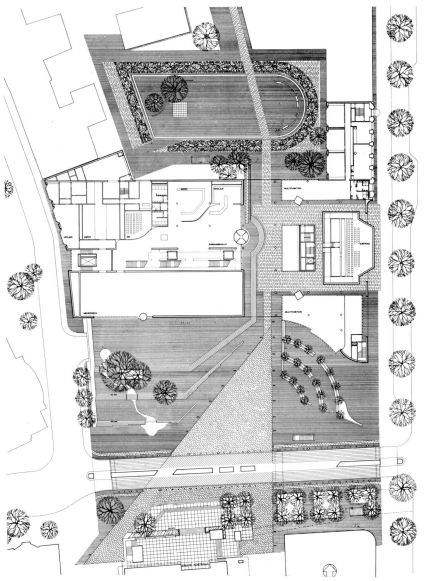

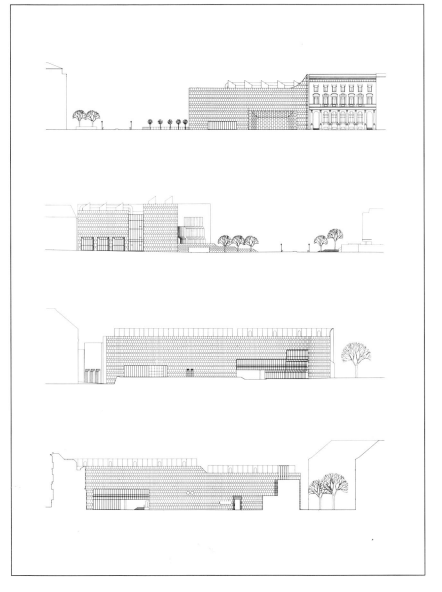

62

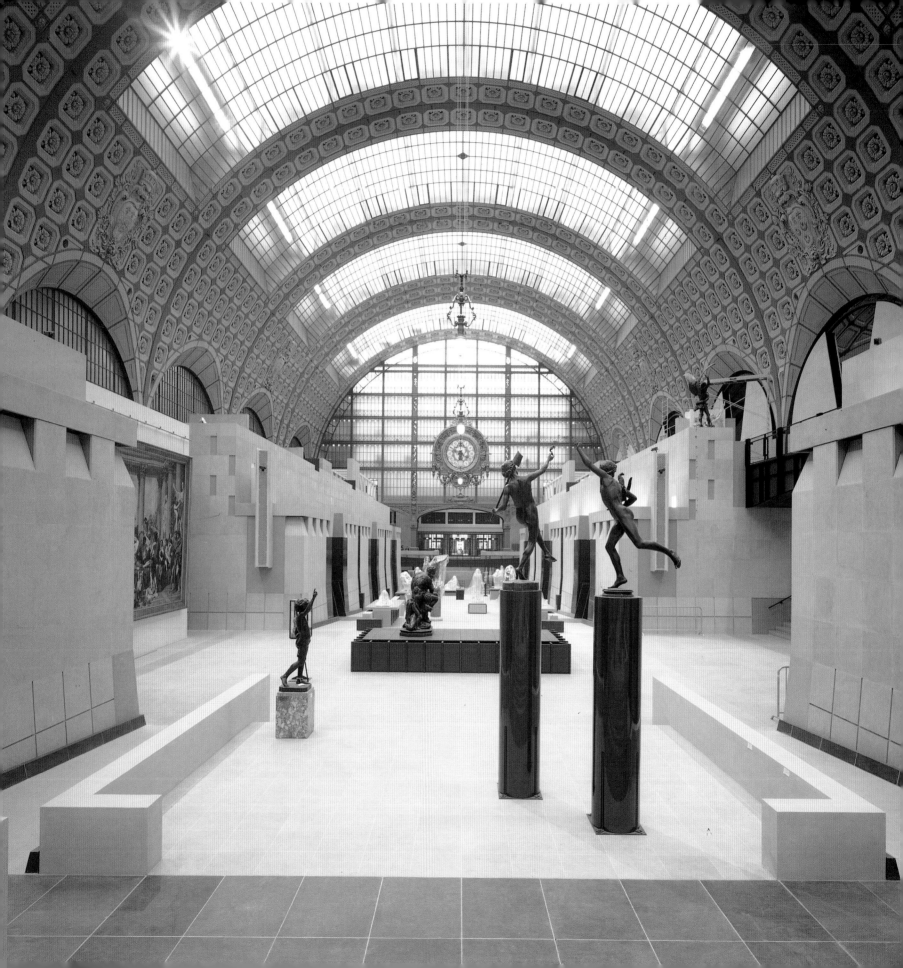

Architect: Gae Aulenti with Valerie Bergeron, Monique Bonadei, Guiseppe Raboni, Luc Richard, Marc Vareille

Collaborators: Piero Castiglioni (lighting), and Emanuela Brignone (1982), Colette Chehab (1981-1982), François Cohen (1984), Nasrine Faghi (1981), André Friedli (1982-1984), Pietro Ghezzi (1980-1982), François Lemaire (1984-1985), Yves Murith (1983), Margheritta Palli (1983), Italo Rota (1981-1985), Jean-Marc Ruffieux (1981-1983), Gérard Saint-Jean (1984), Takaschi Shimura (1980)

The Museum of the Nineteenth Century in the Gare D'Orsay

1980-1986 Paris (France)

This is a museum of considerable scope. Due to its location near the Louvre Museum and the symbolic connotations which a railway station can have, the Gare d'Orsay (designed and constructed by the architect Victor Laloux between 1898 and 1900) has been converted into a 19th century museum. The winning team of the 1979 competition consisted of R. Bardon, P. Colboc and J.P. Philippon. However, after work had begun, it was deemed necessary to reopen the project with the intervention, from 1980, of the team of Gae Aulenti. Leaving what had already been done, but establishing a review of the previous project, they began to work on the interior of the building.

Gae Aulenti had to take into account several factors: the spatial conditions of the old station, the already initiated remodelling project, the complexity of the collections to be installed and the museographic programme as defined by Michel Laclotte, chief conservator in the painting department at the Louvre. Initially the great station had to be organized like a 19th century commercial gallery. Various crossings and route axes were developed from its main longitudinal route. A focused collection was placed in each specific area, recreating the traditional museum space of rooms, galleries, pasages and rotundas. Each work has its own spot within this great variety of spaces and the siting and lighting of each piece has been individually studied. The indirect system of illumination means that each area is uniquely lit. Only collections on the upper floor benefit from natural overhead light. The high Impressionists Gallery (which brings together the contents of the Jeu de Paumme) has a special system of walls and natural light coming through overhead openings. The Amont section (a vertical sequence of rooms) deals with architecture covering the period 1850–1900, and places special emphasis on Parisian works such as the Opera and the Eiffel Tower and on architects like Charles Garnier, Victor Laloux and Henri Labrouste. In addition, there are sculpture rooms which occupy most of the central space; Courbet, Carpeaux and Scurat rooms, and the Bellechasse Gallery, dedicated to Gauguin, the

School of Pont-Aven and Nabis. At the end of the large central space are two dual purpose towers: on the one hand they relate the vast dimensions of the building to human scale and on the other they house, in a strained way, a complete collection of furniture from the second half of the 19th century. Although the project is innovatory in its reconversion of the old central space of the station into a museum interior, there are problems. These include the cold surface treatment of the two aforementioned towers, the excessively ornamental and material presence of the achitecture which backs the artistic pieces, and above all a disjointedness resulting from the complexity of the museum, with its excessive and labyrinthine diversity of rooms.

CIMAISE ELEVATION

MUSÉE D'ORSAY

TOUR COTE SEINE
MOBLIER INTEGRE

2.0.7 MB.013.5

TOUR SEINE COUPE

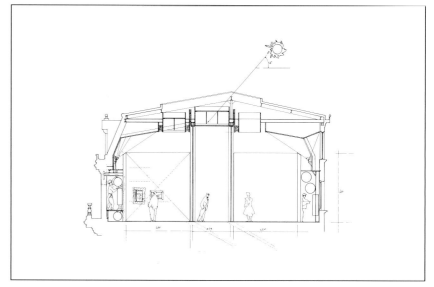

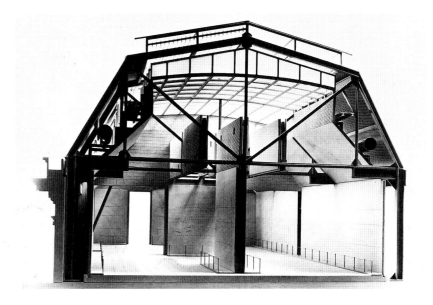

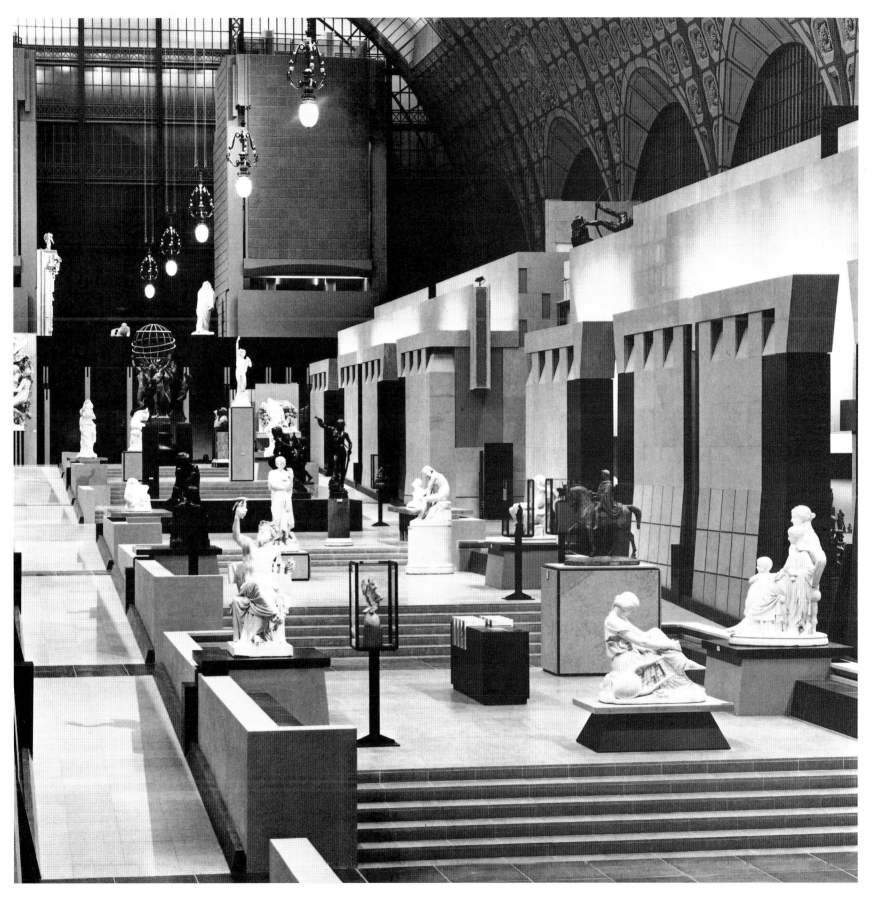

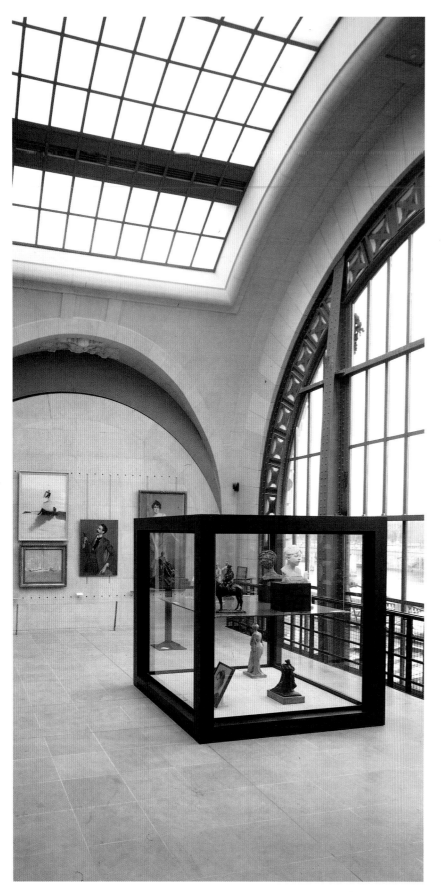

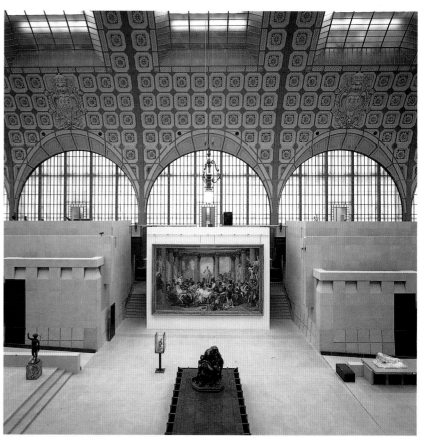

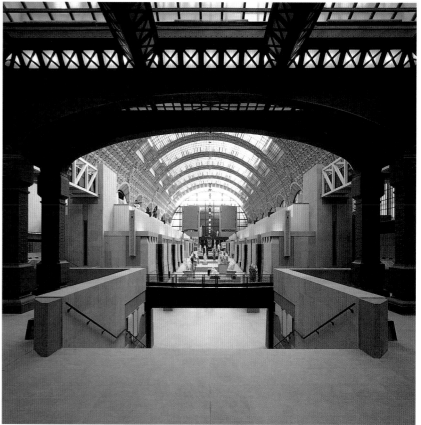

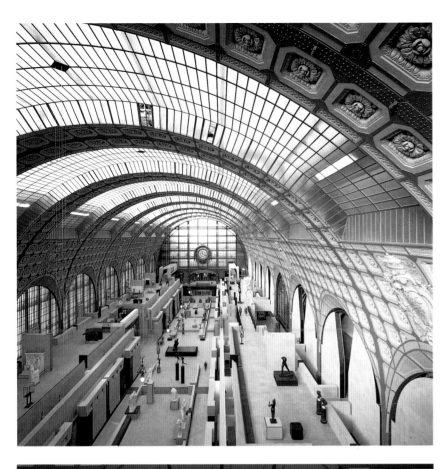

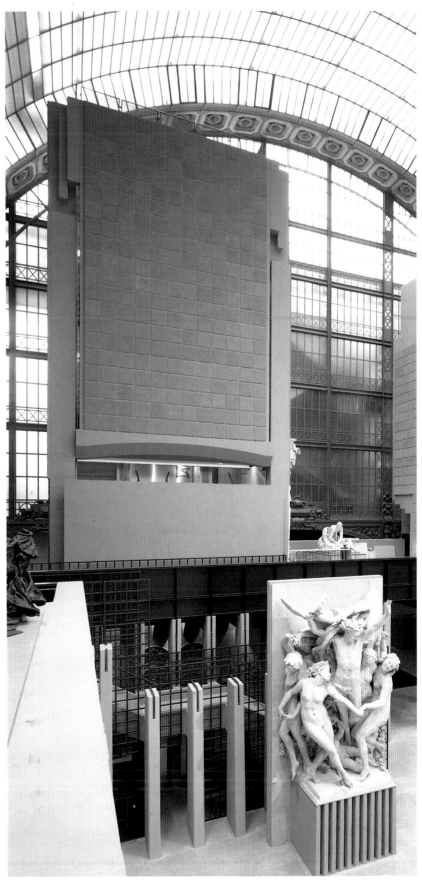

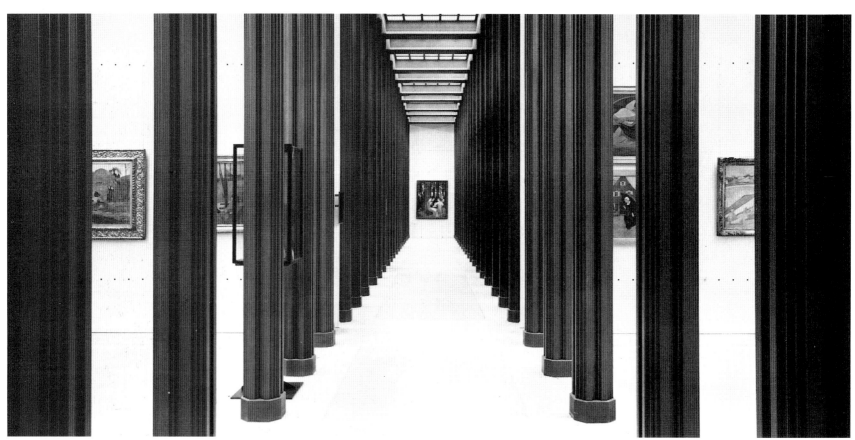

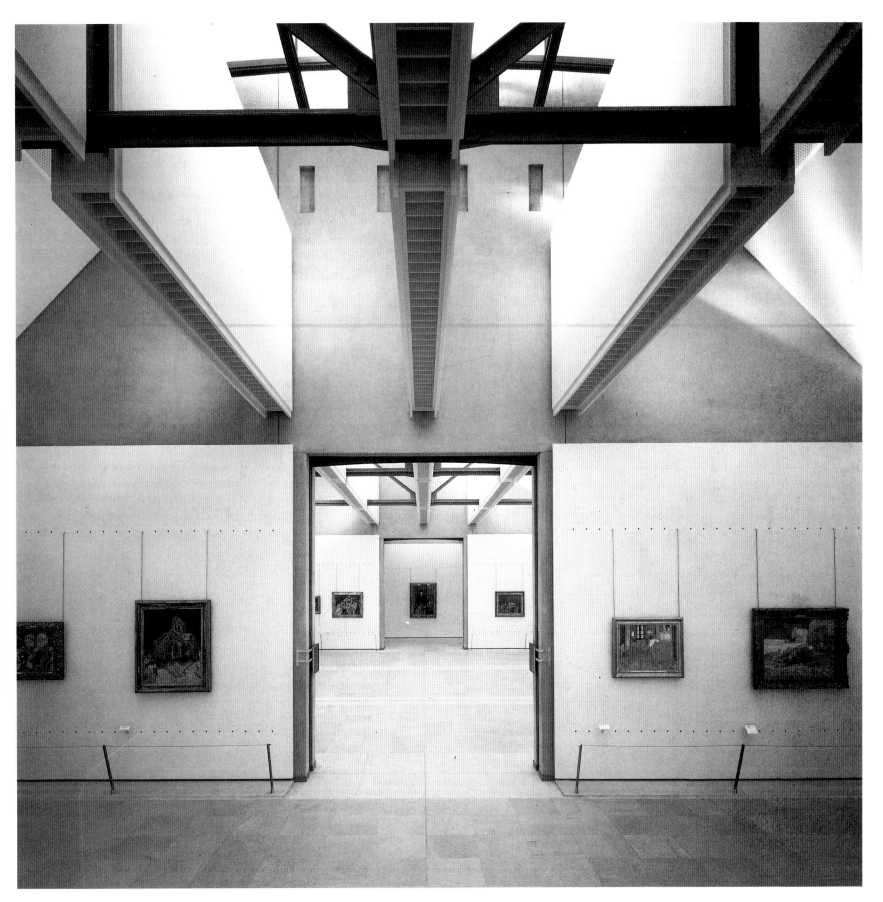

71

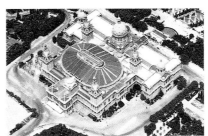

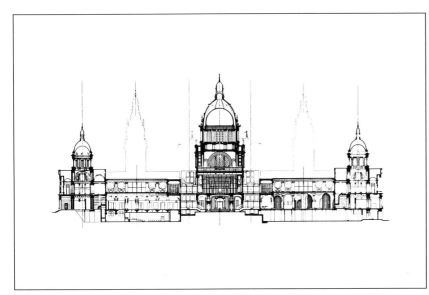

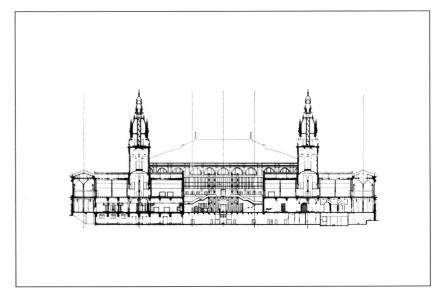

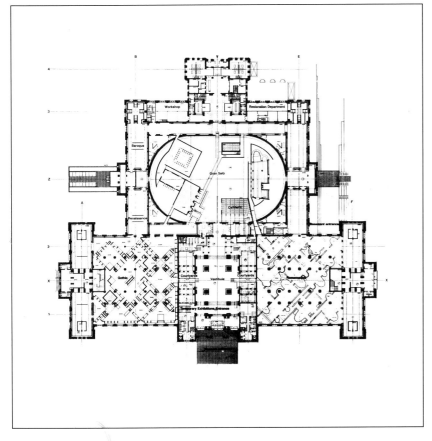

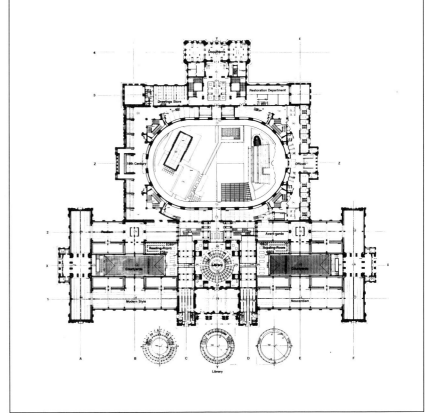

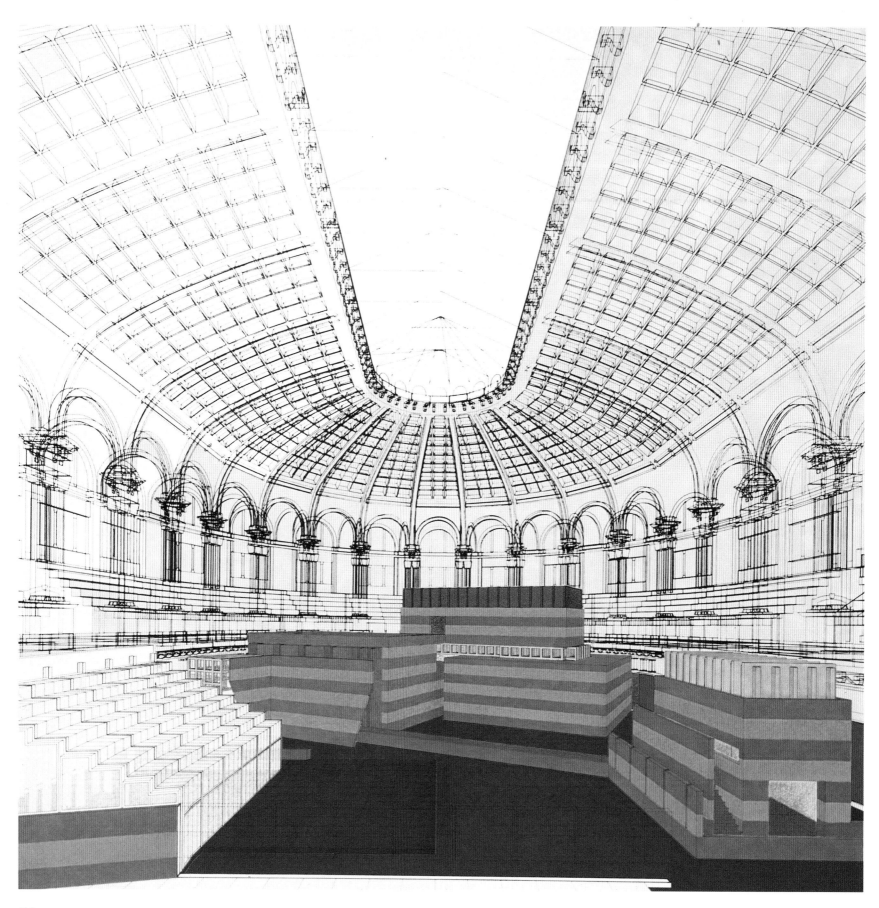

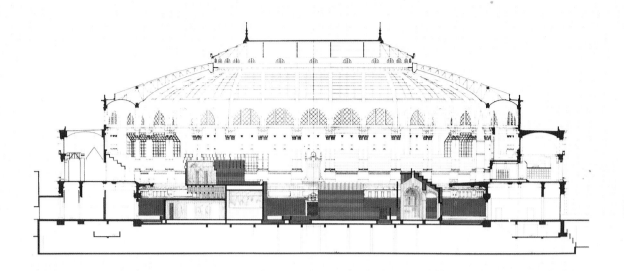

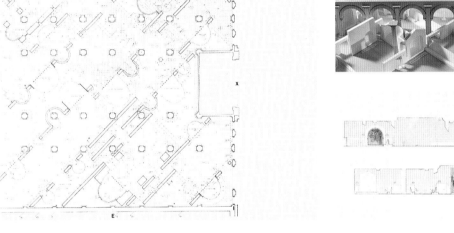

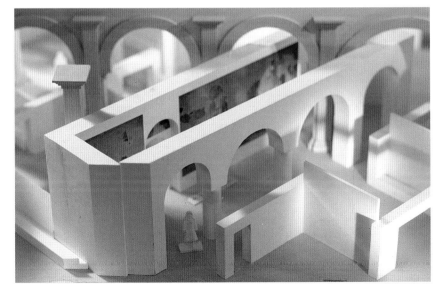

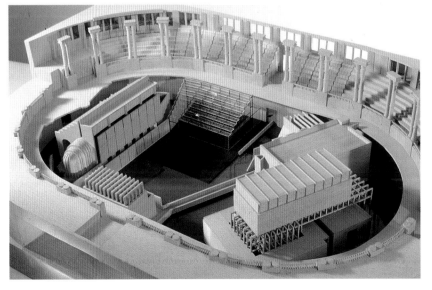

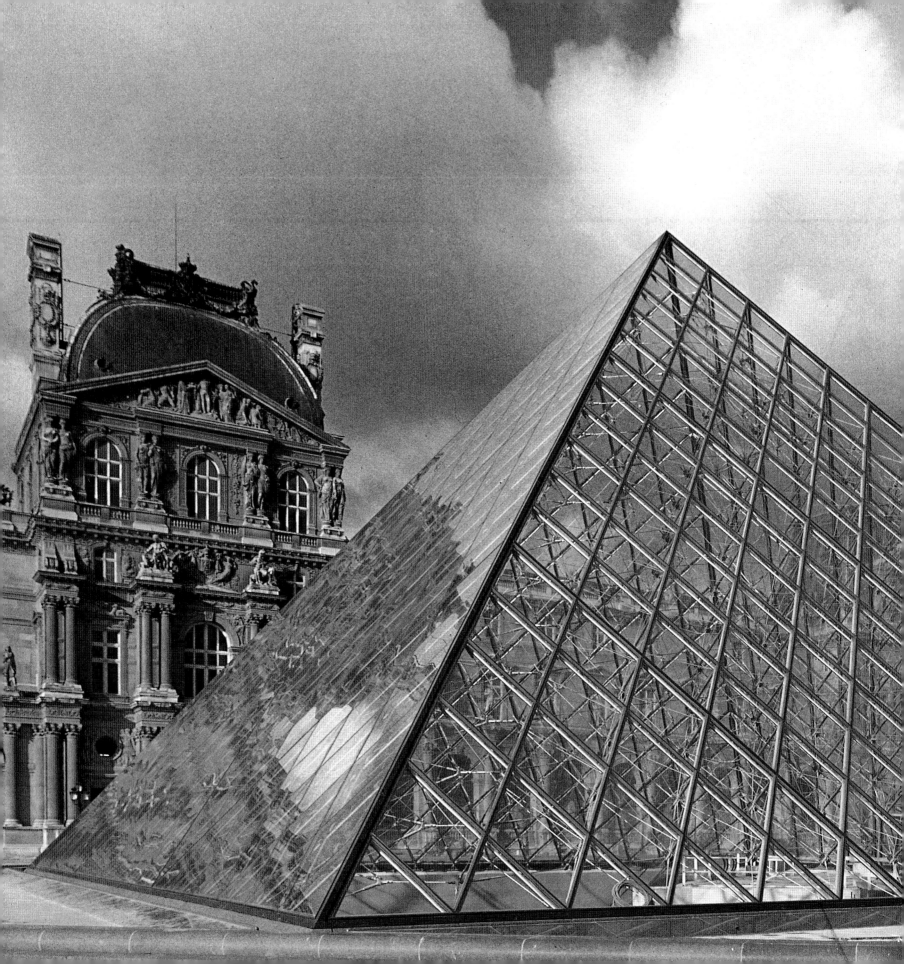

Architects: Ieoh Ming Pei and Partners

Collaborators: Michel Macary, Georges Duval

The Louvre

1983-1989 Paris (France)

This represents an intervention in one of the most symbolically powerful buildings in Paris and the extension of what is regarded as a paradigm of large national museums: the Museum of the Louvre. Natural growth requirements in exhibition rooms, reorganization of routes, and widening of services meant replanning the museum. In 1981, under the presidency of Francois Mitterand, a definitive political decision was made: to enlarge the Louvre, reclaim the Richelieu wing, which was occupied by the Ministry of Finance, and take advantage of as much space under the Cour Napoleon as possible. Because of its proximity to the Seine, this has been restricted to 9.60 metres below sea level, which allows either two levels, or a single space.

The design has solved three types of problem: functional, urban and symbolic. The functional problem was the most complex and urgent. The shape of the new glass pyramid defines a new monumental entrance at the central point of the three wings of the Louvre. From here visitors can choose which part of the museum they are going to visit – the Denon, Sully or Richelieu wings – and get to them directly. Wide corridors are finished in polished travertino marble, and pyramidal skylights and escalators allow comfortable and direct access to the very heart of the old rooms of the museum. Besides restructuring traffic (not yet fully completed) the acquistion of the new underground space of the courtyard and the whole of the Richelieu wing has allowed for the extension of the museum's amenities. Parallel to the Denon and Richelieu wings, a huge gallery of shops will connect coach and car parks, situated in part of the Tuileries garden, with the central nucleus of the pyramid and the large bookshop and café/restaurant area. When the new phases are complete, and the Richelieu wing has been reinhabited (planned for 1993) there will be new exhibition rooms, an increase in storage and conservation space for paintings, offices for technical services, and new spaces like the auditorium and a meeting place for young people.

The Inauguration of the first and most important phase has been linked to the creation of new rooms dedicated to the Louvre's history and to the creation of an amazing space which allows visitors to see the archeological remains of the first medieval tower of the Louvre. These are beneath the Cour Napoleon, in the space between the large pyramid and the Sully Room.

As far as the urban context is concerned, the creation of the pyramid has drastically improved public access systems by foot, metro, private car and bus; and enriches relations with its surroundings, emphasizing the monumental axis of the city which stretches from the Louvre pyramid to the new la Défence arch, through the Tuileries, the Champs Elysées and L'Etoile.

The form and technical resolution of the pyramid are balanced between respect for tradition and the will to modernity. The form of the pyramid connects with classical tradition and recalls the neo-classical, like the pyramid in the Markplatz de Karlsruhe by Friedrich Weinbrener. The use of high technology, transparency, water and nocturnal lighting bring an image of radical contemporaneity to this glass pyramid which is sensitively and precisely constructed with transoms, cordons, struts and structural nodes in a mesh of stainless steel.

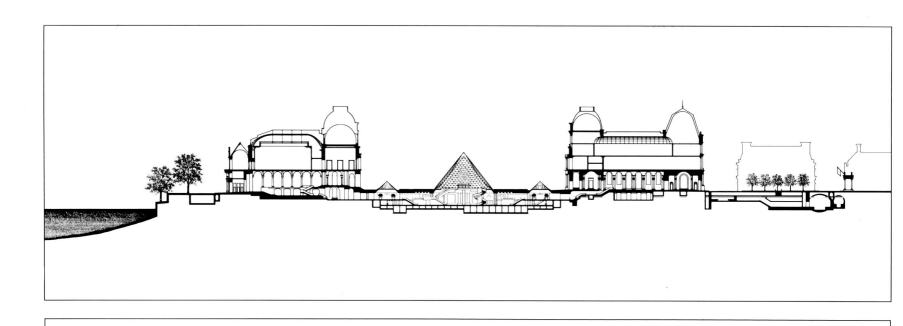

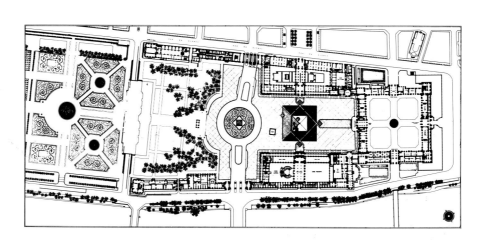

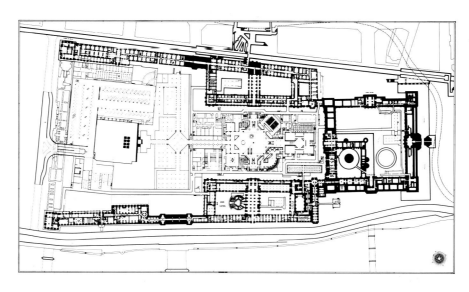

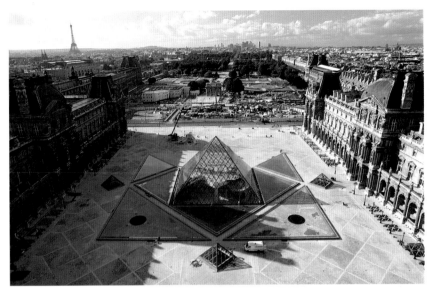

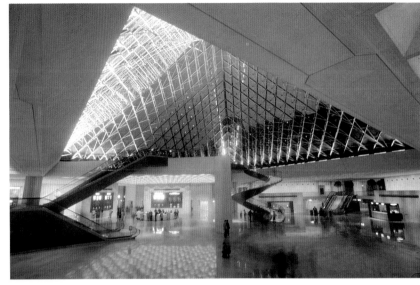

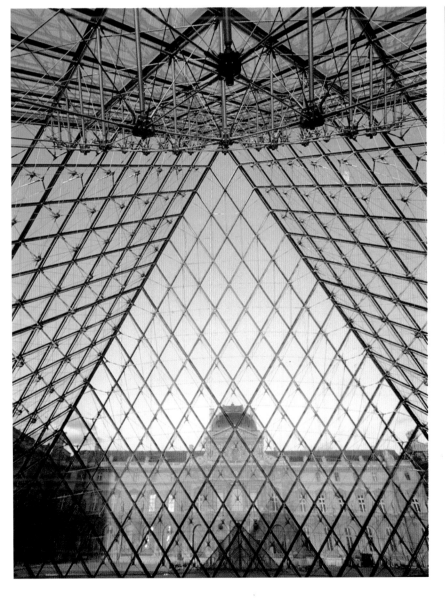

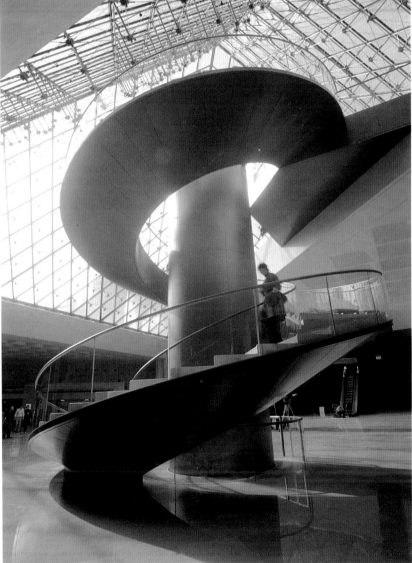

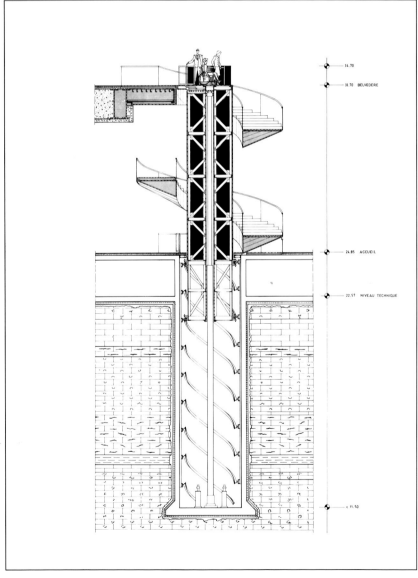

84

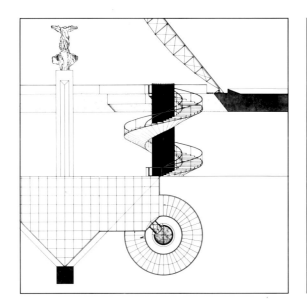

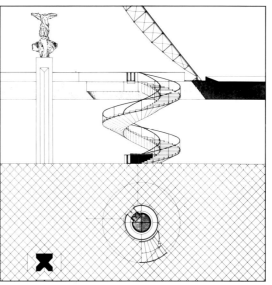

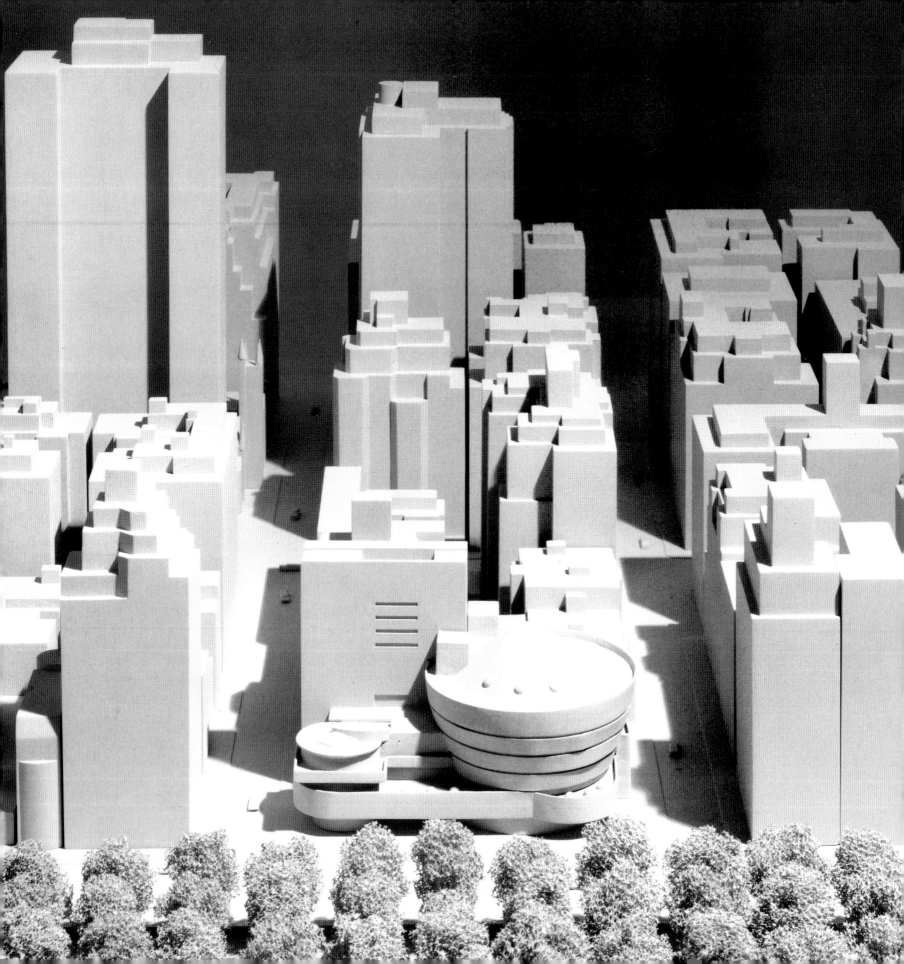

Architects: Charles Gwathmey and Robert Siegel & Associates

Collaborators: Jacob Alspector, Pierre Cantacuzene

Extension of the Guggenheim Museum

1984- **New York (USA)**

The extension of one of the 20th century's principal buildings has not been achieved without difficulties and controversies. The first project for the extension of the Guggenheim was presented in 1985 and generated such criticism amongst public and specialists alike that it had to be revised. Indisputably, exhibition and office space had to be increased, since the spiral-form space of the museum is used for temporary exhibitions and only about three per cent of the permanent collection is on show in a gallery adjoining the rotunda. Even Frank Lloyd Wright had forseen a possible extension to his building. This was another point of antagonism, since the new design is always compared to that of Wright and his successors, the Taiesin practice. In comparison to the first proposal, the second design, put forward in 1987 and initiated in 1989, presents a series of important changes to the exterior shape. The most obvious is the overhanging volume above the cupola, contrasting with Wright's work. The material treatment has also changed. From being an expressive facade, made with red brick and steel panels, it has become smooth, with very few openings – now in horizontal form, by means of white limestone defined by an orthogonal mesh. This means that the new building is more like a backcloth than a protagonist. The new building, consisting of ten floors and a rigorous rectangular ground plan, intersects with the upper part of the rotunda and ends up covering the original triangular interior staircase. Both interventions are still controversial. The extra space is used for exhibiting the permanent collection and also as office space, which occupies the upper floors. A restaurant has been built and the bookshop has also been extended.

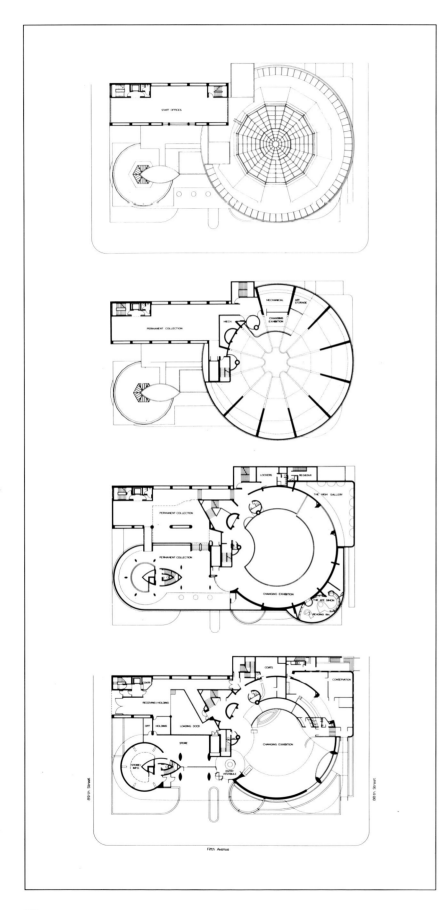

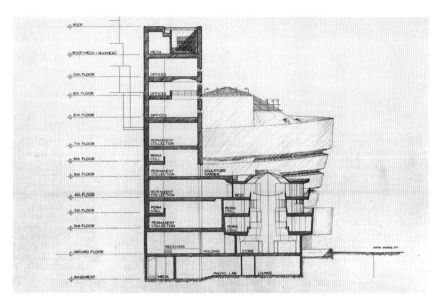

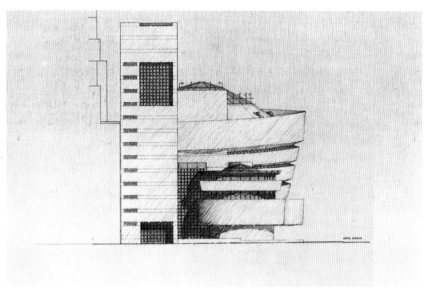

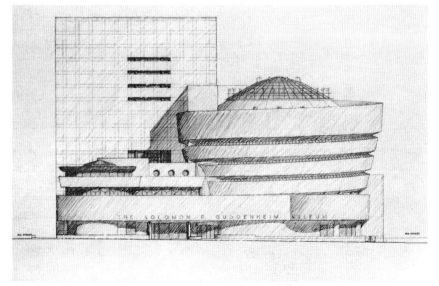

88

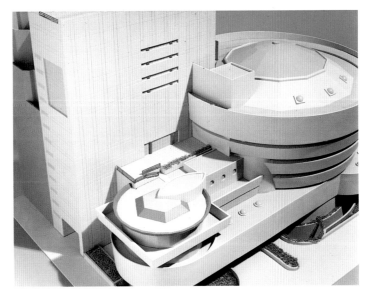

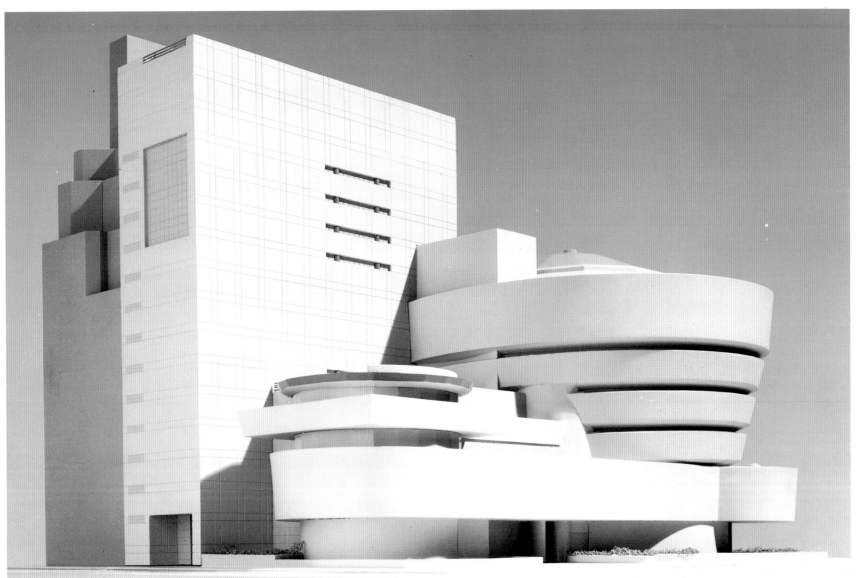

Architects: James Stirling, Michael Wilford and Associates

Collaborators: R. Bevington, P. Ray, J. Cannon, J. Cairns, R. Dye, L. Haven, W. Naegeli, S. O'Donell, R. Portchmouth, P. Smithies, S. Wright

Turner Wing, Extension of the Tate Gallery

1980-1987 London (Great Britain)

The Turner Wing or Clore Gallery is part of the first phase of the ambitious extension of London's Tate Gallery. Dependance on private donations means that this is a slow process. In addition to the already inaugurated Clore Gallery, the total project anticipates a sculpture museum, a museum of Art Nouveau, a museum of 20th century art, a study centre, and a library, using the grounds of the old Queen Alexandra Hospital. The whole complex will be arranged around a kind of large open courtyard, next to one of the lateral facades of the old Tate Gallery building. James Stirling has planned each section in such a way that it retains autonomy. This allows the project to be realized in phases whilst each section is integrated into an already established unified whole.

The Clore Gallery is L-shaped and designed specifically to house the collection of paintings and watercolours of J.M.W. Turner. Unlike the main building, it has no front entrance, but a side entrance reached through a garden. On the ground floor there is a vestibule, auditorium, sitting room, and – to the rear – warehouses and other rooms annexed to the museum. On the upper floor, reached by a flight of steps of palatial and domestic scale, are the vivdly coloured exhibition rooms. The manner and system of lighting recalls the tradition of 19th century galleries and museums of art, especially the Dulwich Gallery, also in London, designed by John Soane between 1811 and 1817. As in traditional museums, each room is designed to house concrete periods in Turner's work. The material treatment of the interior also recalls the comfort and quality of 19th century museums. The lighting system is in fact highly sophisticated and uses both natural and artificial light, by means of sensors and computers. This provides the correct level of internal light in relation to the light outside, so that there is not too much light for the paintings but sufficient for the visitor to see, whilst retaining a sense of the weather outside. The facade uninhibitedly and ingeniously mimics the existing monumental and classical building. The cornice is continued and a modulated square allows a gradual and harmonious transition from the ochre tones and colours and the stucco of the old building, to the

brick of the new wing. In this way, the public and monumental connotations of the new facade partially disappear and a modern and functional facade emerges in the background.

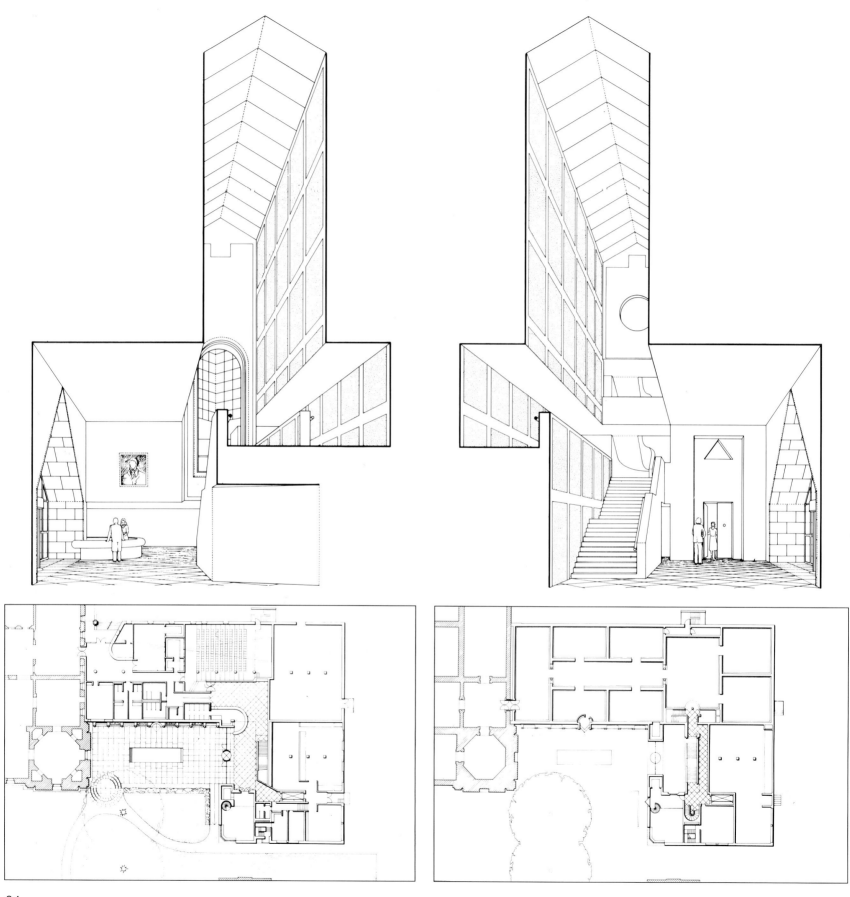

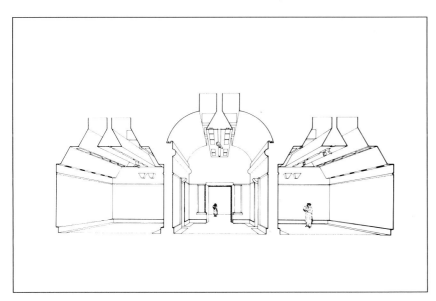

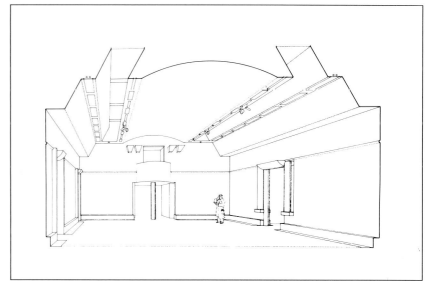

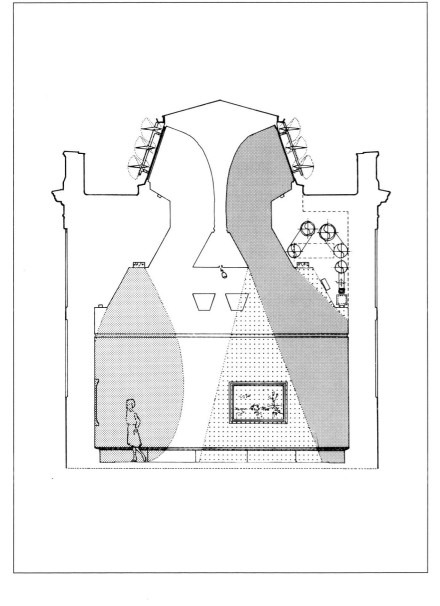

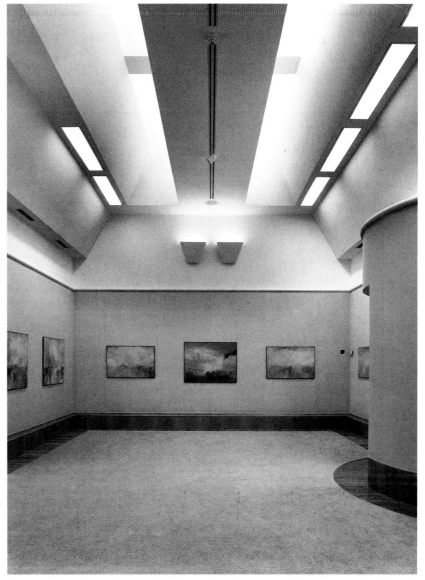

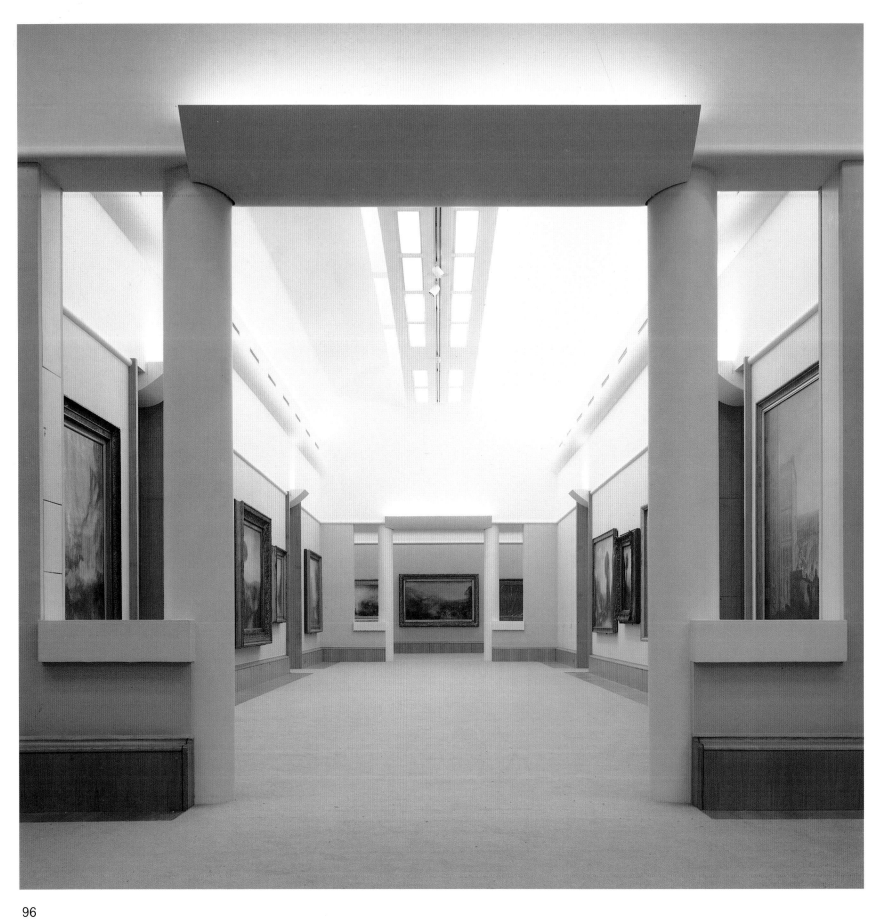

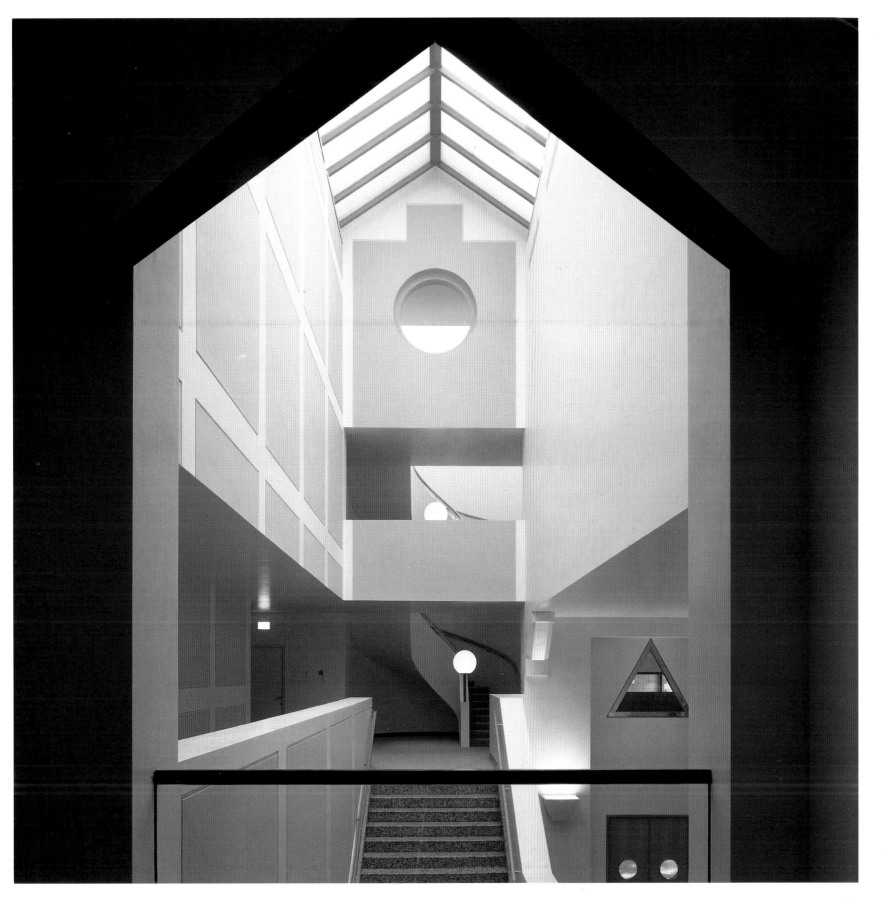

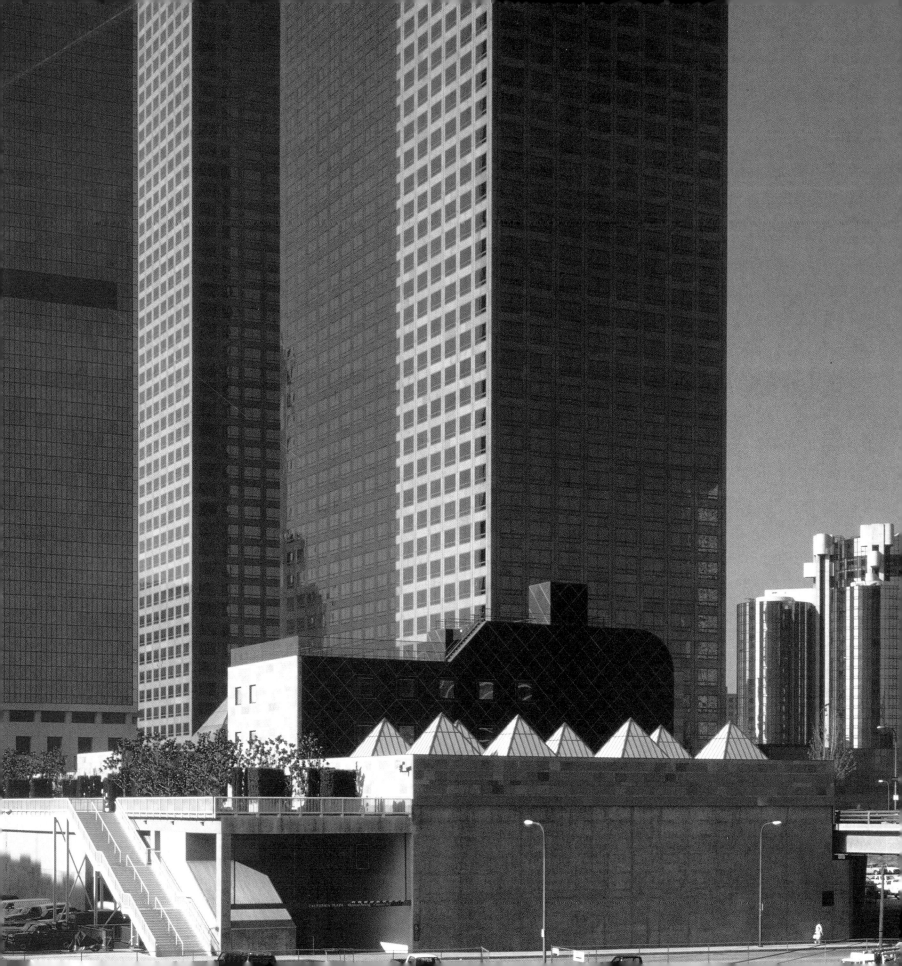

Architect: Arata Isozaki

Collaborators: Gruen Associates

The Museum of Contemporary Art

1981-1986 Los Angeles (USA)

The site ordinances of this new museum have been the main determinant of its development. The new building for the Museum of Contemporary Art of Los Angeles is in the Bunker Hill area, the very heart of downtown Los Angeles. Designed by the architect Arthur Erickson, the urban plan of this area foresaw mixed uses: hotels, offices, business centres, housing and public buildings. The promoters of the area's business centre envisaged the construction of the museum at the side of tall skyscrapers. Ordinances required a building of low height, with a pedestrian walkway crossing its axis. The severe urban requirements have meant that only Arata Isozaki has been capable, in his mastery of an attractive formal language, of achieving a result of high architectonic quality.

The building is built around a terraced courtyard. The galleries are below ground level, most having overhead lighting. Under the courtyard, the galleries lead into each other from left to right. Above the courtyard, the only building which stands out is the section devoted to administration, with a roof in the shape of a semicircular dome. The museum is fragmented by the pedestrian route which crosses it. The whole geometric composition of the building is based on the golden section as the Western method of planning shapes and subdivides spaces, and on the oriental theory of ying and yang, positive–negative. The rooms in the extremes of the building have expressive skylights in volumetrically pure shapes: various pyramids and a series of linear skylights. These rooms are double height whilst other rooms, under the courtyard and the office section are of single height and artificially lit. The exhibition rooms are half size, with a voluntarily neutral form and finish: smooth white walls, movable partitions, a parquet floor without a skirting board and homogeneous overhead light from the skylights. This overhead light has been criticized by a few Italian specialists for the way it dwarfs and distorts the proportions of sculptures. The exterior is a natural reddish coloured stone, contrasting with the transparent skylights and the lustre of the semi-cylindrical roof of the offices. The building is defined by the cylindrical roof of the administrative building and the expressive glass pyramids of the skylights. The building has four levels: courtyard, with entrances to the museum and offices, besides a bookshop and library; ground floor, with exhibition rooms and cafe; first basement, with a 250-seater auditorium and a vestibule which can be used for dance and musical performances, video installations and other enterprises; and the second basement which contains storage space, shops, studios and offices.

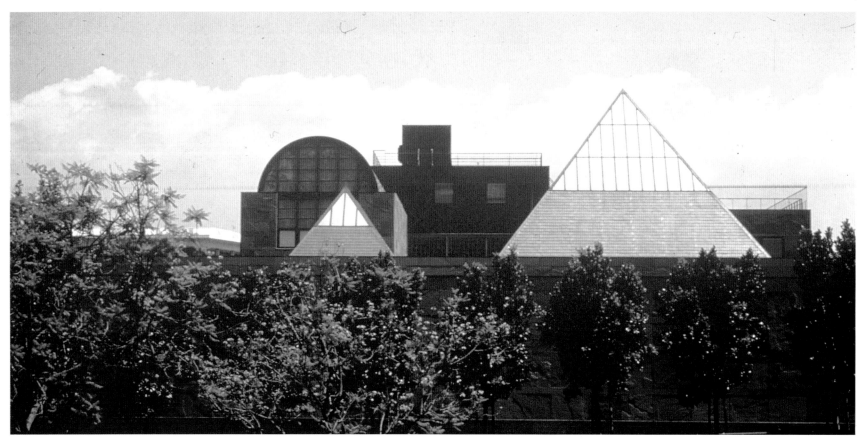

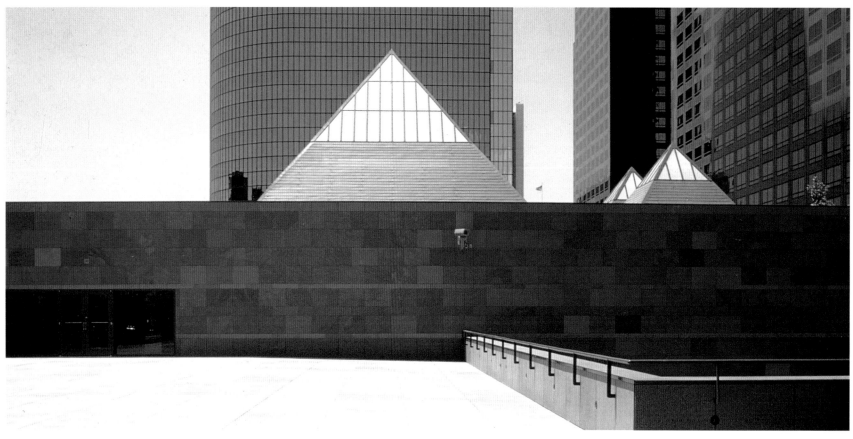

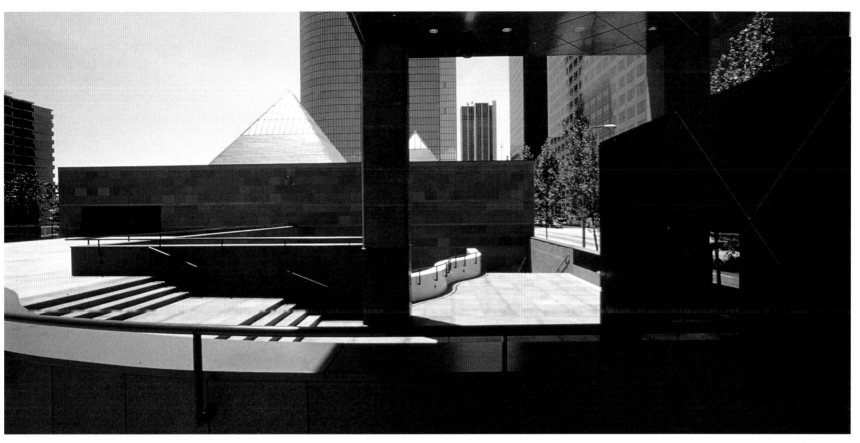

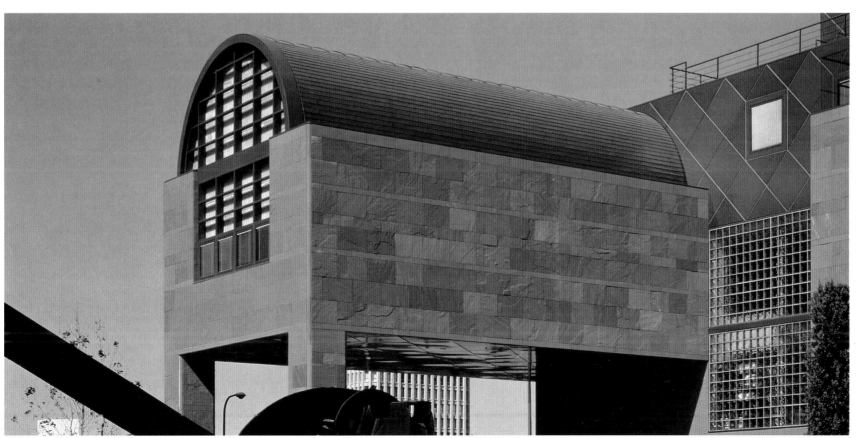

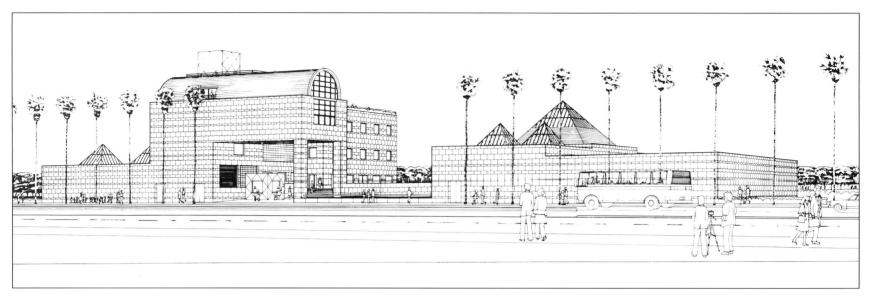

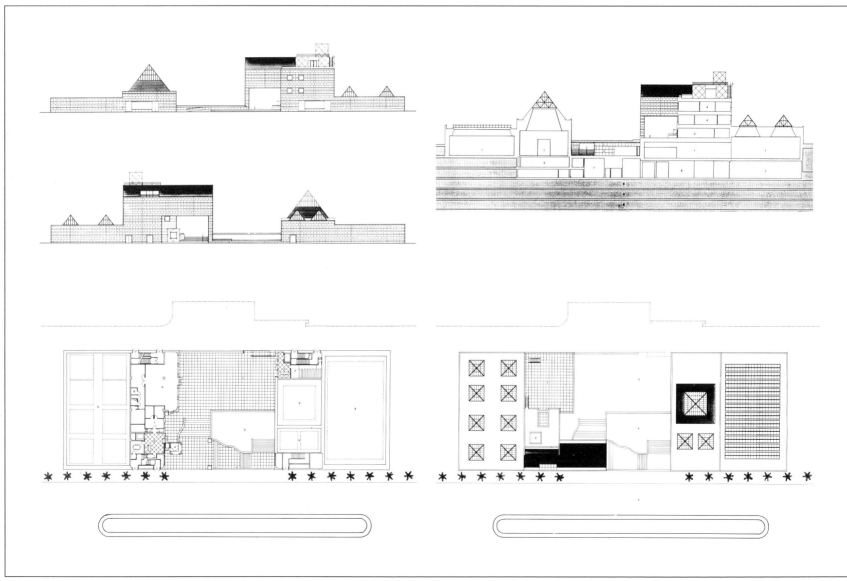

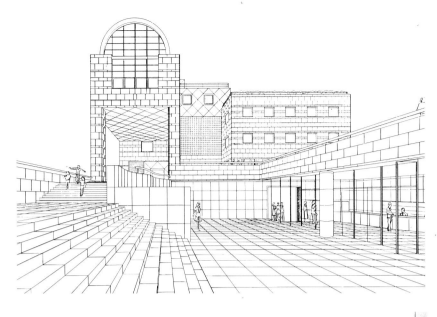

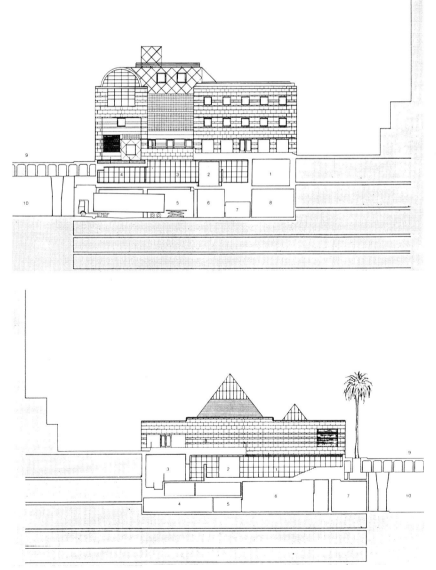

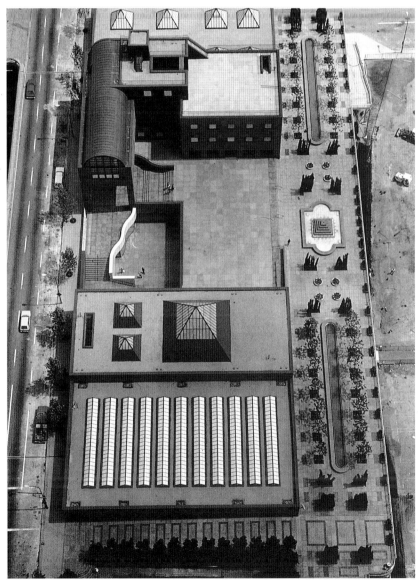

103

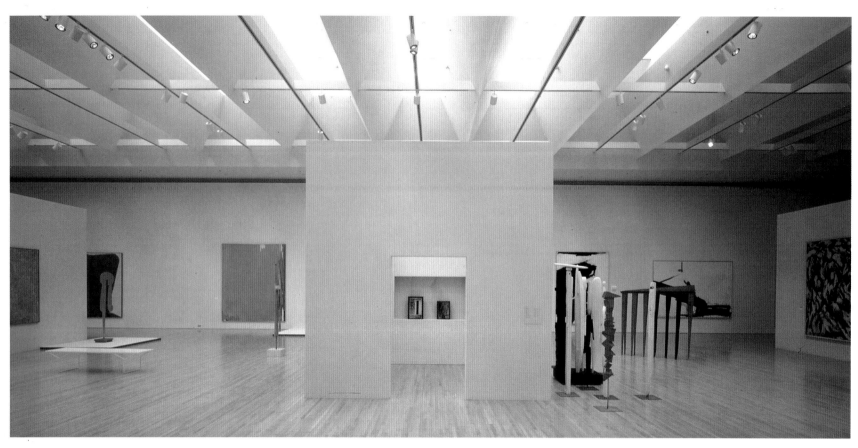

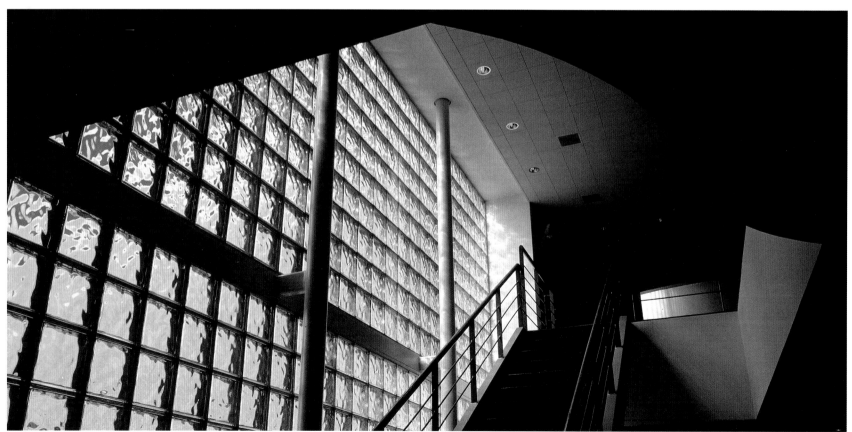

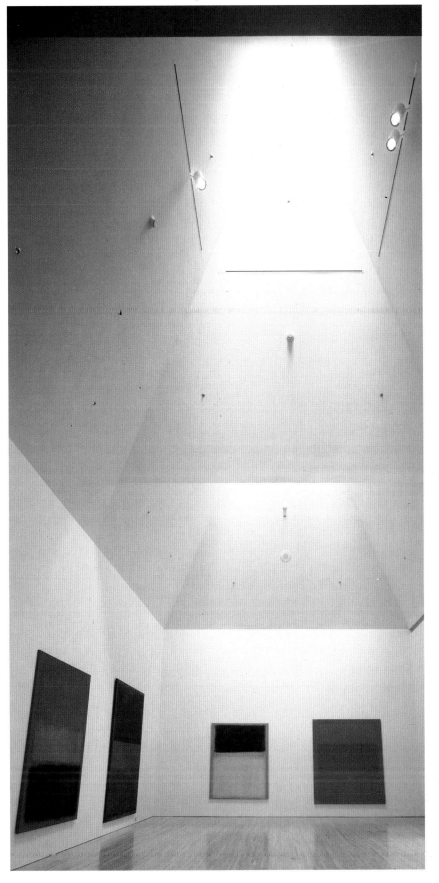

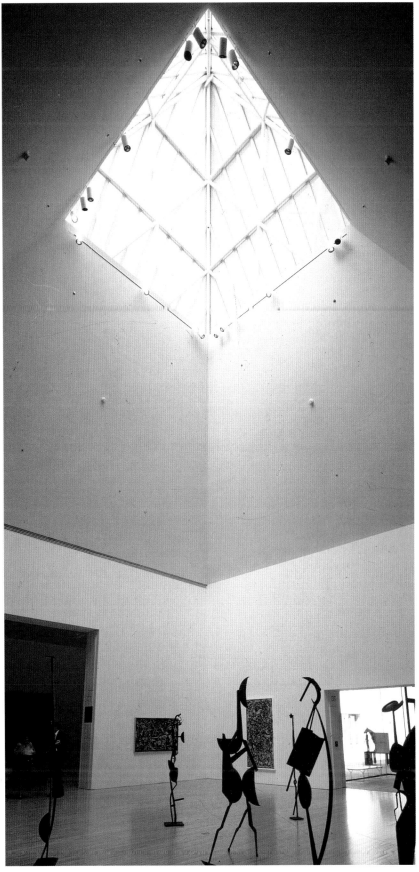

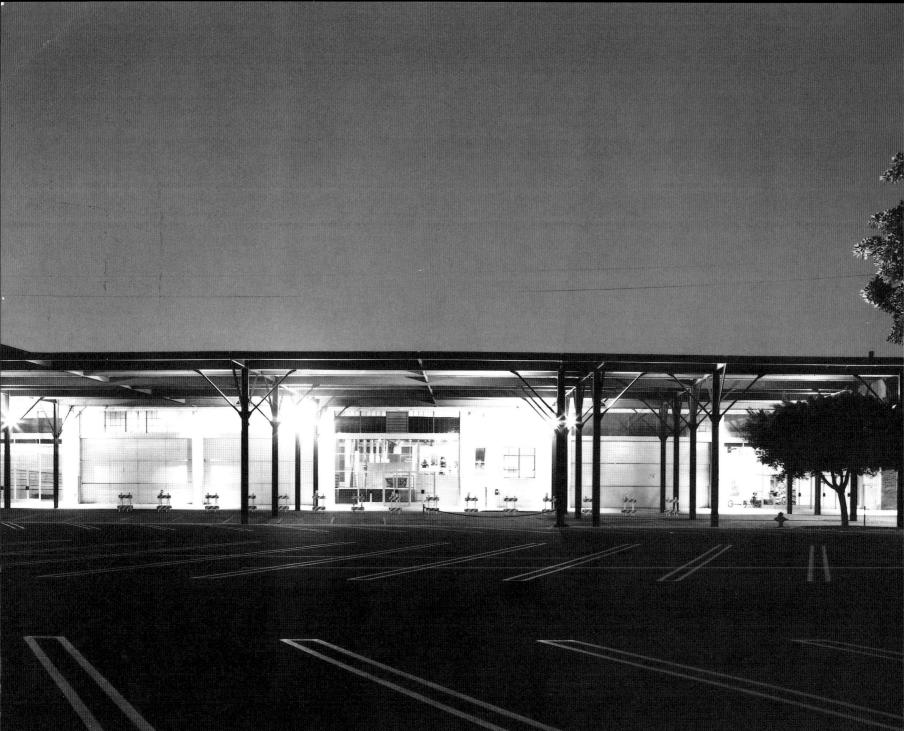

Architect: Frank Gehry

The Temporary Contemporary. The Museum of Contemporary Art

1983- **Los Angeles (USA)**

When in 1982 Arata Isozaki drafted his design for the Museum of Contemporary Art which he began in 1980, it was obvious that the building would not be finished for the 1984 Olympic Games. So in 1983, some old warehouses were requisitioned as a provisional museum of art, using a fairly modest budget. It was so successful that, in spite of the fact that the new museum building is now open, the Temporary Contemporary is still in use and will probably become permanent. The Museum of Contemporary Art will hold traditional work and the Temporary Contemporary more current and experimental art. In this way, the design has provided a temporary space for the first public programmes of the Museum of Contemporary Art, including contemporary painting, sculpture and design exhibitions, along with performances and montages.

The re-occupation and transformation of the two old warehouses involved an anti-seismic treatment of the structure, an improvement in security and basic systems of the construction, new mechanical and electrical measures, flexible lighting in exhibitions, rest rooms for the public and a series of ramps making the whole building accessible to wheelchairs. The interior of the building is basically white against the confusion of metal pillars, hanging divisions and ramps. The entrance is in Central Avenue, the street space conceived as a foyer, with a porch of steel and metal web. This is the most expensive architectonic element of the museum, and its purpose is to give it a public image and to define an entrance territory to the transitory population, adjoining Little Tokyo. The end of Central Avenue and the planning of the porch were done in strict cooperation with the town and local corporation. The remodelling of the building and the installation of the first exhibition was completed in less than six months and the presentation of work was basically the collaboration of artists like Lucinda Childs and John Adams. The fundamental objective of intervening with these warehouses has been not to change the existing construction, and to create a flexible space which can be used for the exhibition of contemporary works of art, especially those which are large and experimental.

SECTION A-A

SECTION B-B

MOCA - TEMP.

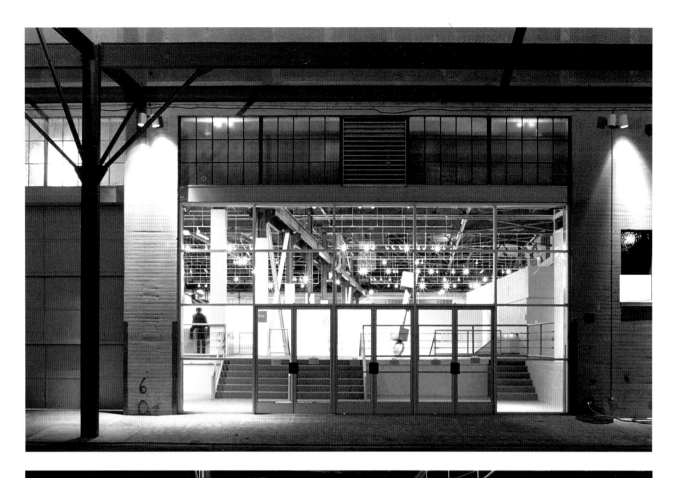

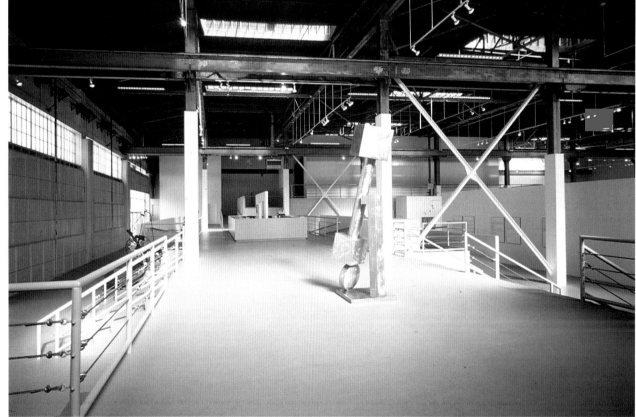

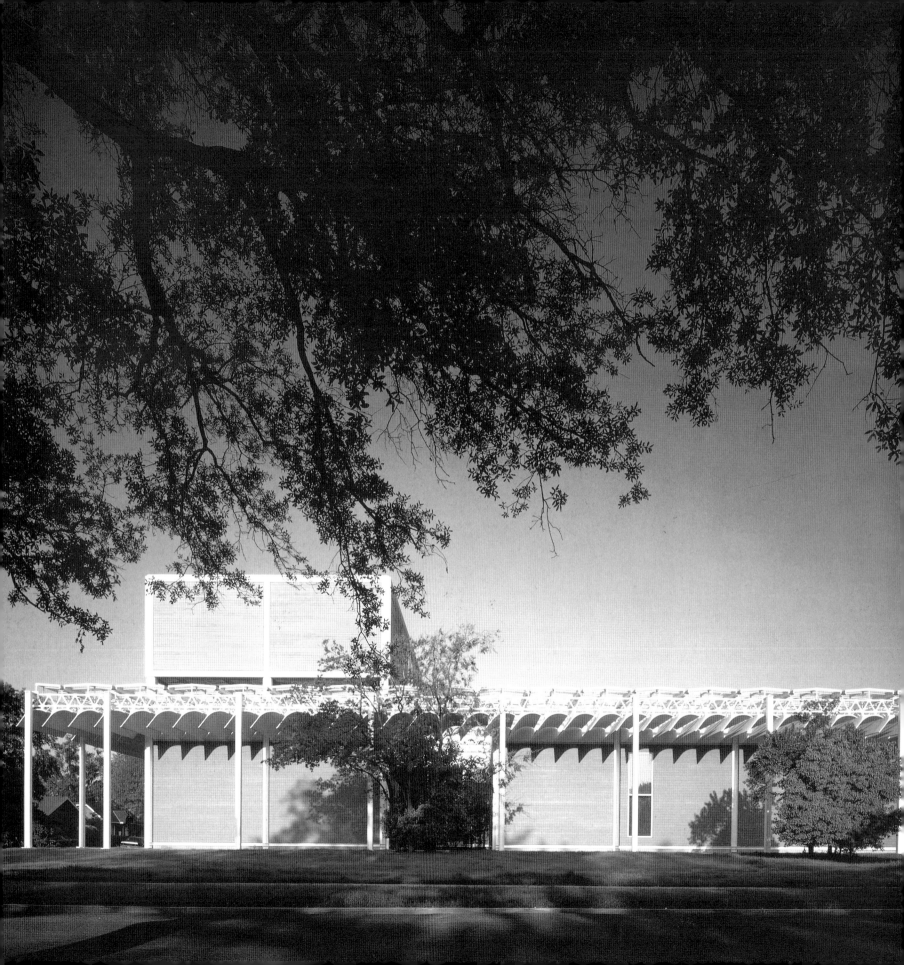

Architect: Renzo Piano

Collaborators: Fitzgerald (Houston), Peter Rice,
Tom Barker, Ove Arup and Partners, S. Ishida, M. Carroll,
F. Doria, M. Downs, C. Patel, B. Plattner, C. Susstrunk

The Menil Collection Museum

1981-1987 Houston (USA)

This new museum has the same characteristics of size and form as traditional 19th century museums and galleries of art, but it has an innovatory overhead lighting system which has been an important landmark. The Menil Collection is in a residential suburb of Houston shaped by one-family houses with gardens, bungalows in the middle of subtropical vegetation. For this reason it takes the form of a horizontally shaped pavilion, and is integrated into its neighbouring context. Even the formal treatment of the facade, with its wood finish, mimics these surroundings. The museum has a domestic, anti-monumental atmosphere. So as not to create an excessively large building and to achieve perfect integration into the site the complementary activities of the foundation-like auditorium, bookshop and restaurant have been housed in adjacent houses, giving the appearance of a kind of museum-village.

The interior of the compact and homogeneous mass of the museum is in two parts. In one are the basic facilities of the building, on three levels: in the basement, conservation and photographic laboratories; on the ground floor, reception and library; on the first floor, offices. The other part is used for the exhibition of primitive art, contemporary art, modern painting and sculpture, with a basement for storage of unexhibited works. The highest space, the upper floor dedicated to offices, rises to allow the system of fibre laminates which light the rooms to pass underneath it. Perpendicular to the two zones described in the centre is a transverse axis for entry. A longitudinal distribution axis unfolds between the two zones. The whole building is surrounded by a portico. The museum is essentially composed of fibre-laminated elements, repeated up to 300 times. This achieves high levels of natural light – 800 lux as opposed to the 200 lux of conventional art galleries. This was the wish of the promoters of the museum (Jean and Dominique de Meni) and it means that each painting and sculpture can be seen perfectly with all its textural and chromatic qualities. Along with laminates, the dark wooden floor and totally white walls help to achieve maximum light. This is the result of a new concept in the exhibition of works of art. Here we have a large collection of art made up of some 10,000 works of which only a part is exposed to this high natural light. The work is shown rotationally under very good lighting conditions one month a year and the rest of the time is stored under strict humidity and natural light conditions. The prefabricated laminates are joined together and to the light structure of the roof, and are positioned according to the quantity of light outside. The surface treatment of the fibre panels allows the reflection and diffusion of light on both sides. It seems odd that a whole museum building should be generated from the repetition of one technological element, but this is undoubtably a far-reaching contribution to the evolution of contemporary museums: technologically sophisticated and on a human scale, whilst also continuing the tradition of art galleries with natural overhead lighting, but converting what were traditional skylights into positionable plates.

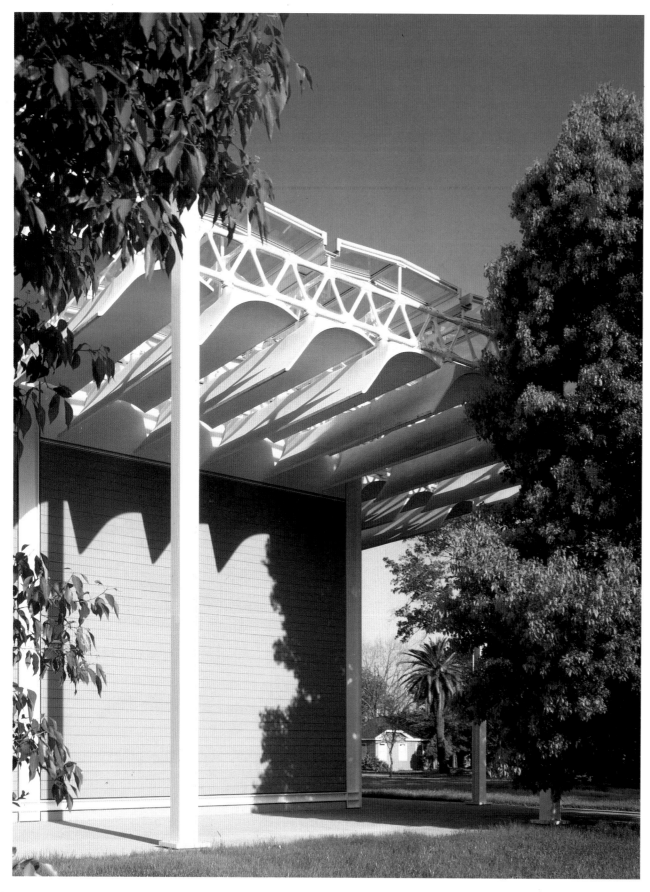

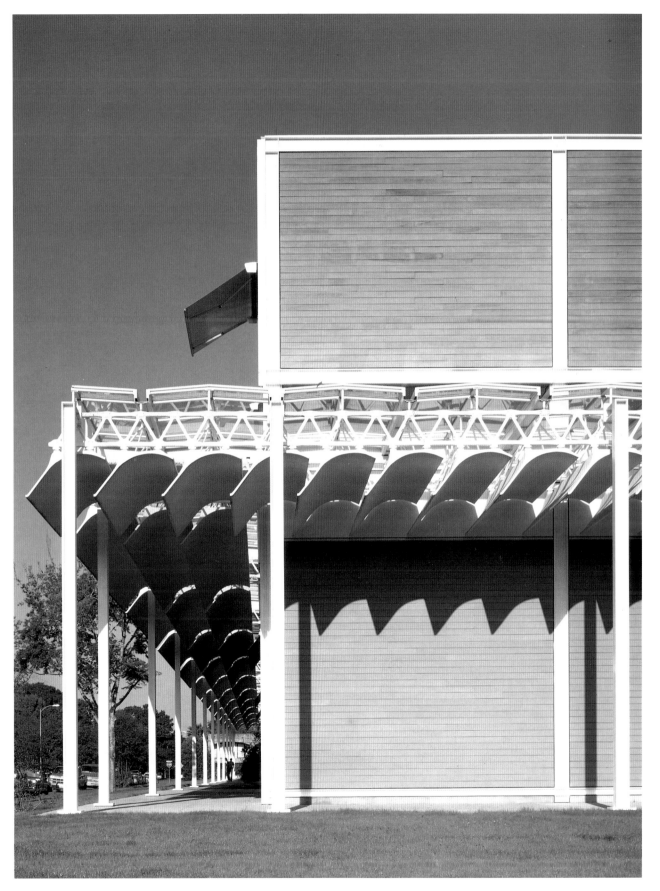

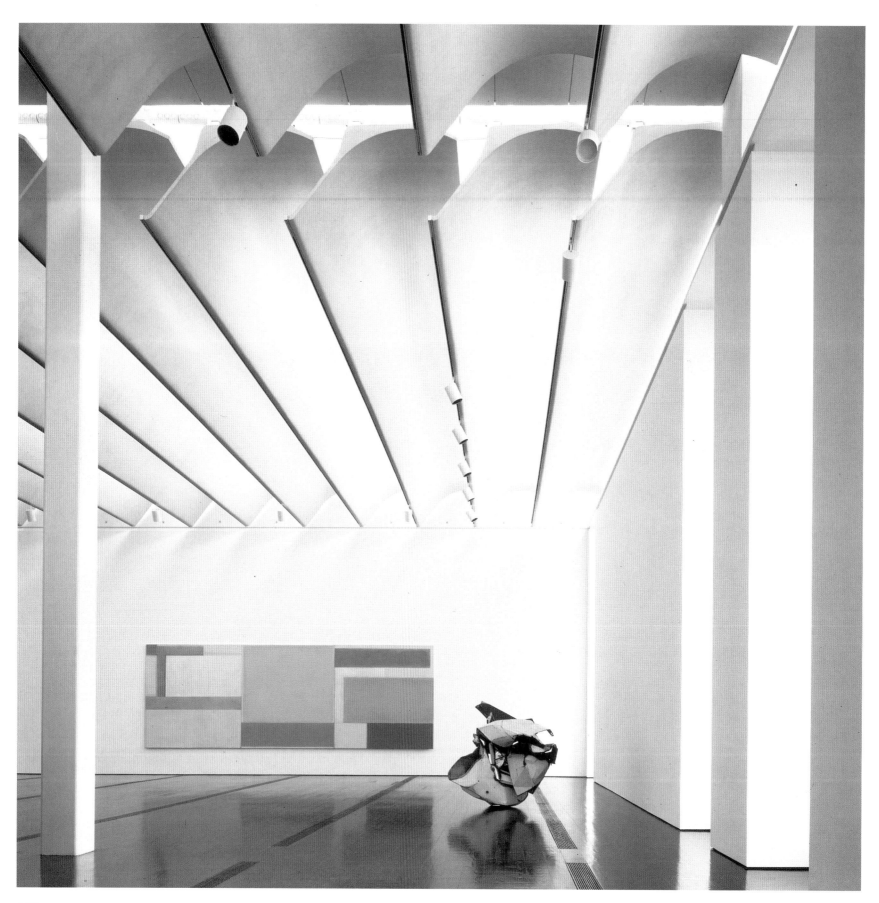

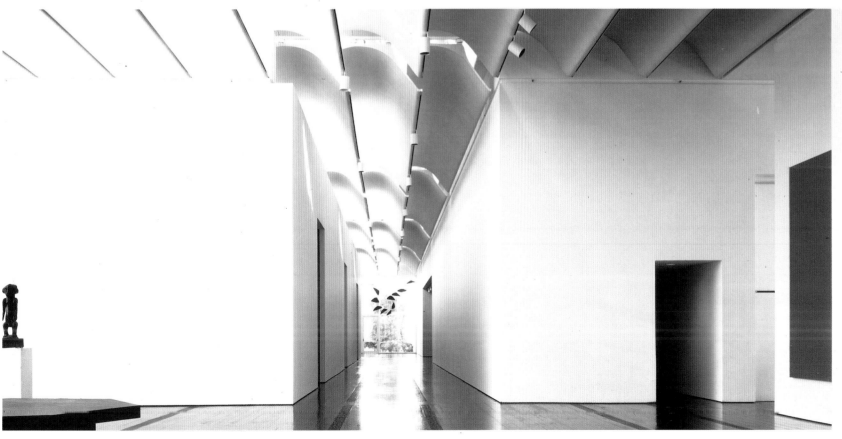

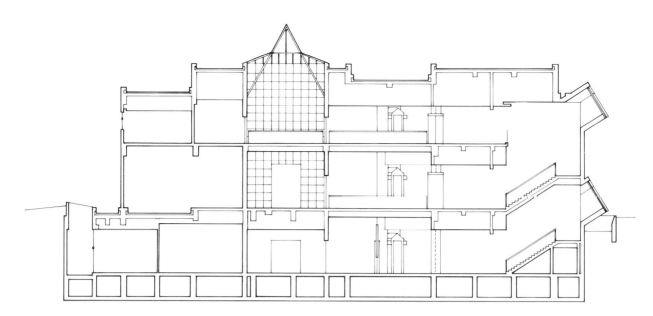

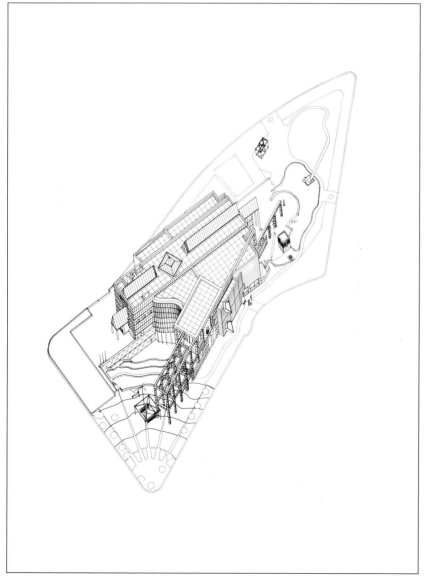

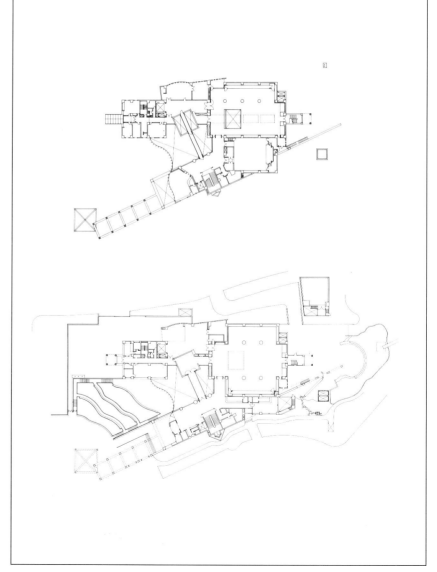

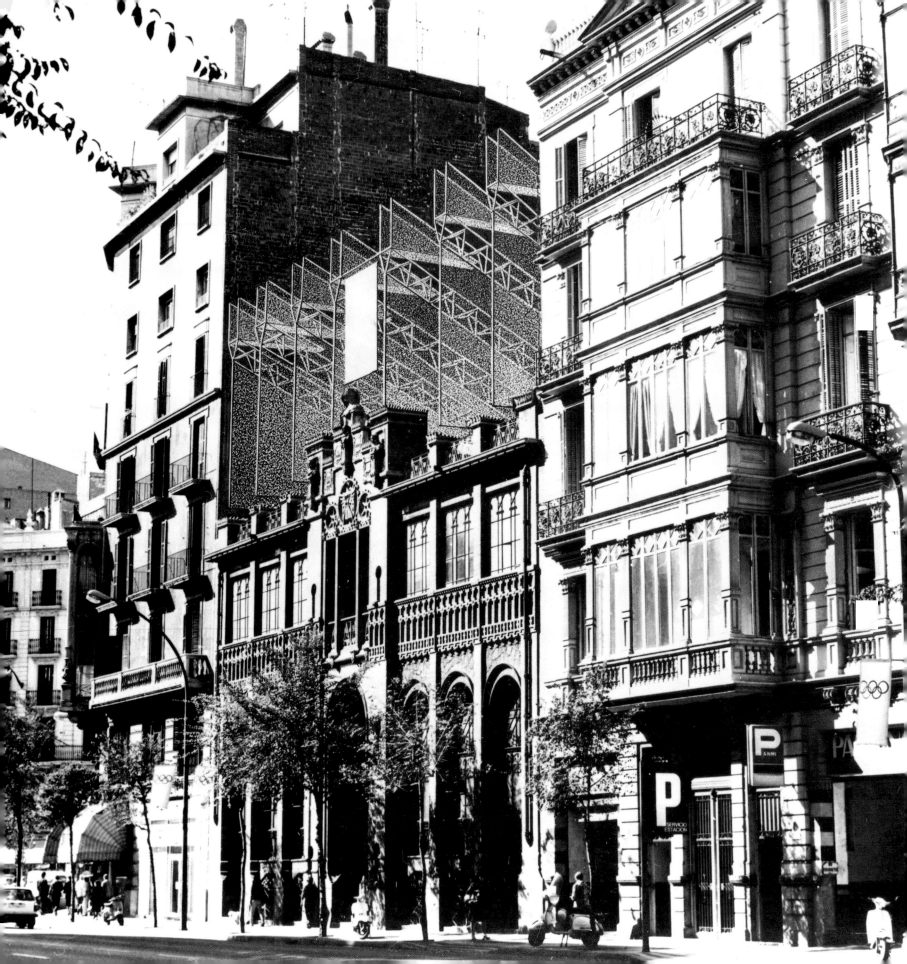

Architects: Lluis Domènech, Anton Alsina

Collaborators: Ramón Domènech, Anton Alsina

Antoni Tapies Foundation

1985-1990 Barcelona (Spain)

This centre of contemporary art, which houses an important part of the work of the Catalan painter Antonio Tapies, is situated in the old Montaner i Simon printworks of the modernist architect Lluis Domenech i Montaner. The building was finished in 1879 and constitutes one of the initial milestones of Catalan modernism, and in the case of the work of Domenech i Montaner, one of the first works of his proto-rationalist position.

The new design reclaims the original technical, spatial and aesthetic values of the building, with large spaces and overhead lighting, and adapts these to its new use. The spatial characteristics of the building have been reinterpreted, understood as a horizontal sequence of three spaces: a main area overlooking the street, an interior area with large rooms, and an area of lesser height inside the blocked courtyard. The building is based on a mixed technology of brick and iron: the brick used to form the skin and the iron as a structural element of industrial space. It has large unitary spaces which are naturally-lit overhead; graceful six metre high pillars define the open layout. An attempt has been made to integrate the special characteristics of an industrial building, to convert it into a centre of art exhibiting the Foundation's collection in a rotational manner.

The new intervention has basically been centred on the introduction and design of new stairways which join up the different areas of the centre. The exhibition rooms are in the old spaces of the printworks. At the end of the ground floor is the function room in the actual courtyard area. The attic, in the first gallery, between the entrance and the semi-basement, has been used for the most public facilities: ticket office and bookshop. The space below this area is for storage and examination of pictorial work. The first floor is intended as a place for more restricted activities, as are the library, the general archive, the reading and seminar room and an exhibition room for temporary exhibitions. The library takes advantage of the old shelving of the printworks house. The second floor houses administration. In the courtyard is a summer terrace, which is reached via the exhibition rooms. In the basement, there is sufficient space for storage and another exhibition room. To improve the natural light of the large exhibition rooms the existing system of skylights has been totally renewed.

The intervention in this beautiful and elegant example of industrial and urban architecture, transforming it into a museum of art, also manifests itself in the facade. It has been necessary to resolve the problem of height difference between the old modernist printworks, now a public building, and neighbouring buildings, overcoming the oppression which results from being squeezed in between the party walls of neighbouring houses. Following the structural order of the existing building, eight new projecting girders have been inserted which support plain sheets of metal mesh. This will serve as a support to a contribution by Antoni Tapies which will underline the new identity of the museum.

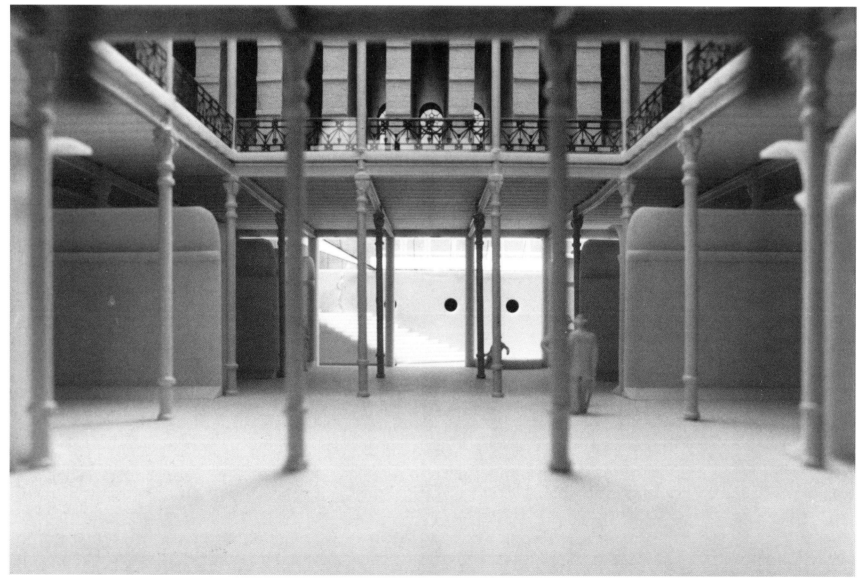

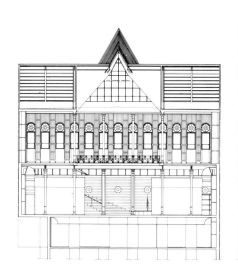

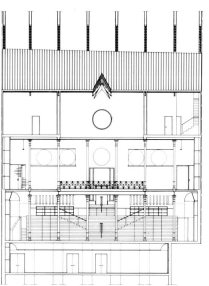

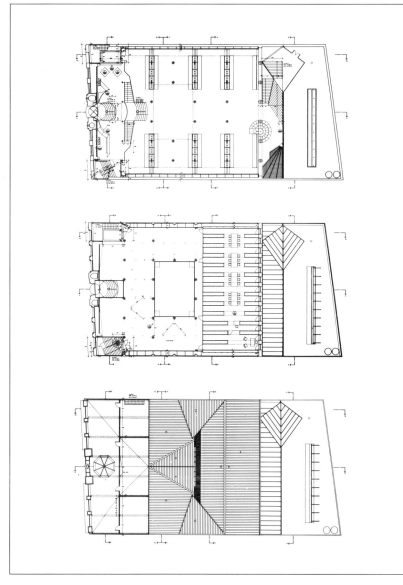

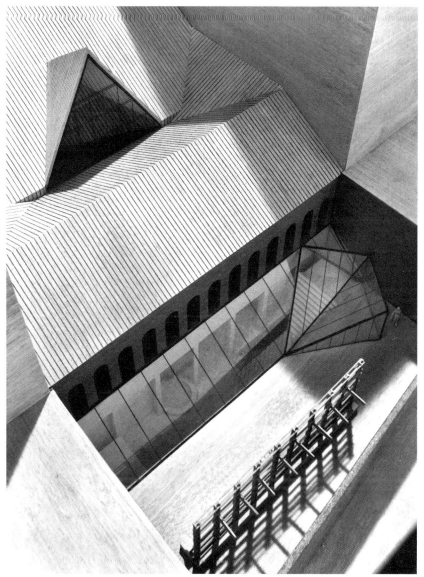

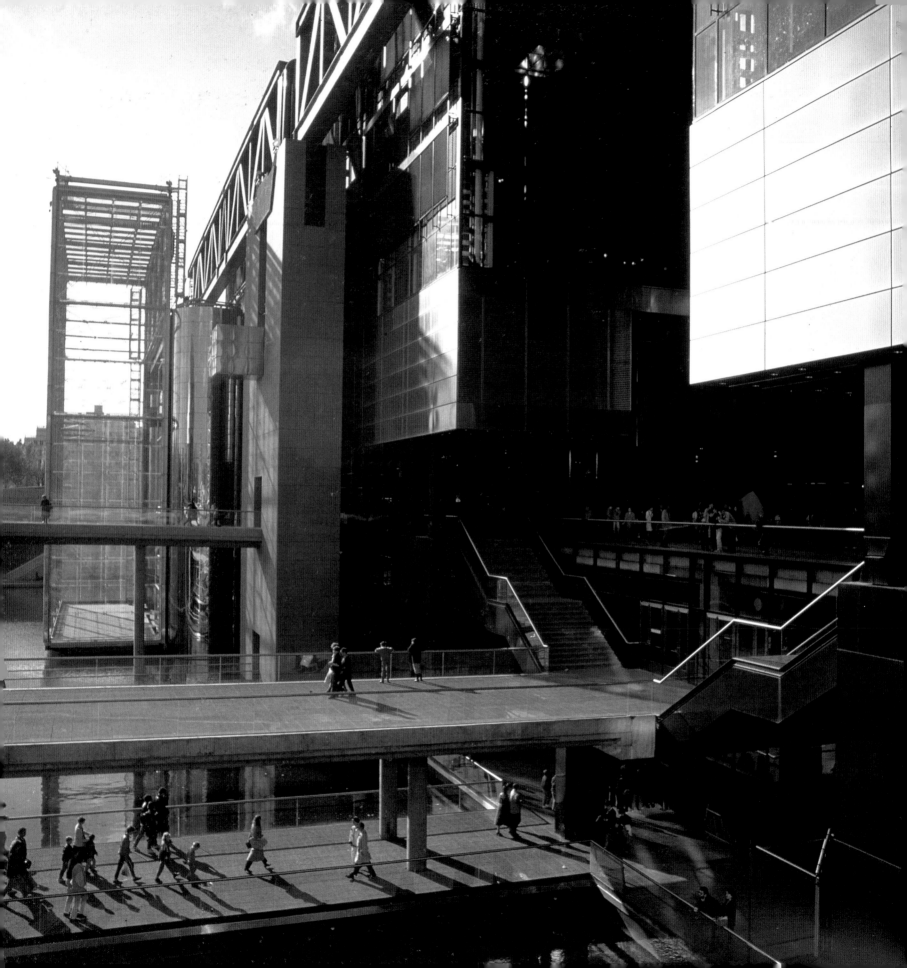

Architect: Adrien Fainsilber

Collaborator: Sylvain Mersier

National Museum of Science, Technology and Industry

1980-1986 Paris (France)

The design is by the winner of the 1980 competition. This museum of science and technology is part of the large Villette Park complex, devoted to culture and leisure, which now has a crucial role in Paris. Following Bernard Tschumi's new layout for the park, there are gardens and follies; and the 19th century Grande Halle has been conserved and is being used for large exhibitions and conferences. A series of new buildings devoted to culture and music, like Cité de la Musique and Le Zenit, have also been built. Also in this complex are the new museum, and la Geode, a cinema with a spherical screen, designed by Fainsilber in 1985.

The present museum is in a building originally designed as a new, modern slaughterhouse, using reinforced concrete. But then the markets and slaughterhouses of La Villette were moved to the outskirts of Paris and this abattoir was abandoned before completion. Part of the brief of the competition was to come up with a solution which took advantage of the pre-existing structure.

The aim of the competition was to build the biggest scientific museum in the world. It was planned as an operation of maximum prestige, technological show and economic effort. It has a high daily budget and a size way beyond other large Parisian monuments.

Fainsilber's design takes up the largest part of the aforementioned pre-existing abattoir structure. The whole area is crossed by canals and because much of the museum and la Geode are surrounded by water, so the already huge dimensions seem even larger. The museum has a beautiful clear bioclimatic facade, and a vertical greenhouse. Using high technology, a mesh of stainless steel tubes has been created. The windows are 2 x 2 m reinforced glass panels, hung, linked and held by a system of prestressed cables, creating a smooth and continuous exterior surface.

The building, like most science and technology museums, consists of a huge container inside which a diversity of cultural and scientific activities go on, based on the attraction of simultaneous single-theme exhibitions. The interior is organized as a monumental and theatrical central space, and entry is gained via different entrances and footbridges, which are joined together by dozens of escalators. These give access to spaces on the six levels of the perimeters of the building. Various mediathèques, information points, exhibition rooms, reception rooms and workshops for young people and children, a planetarium, cinemas, an international conference centre, shops and bars are housed within. It is like a great scientific city or enormous commercial gallery for the exhibition of scientific, technological and industrial progress. The natural light of the great hall is obtained via two huge rotating cupolas, 17 m in diameter, which direct solar light to the very heart of the building.

Within the building, a response to the diversity of technical requirements can be seen: a modern and rigorous standard of fire regulations, the continuous mounting and dismantling of exhibitions, control and direction systems for a great quantity of visitors, etc. Various light, interchangeable and prefabricated internal structures have been devised by architects Brullmann and Bougeras Lavergnolle to serve as supports to constantly changing exhibitions.

Architect: Adrien Fainsilber

Collaborator: Sylvain Mersier

National Museum of Science, Technology and Industry

1980-1986 Paris (France)

The design is by the winner of the 1980 competition. This museum of science and technology is part of the large Villette Park complex, devoted to culture and leisure, which now has a crucial role in Paris. Following Bernard Tschumi's new layout for the park, there are gardens and follies; and the 19th century Grande Halle has been conserved and is being used for large exhibitions and conferences. A series of new buildings devoted to culture and music, like Cité de la Musique and Le Zenit, have also been built. Also in this complex are the new museum, and la Geode, a cinema with a spherical screen, designed by Fainsilber in 1985.

The present museum is in a building originally designed as a new, modern slaughterhouse, using reinforced concrete. But then the markets and slaughterhouses of La Villette were moved to the outskirts of Paris and this abattoir was abandoned before completion. Part of the brief of the competition was to come up with a solution which took advantage of the pre-existing structure.

The aim of the competition was to build the biggest scientific museum in the world. It was planned as an operation of maximum prestige, technological show and economic effort. It has a high daily budget and a size way beyond other large Parisian monuments.

Fainsilber's design takes up the largest part of the aforementioned pre-existing abattoir structure. The whole area is crossed by canals and because much of the museum and la Geode are surrounded by water, so the already huge dimensions seem even larger. The museum has a beautiful clear bioclimatic facade, and a vertical greenhouse. Using high technology, a mesh of stainless steel tubes has been created. The windows are 2 x 2 m reinforced glass panels, hung, linked and held by a system of prestressed cables, creating a smooth and continuous exterior surface.

The building, like most science and technology museums, consists of a huge container inside which a diversity of cultural and scientific activities go on, based on the attraction of simultaneous single-theme exhibitions. The interior is organized as a monumental and theatrical central space, and entry is gained via different entrances and footbridges, which are joined together by dozens of escalators. These give access to spaces on the six levels of the perimeters of the building. Various mediathèques, information points, exhibition rooms, reception rooms and workshops for young people and children, a planetarium, cinemas, an international conference centre, shops and bars are housed within. It is like a great scientific city or enormous commercial gallery for the exhibition of scientific, technological and industrial progress. The natural light of the great hall is obtained via two huge rotating cupolas, 17 m in diameter, which direct solar light to the very heart of the building.

Within the building, a response to the diversity of technical requirements can be seen: a modern and rigorous standard of fire regulations, the continuous mounting and dismantling of exhibitions, control and direction systems for a great quantity of visitors, etc. Various light, interchangeable and prefabricated internal structures have been devised by architects Brullmann and Bougeras Lavergnolle to serve as supports to constantly changing exhibitions.

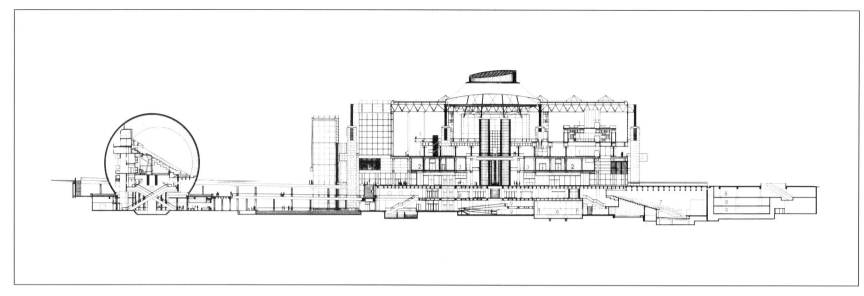

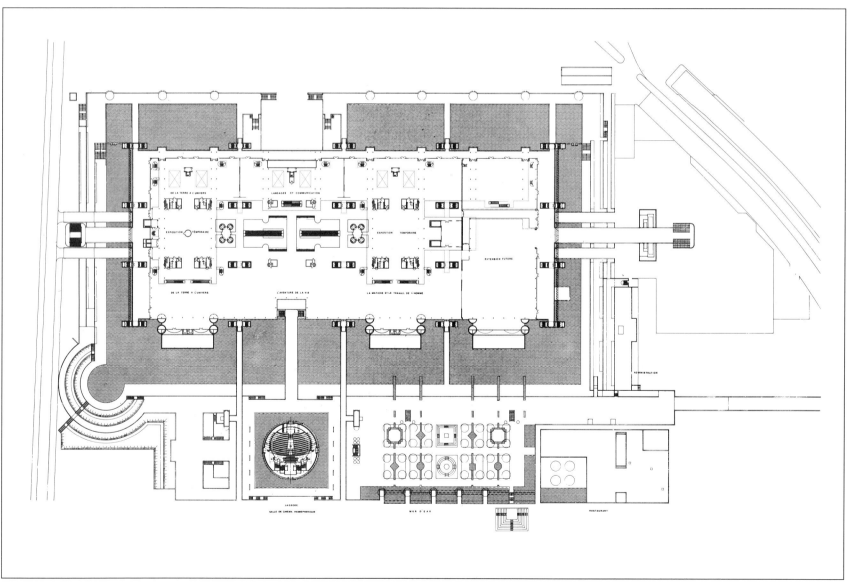

DE LA TERRE A L'UNIVERS

LANGAGES ET COMMUNICATION

EXPOSITION TEMPORAIRE

EXPOSITION TEMPORAIRE

EXTENSION FUTURE

DE LA TERRE A L'UNIVERS

L'AVENTURE DE LA VIE

LA MATIERE ET LE TRAVAIL DE L'HOMME

ADMINISTRATION

LA GEODE
SALLE DE CINEMA HEMISPHERIQUE

MUR D'EAU

RESTAURANT

130

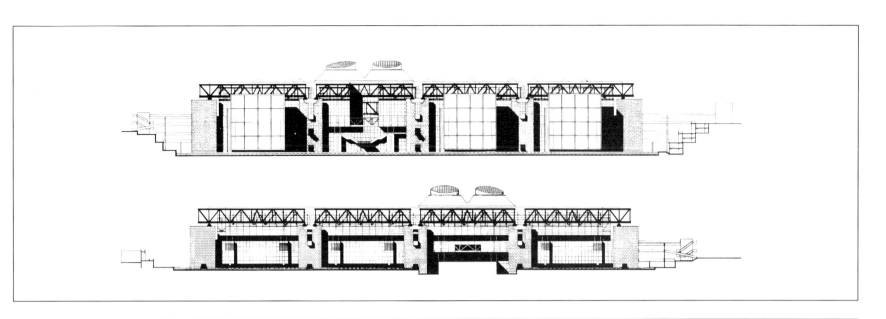

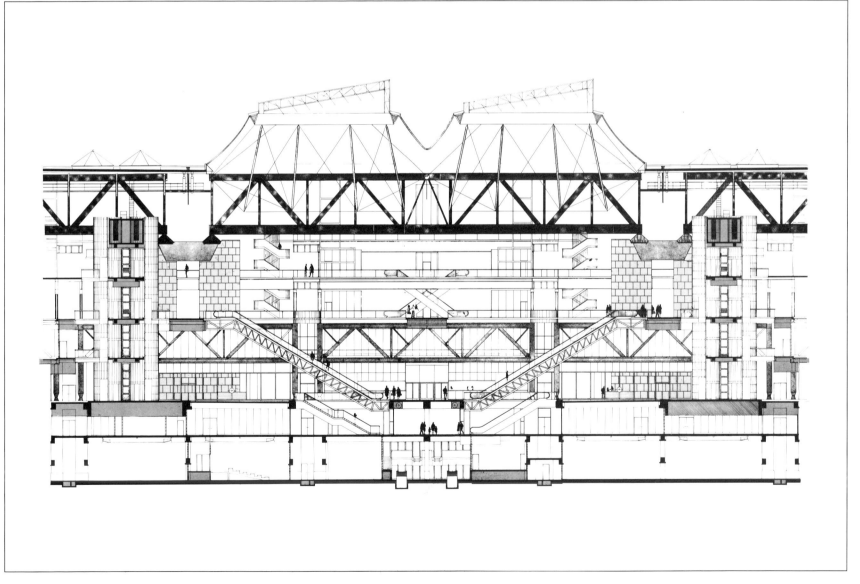

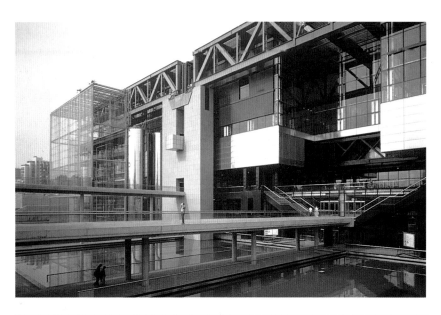

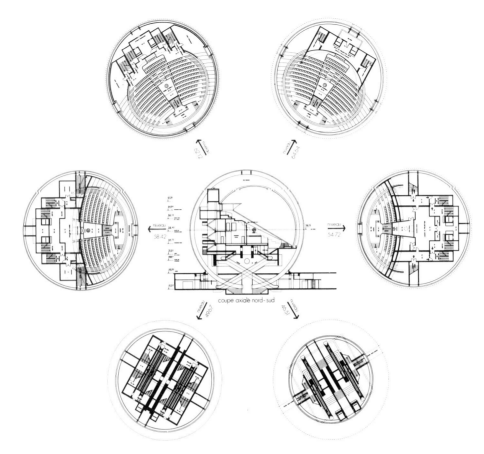

coupe axiale nord-sud

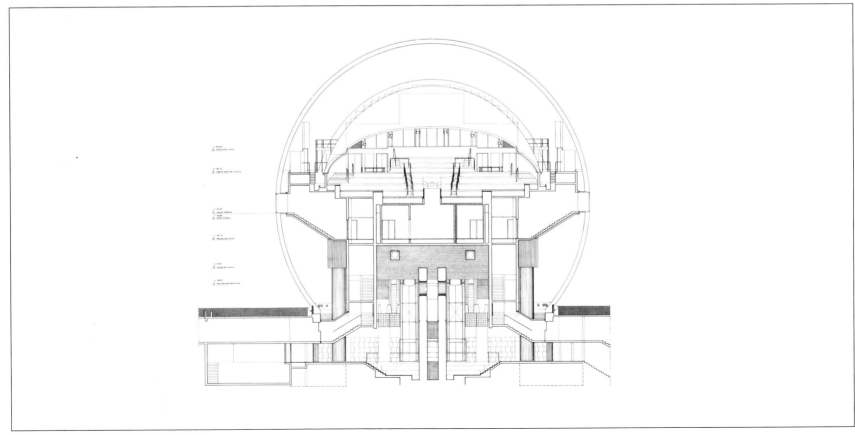

Architects: Marco Albani, Franca Helg, Antonio Piva

Collaborators: Girolamo Zampieri, Peter Eberle

Civic Museum in the Church of the Hermits

1969-1985 Padua (Italy)

The Civic Museum of Padua is housed in two cloisters adjacent to the convent of the Hermits, built in the 16th century. Inside the museum space are rich and splendid collections of very different typologies. Carried out over various phases since 1969, the project has involved creation of an access area to the museum in the principal facade of the church, restoration of the 15th century cloister, rebuilding of the cloister destroyed during the tragic bombings of the last war, restoration of the medieval area and construction of a new art gallery.

The exhibits are diverse and belong to different periods of history: tablets, sarcophagii, sculpture, ceramics, mosaics and jewellery belonging to Egyptian, Greek, Etruscan, Roman and other periods. An exhibition system flexible enough to show the great variety and range of the repertoire of objects has been designed, whilst at the same time it is detailed enough to emphasize the material characteristics, form and weight of each object. The possibility of extending the collection in case of new acquisitions has also been taken into account.

The exhibition of works of major importance is emphasized not only by their privileged location but also by careful lighting which accentuates the formal and chromatic characteristics of the pieces. Signposting, with route indications and information panels, is organized as a system of interchangeable modules. The careful presentation of each individual piece is as important as the critical historical discourse of the museum as a whole.

PROSPETTO OVEST PROSPETTO SUD SEZIONE B-B

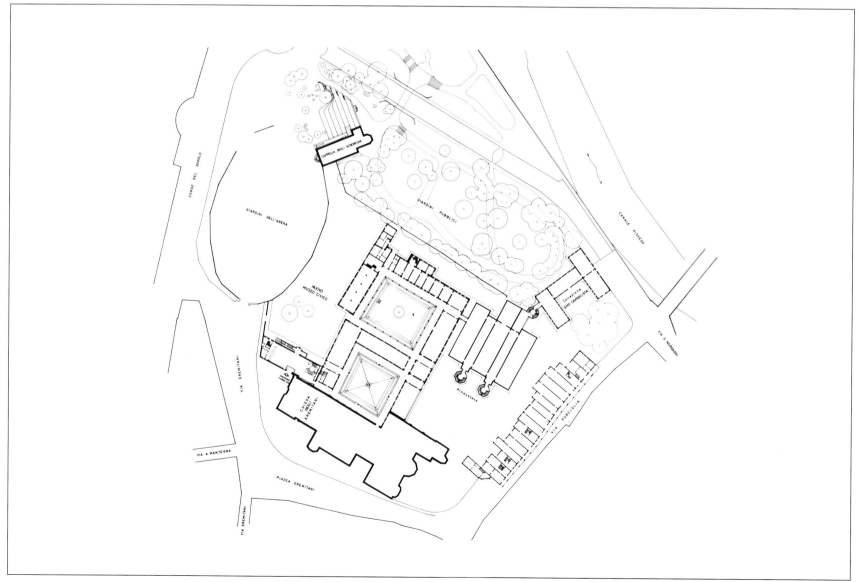

138

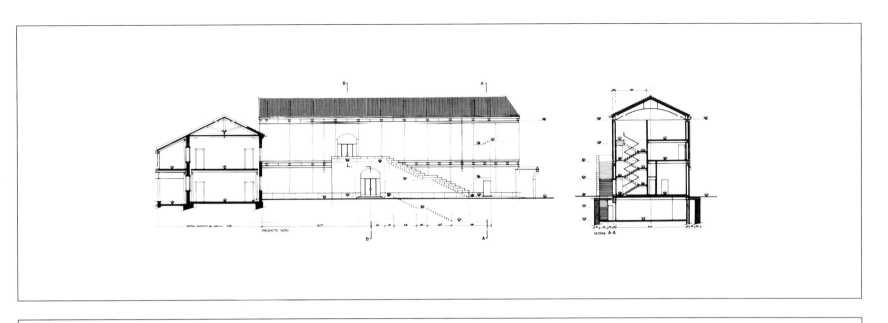

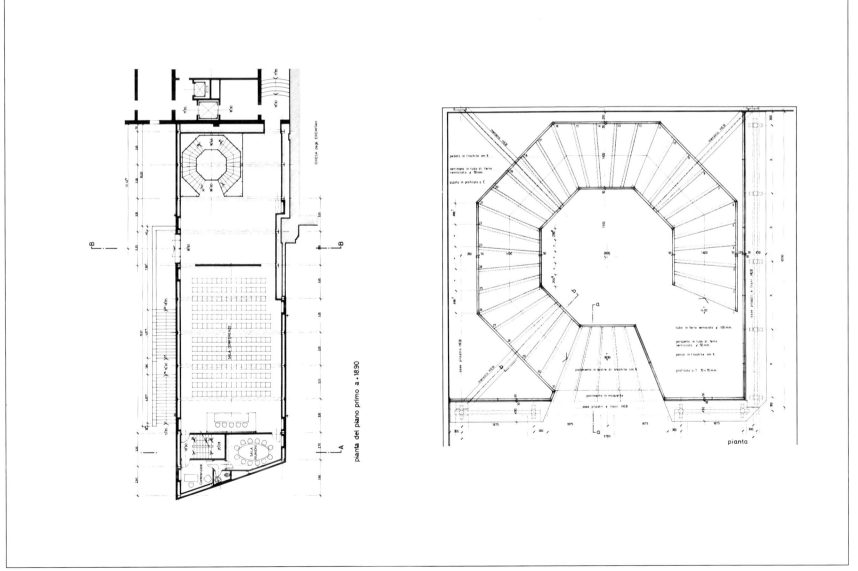

pianta del piano primo a +18,90

pianta

Architect: Guido Canali

Collaborators: Marco Fogli, Gianpaolo Calestani,
Claudio Bernardi, Italo Lupi

National Gallery in the Palazzo della Pilotta

1970-1986 **Parma (Italy)**

The National Gallery of Parma is inside the huge historical complex of the Palazzo della Pilotta, formed by areas of very different character – huge halls and stairways, galleries, courtyards, a theatre and so on. They are housed in different buildings, for example the Farnese Theatre, the Museum of Antiquity, the Palatine Library, the National Gallery and the National Centre, the Department of Art of the Research Centre and Archive of Communication and other institutes of art.

A large part of the National Gallery's collection has been installed in phases in this great variety of spaces, by creating various partial exhibitions. The art gallery has still not been realized.

The design has taken account of the architectonic identity of each one of the historical spaces. Most of the new museographic intervention has been in its structures, for example a huge tubular mesh has been inserted in the ceiling as a support for installations. To articulate the long routes and many spaces of the old complex, and to install the variety of pieces and collections, architectonic interventions like footbridges, ramps, platforms and stairs have been created. This makes for a great contrast between the three types of elements of the museum: the interior walls of the historic buildings, which are bare except in the theatre; the new metallic footbridges, pedestals and girders; and the exhibits, a series of sculptures and paintings, amongst other objects. The separate perception of the historic container and the modern museographic container is striking.

The courtly space of the Farnese Theatre, exactly above the entrance area to this cultural and artistic complex, serves as a great admission room to the whole museistic route. Starting with a footbridge, a long route is followed through the galleries which house collections divided by period: Tuscan painting of the 14th and 15th centuries, emilian and Lombardian painting of the 15th century, emilian painting of the 15th and 16th centuries, Italian painting of the 15th, 16th, 17th and 18th centuries, Correggio and Parmigianino, neoclassical painting and so on.

This is typical of the way civic museums develop, accommodating very different spaces and thus forming complex shapes. This leads to a labyrinthine, although enormously stimulating result.

144

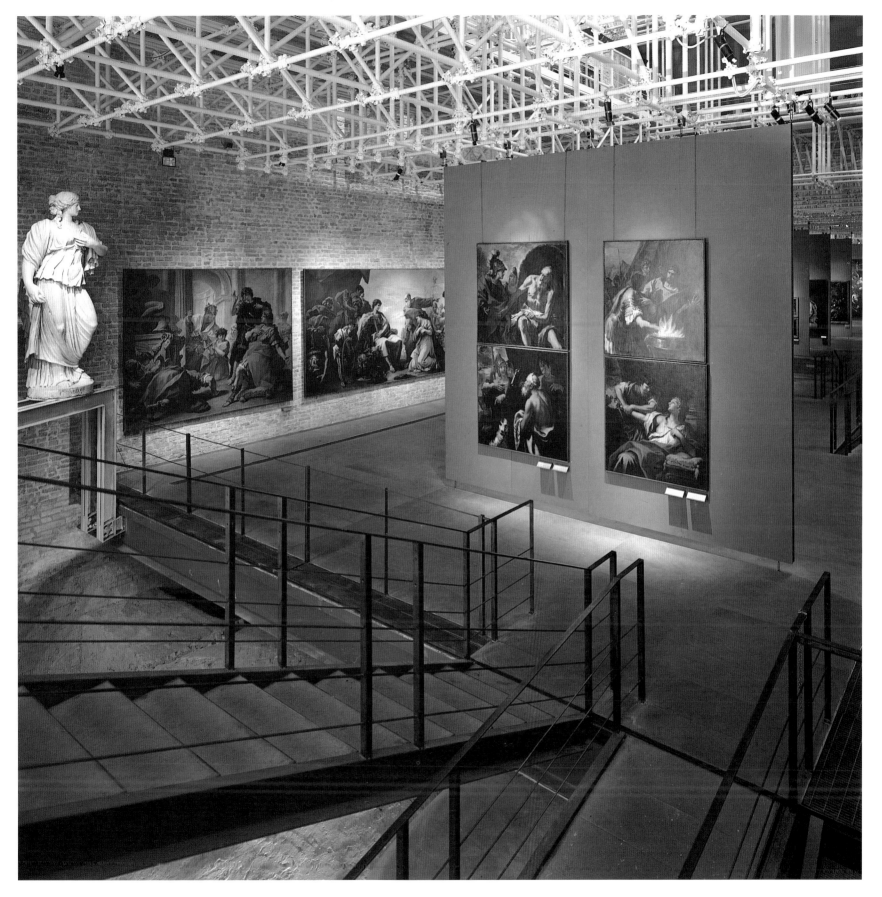

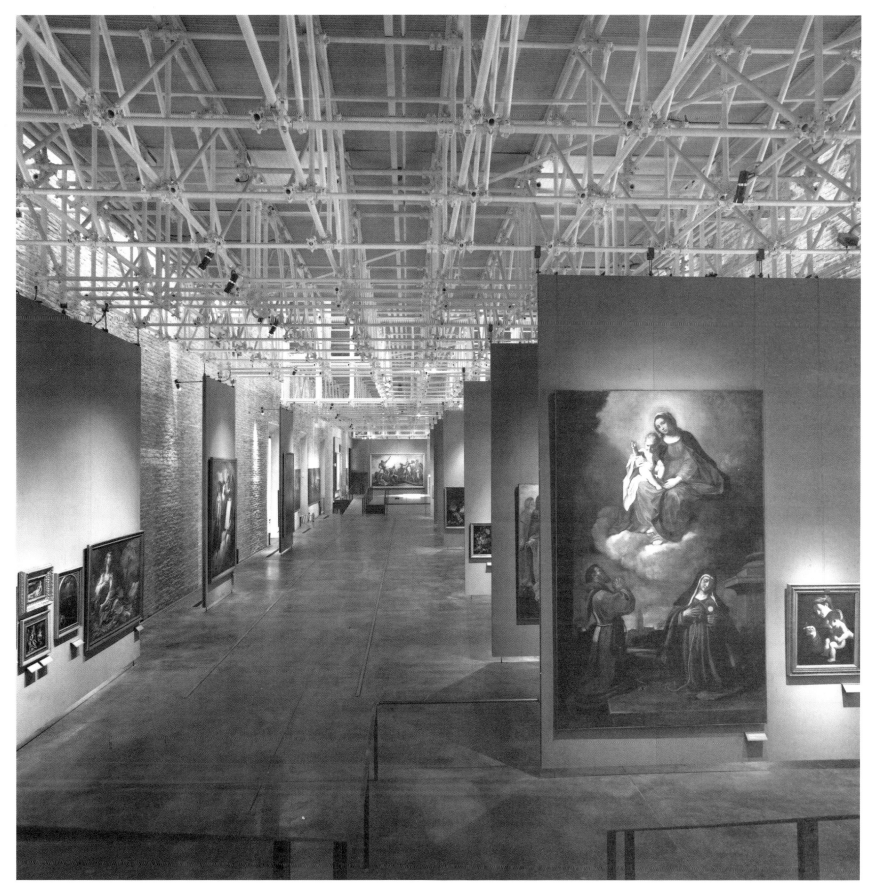

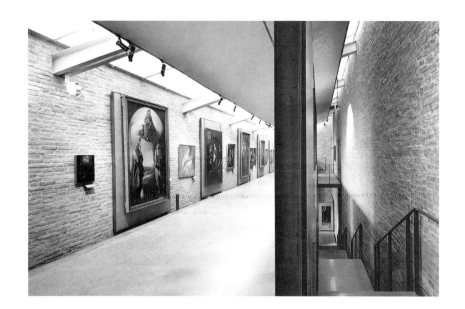

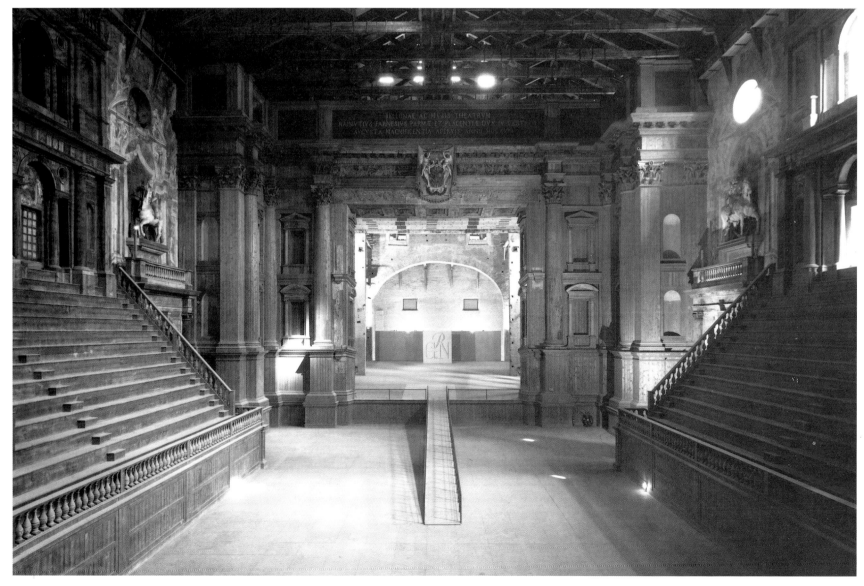

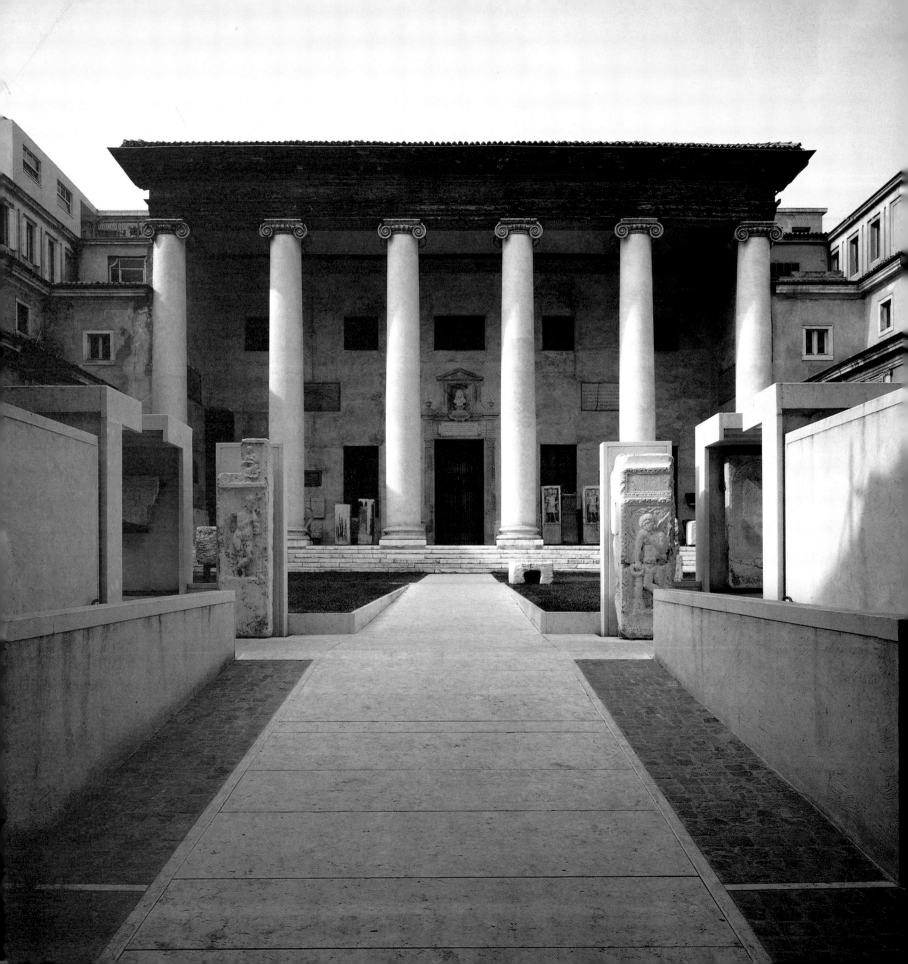

Architect: Arrigo Rudi

Collaborators: Prof. Lanfranco Franzoni,
Licino Cristini, Sergio Gallina

The Maffeiano Lapidary Museum

1977-1982 Verona (Italy)

This Archcological Muooum ic right in Verona's historic centre, Bra Square, next to the wall of the scaligero-viscontea epoch. The area is dominated by the Domenico Curtoni's Philharmonic Theatre, built between 1609 and 1611. At the beginning of the 18th century, the celebrated Scipione Maffei proposed the creation of what would be the first European example of a public museum. The object was to present an archeological collection, formed by classic stone, in an open area. It would be an archeological garden to promote the renaissance of classical art, in the context of the first polemics between incipient neoclassicism and decadent baroque. The first provisional systematization was realized by Maffei in 1719 and the architect Alessandro Pompei proposed an architectonic intervention in the museistic complex. He designed a simple square area, emphasized by an Ionic portico and surrounded by a small perimetral portico in the doric style which would house the stones. The complex was finished in 1745.

The neoclassical architecture and the systematization of the Maffei collection have changed over time. In 1927, the square courtyard was changed by addition of an exedra. Between 1957 and 1969 two more floors were added to this exedra. When in 1976 Arrigo Rudi took on the restoration of the museum, the main objective was to bring it back to its original state. The ground level has therefore been reopened and the square form of the portico has been retrieved.

Mounts are made so that all exhibits are clearly seen in their entirety. A metallic modular system has been devised to support the stones in the courtyard. The stones of larger dimensions are placed on specially designed iron supports to show their form and allow comfortable viewing.

Inside, on two levels served by a lift, is the Greek, Etruscan, Roman and paleovenetos material; the collection of Greek epigraphs is the richest in Italy. All manner of display cabinets, pedestals, tables and reading desks have been designed following the same modular criteria and the objective of making each exhibit legible. Carlo Scarpa's influence is evident in the design of panels, partitions and materials. The richness of the pink-coloured walls and the red floor make the whites and greys of the marble and inscriptions stand out. The exhibits of particular archeological interest and refined quality are placed in relief by elegant metal supports. Two completely hipogea rooms allow a view of the old wall.

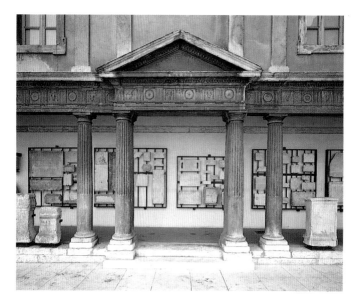

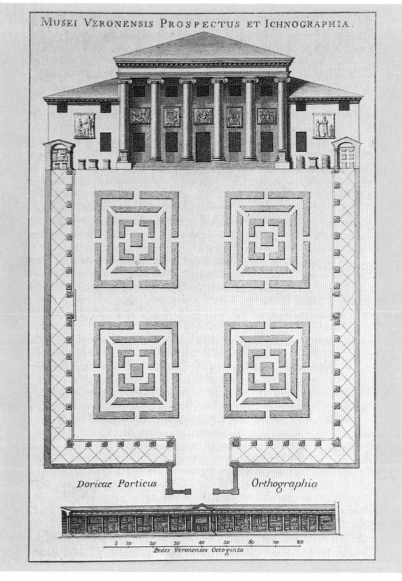

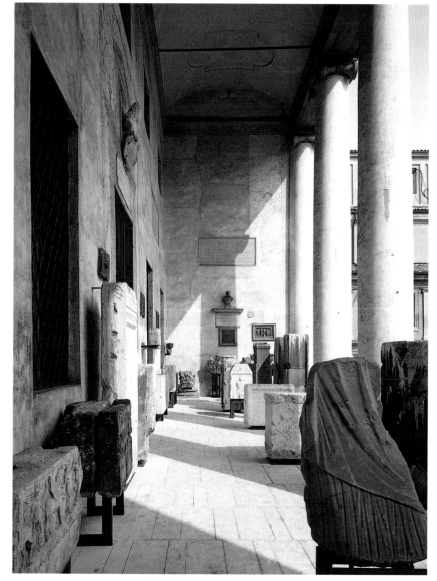

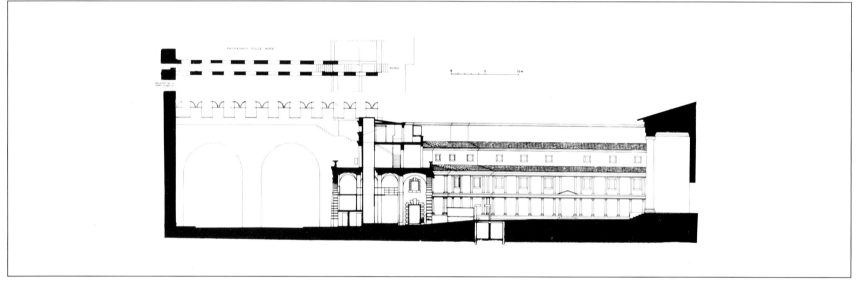

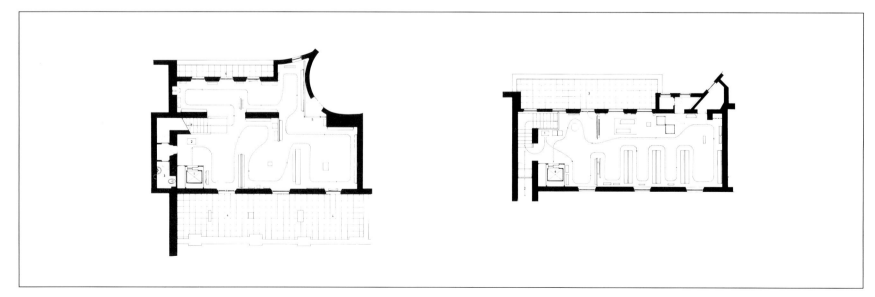

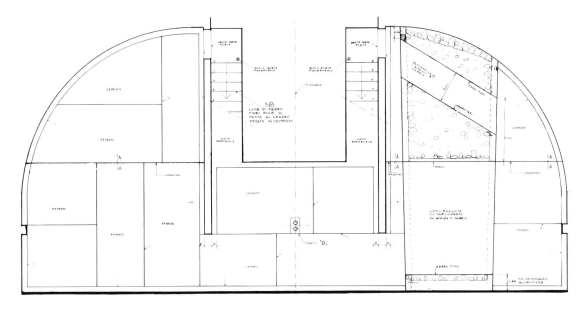

AR 88 Composizione con Deutsches Geschichts Museum

Architect: Also Rossi

Collaborators: G. da Pozzo, F. Saverio Fera,
I. Invernizzi, D. Nava, M. Scheurer

Museum of German History

1987- **Berlin (West Germany)**

Architectonically, it is like a cathedral without an apse or a huge hangar to which a series of emerging smaller hangars have been added. The complex is formed from the articulation of a series of areas; it is understood that, in an age where synthesis is impossible, the museum must be based on fragments, different masses which respond to the programme and which make reference to paradigmatic examples.

The relation to the great models of tradition and to German architecture is predominant. The admission space is an enormous cylinder which represents a rotunda; its purpose is to house a bookshop, shop and cafe, and serve as a rotula. The large exhibition space looks like a great warehouse on which a series of sloped areas lean. In the central nave, there are obvious references to industrial and classical German architecture from the beginning of the 20th century, notably the Heinrich Tessenow School in Hellerau. The library, auditorium, cinema, theatre, meeting rooms and information area are in a building where glass hangings alternate with blind walls, with space dedicated to teaching work, recalling the AEG factory by Behrens, the Fagus building by Gropius and the glass architecture of Mies van der Rohe. The L-shaped administration building which is the most urban facade, opposite the Reichtag and the Alsenplatz, is in colonnade form, in homage to the Altes Museum of Schinkel. Behind this fragmented complex, a minaret has been erected, originating in images of the 'Rossiano' world.

As far as materials are concerned, brick evokes old Berlin; white stone, the colonnade of Schinkel; glass, the meditation on German classical tradition in Mies van der Rohe; the corrugated iron roofs echo silent urban industrial architecture.

The interior of the museum is designed to house permanent and temporary exhibitions. It is spine-shaped: a large central distribution gallery on the axis gives access to a series of rooms either side. The mounting of exhibitions in each room, based on showing written or filmed material, is designed for teaching.

In spite of the option of a museum constructed from diverse fragments, Rossi's design is based on the reinterpretation of the typological tradition of the great European museums.

With its highly designed exterior, the essential value of this museum as an urban monument is highlighted. It integrates well into the surrounding area, and continues the tradition of the great national museums of Europe, to the extent that it refers formally to examples of German architecture.

The museum is in the esplanade, bordered by the curve of the River Spree, where the old Reichstag rose.

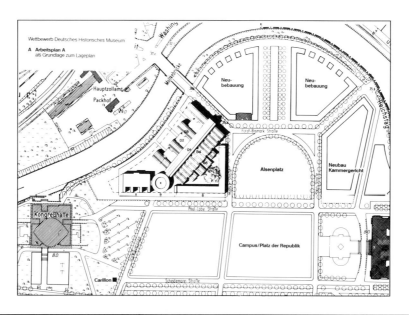

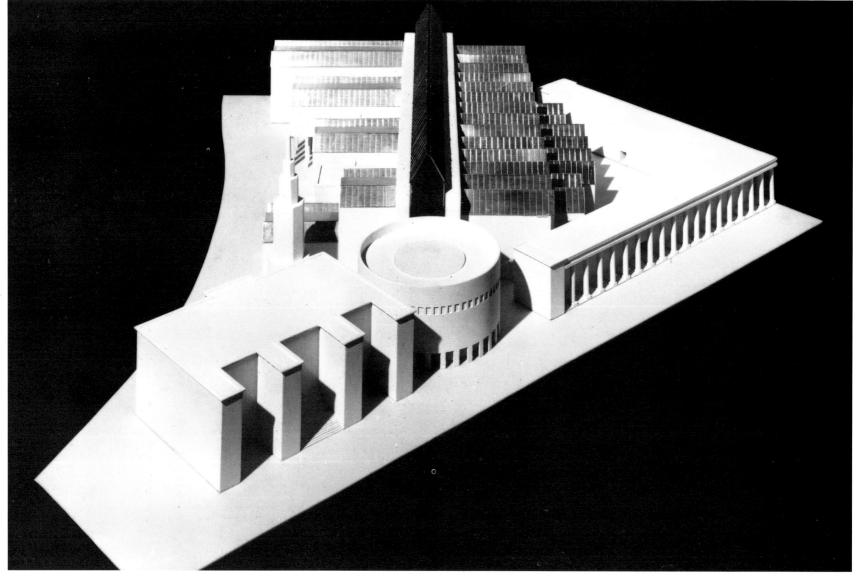

158

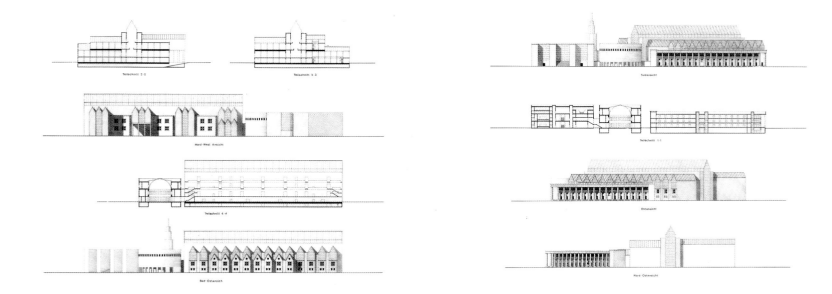

Teilschnitt 2-2

Teilschnitt 3-3

Südansicht

Nord-West Ansicht

Teilschnitt 1-1

Teilschnitt 4-4

Ostansicht

Süd-Ostansicht

Nord-Ostansicht

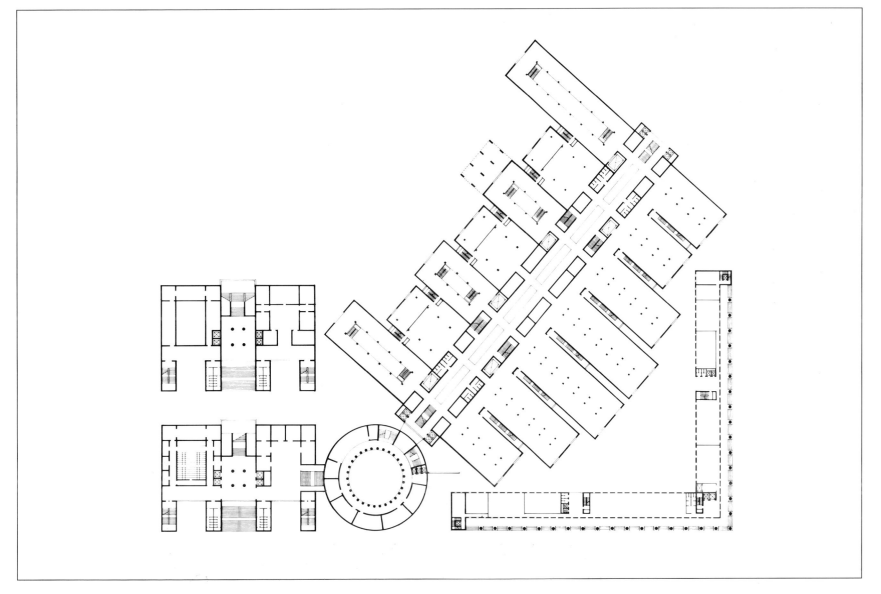

159

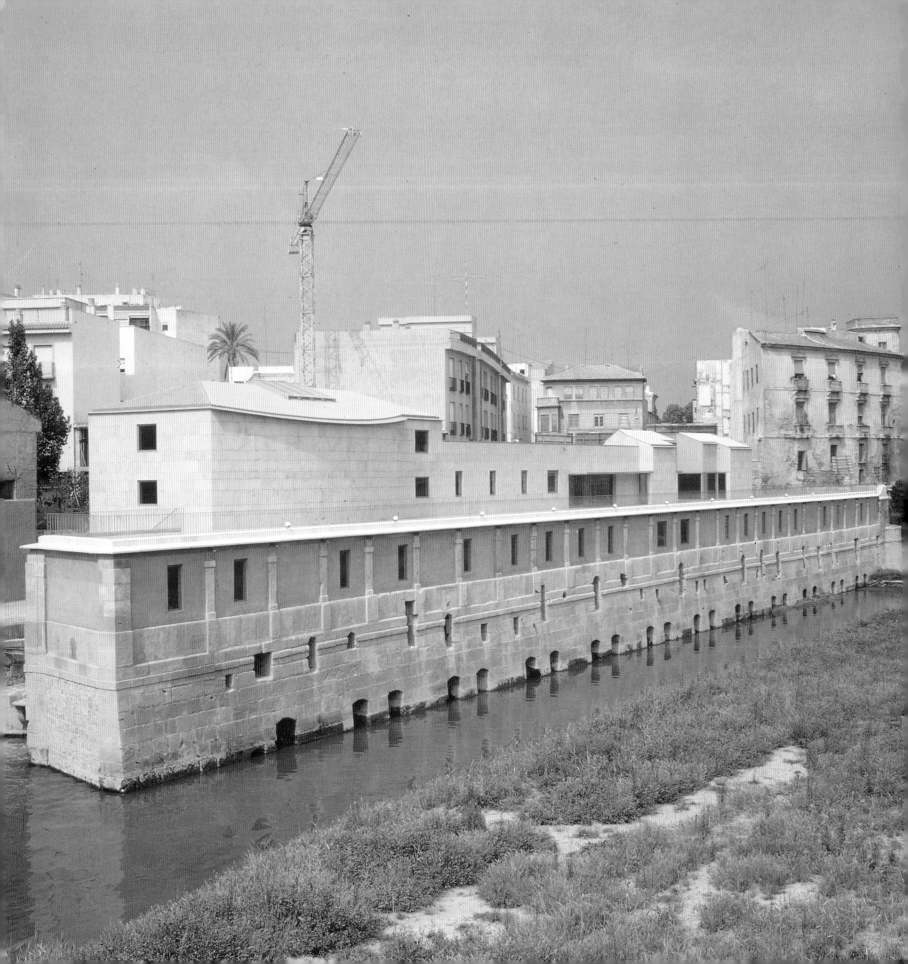

Architect: Juan Navarro Baldeweg

Collaborators: Julián Martinez, J. M. Mercé,
Lucrecia Ensenat, Pau Soler

The Water Museum

1983-1988 Murcia (Spain)

This consists of the restoration of an important part of the urban nucleus of Murcia. The old water mills building has a crucial role in defining the left bank of the Segura River and in the visual relation to the Carmen 'barrio'. Conceived during the first half of the 18th century, at the same time as the containing walls and the Puente Viejo, the building is housed within the mill's mass of hydraulic mechanisms. The mill, in a prismatic and extended form, has a stone socle and a grand floor with an arrangement of pilasters indicating interior workspaces. With the passing of time space has been added on to the original structure. The main objective of this project has been to recapture the original 18th century unitary condition of its prismatic rotunda form. Once this original form is recovered autonomous new space will be added above: public library, cultural centre and café/restaurant.

The programme forsees a Cultural Centre and Hydraulic Museum. The old squares, physically separated on the south side of the square which is defined in the entrance of the museum, have been reinhabited for use as temporary exhibition rooms. The space for the conservation of these pieces of archeological industrial heritage is based on presenting the old mills in their most genuine form and in their proper context, emphasizing, by the treatment of the container, its presence as a singular object. The grey concrete and stone floors, the light simple railings and other elements, help to bring out the indisputable character of the historical exhibits.

On this floor of the museum is a small function room, with wooden seats, which gets overhead light through the vertical axis of the upper courtyard skylight of the library. The library area, like inner and passive space, is sculptural and closed; on the other hand, the cafeteria/restaurant space is more expansive, having braked forms and open space. This level, with the bar terrace serves as a vantage point, looking over the museum and river, to the town.

In this way the linear scheme of the old mills, in the interior of the old prismatic space along the route of the river, coexists with the formation of new space dedicated to new uses which tend to become independent and organize themselves as autonomous places above the solid area of the museum.

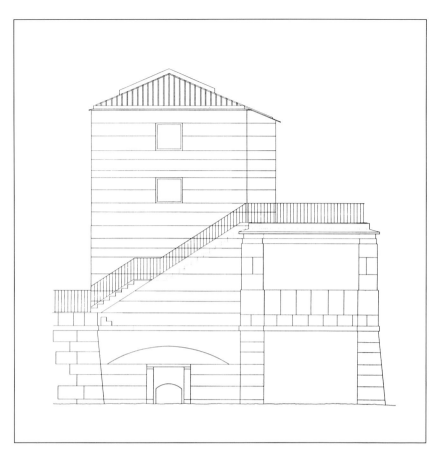

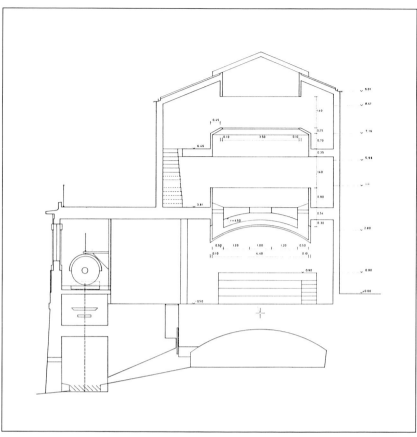

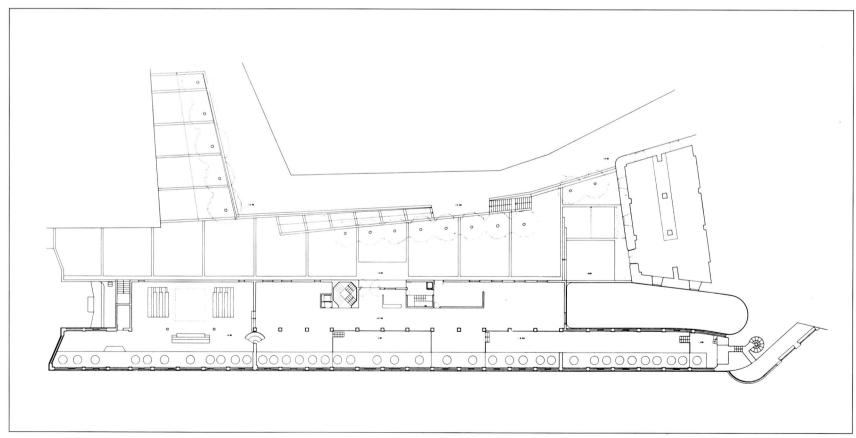

162

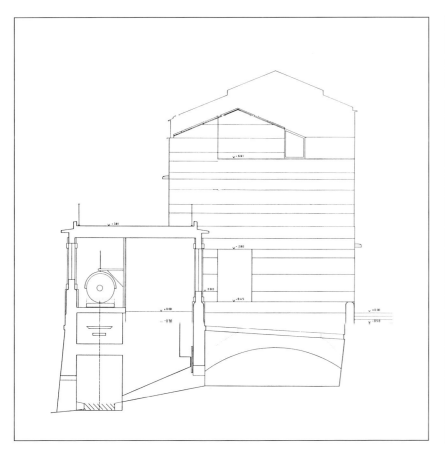

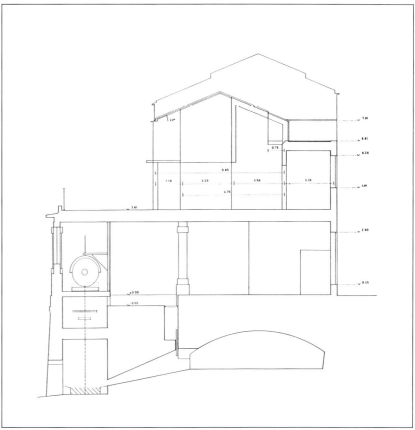

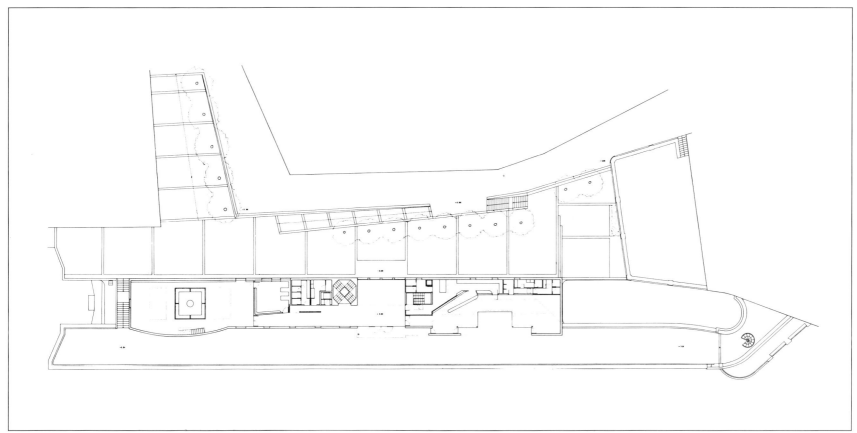

231×112

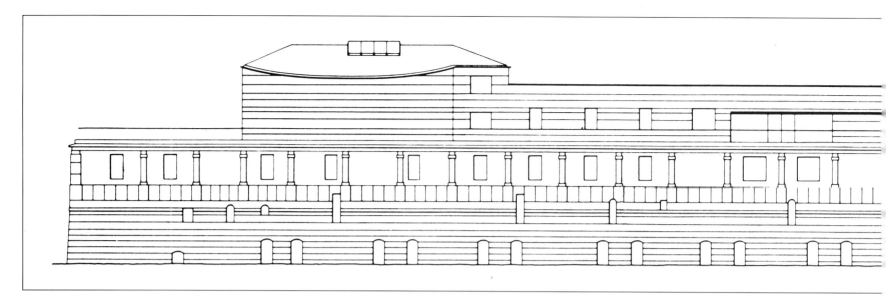

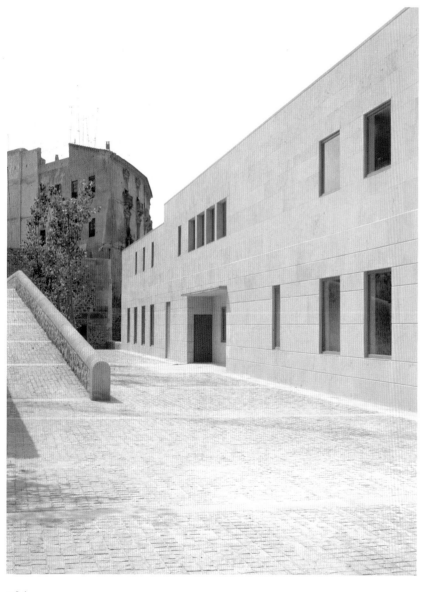

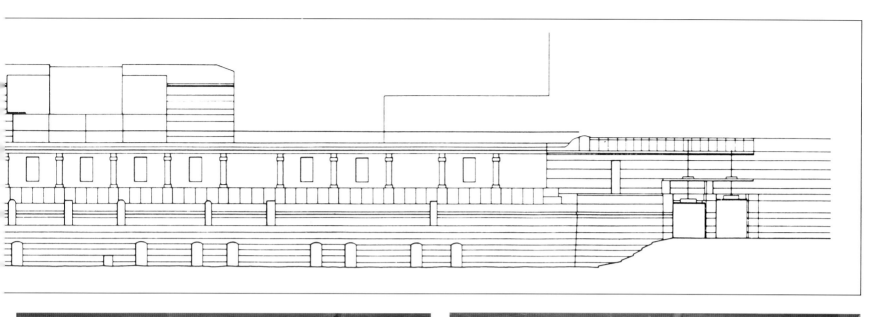

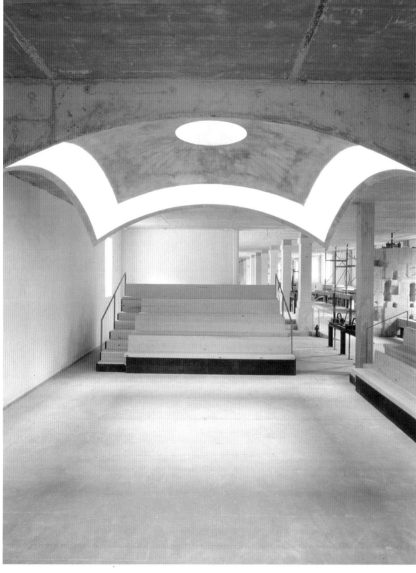

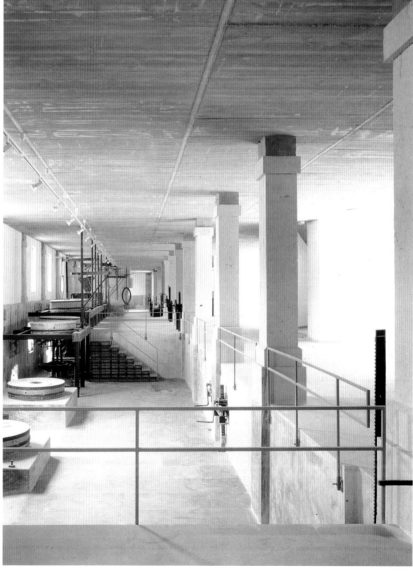

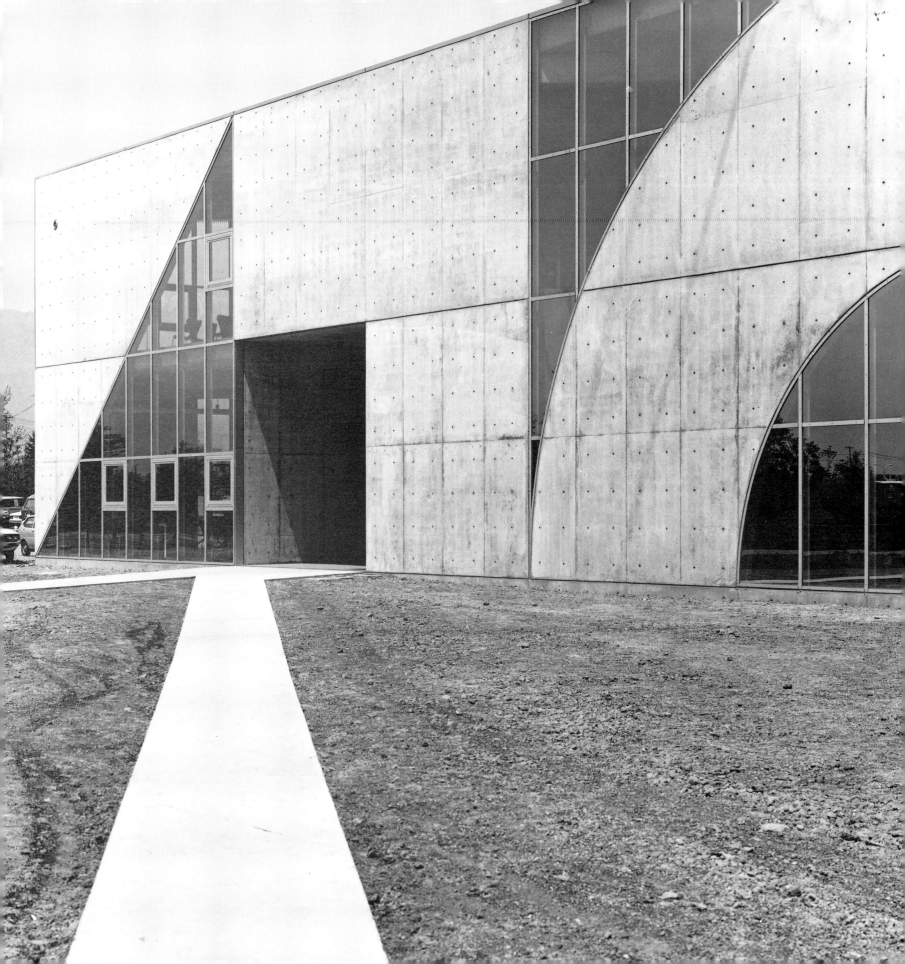

Architect: Kazuo Shinohara

Collaborator: Toshihiko Kimura

Print Museum

1982- Matsumoto (Japan)

This museum is dedicated to the Japanese technique of ukiyo-e printing, literally 'image of the floating world', which incorporates woodcuts as much as landscapes and portraits of kabuki theatre actors. It was commissioned by a private collector who wished to show the whole of his collection. Shinohara designed a large container in which geometry dominates; layout, height and mass are resolved by strict adherence to geometric motives, chiefly the right-angled triangle, the square and semi-circular borders. The geometric form of the combination of blind walls and glass faces is also designed to resist seismic movements.

The bare concrete walls emphasize this neutral geometric box. The space is also defined by the juxtaposition of concrete faces and large panes of glass. On the ceiling the structure manifests itself diagonally from the flat roof. The lighting and air conditioning systems are exposed and emphasize that this is essentially a huge warehouse. Even the interior furniture follows this strict geometric logic which is indicative of the conceptual and minimalist architecture which Shinohara has developed.

The entrance, vestibule and distribution areas are lit naturally. The need to protect the prints from natural light led to exhibition and conservation rooms which are totally blind and artificially lit. Illumination is by movable lamps in guides placed along diagonal girders.

The ground floor is for the presentation of works. The upper section of the double height vestible houses a conference room.

The geometrical radicality of the building is varied and enriched by the use in front of different colours associated with the diverse basic forms used.

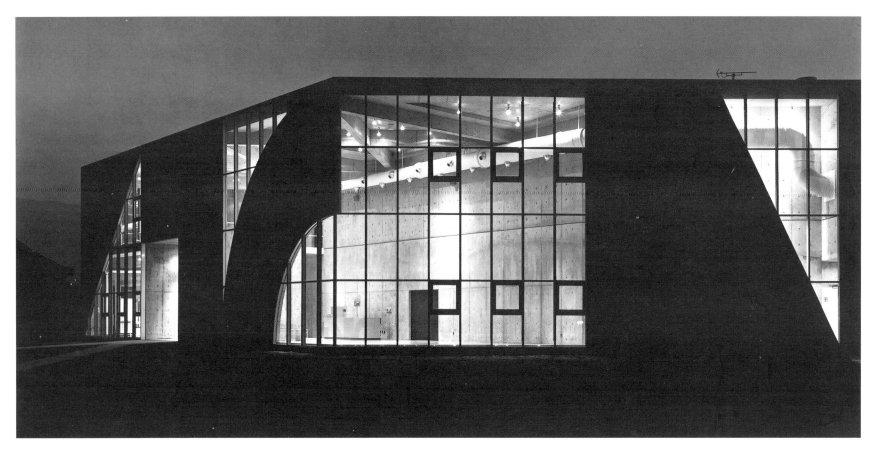

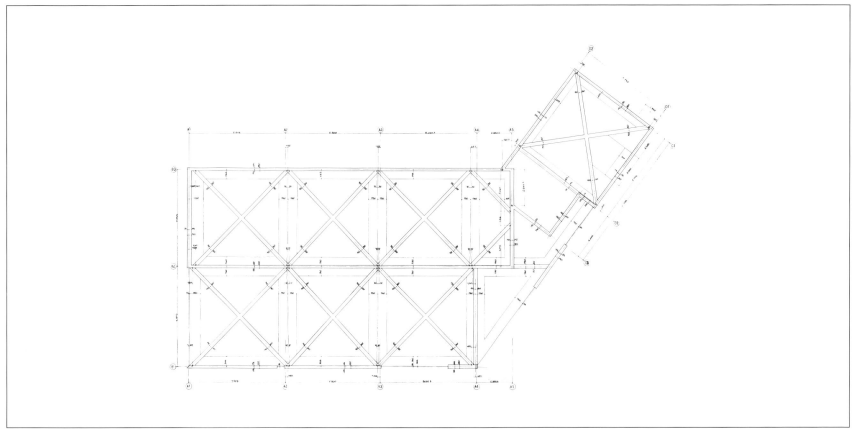

Architect: Mario Botta

The Multimedia Space for Contemporary Art

1988- **Palermo (Italy)**

This is a building of clearly defined volumetric forms. The floor is perfectly square, with a turret in each of the four corners, housing vertical communications systems and services. The building is constructed as a large circular courtyard, which gives access, on the roof, to a sloping garden. In these volumetrically-defined spaces, like a truncated cylinder inscribed in a cube, are the rooms and galleries of the cultural complex whose purpose is to enrich the cultural and artistic life of Palermo and its field of influence.

Besides exhibition spaces, the building has two basements, offices on the first floor and galleries covering the whole of the second floor. The terrace is designed as an open-air bar. The large open areas on the ground floor and in the spaces perimetral to the cylinder are multifunctional. The central cylinder allows natural light into the building; a system of stairs which give access to all levels are housed between its curved walls. The building is designed as an architectonic and technological support for all varieties of art. Therefore a volumetrically defined container has been created, clearly connected with stairs and perfectly lit overhead.

It is possible that as the design is perfected and built, important changes may be made to the whole form of the building as well as its interior.

SEZIONE A-A

SEZIONE B-B

172

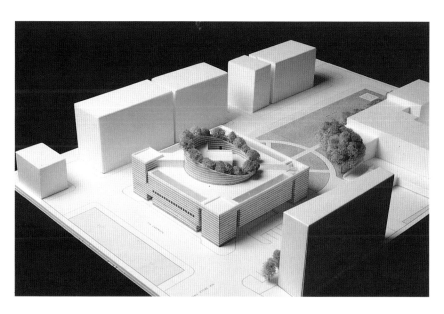
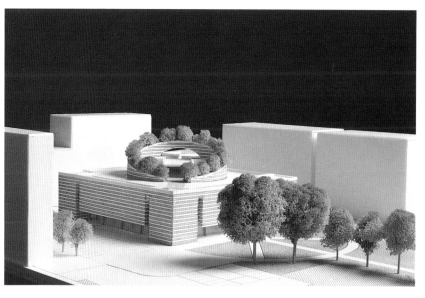
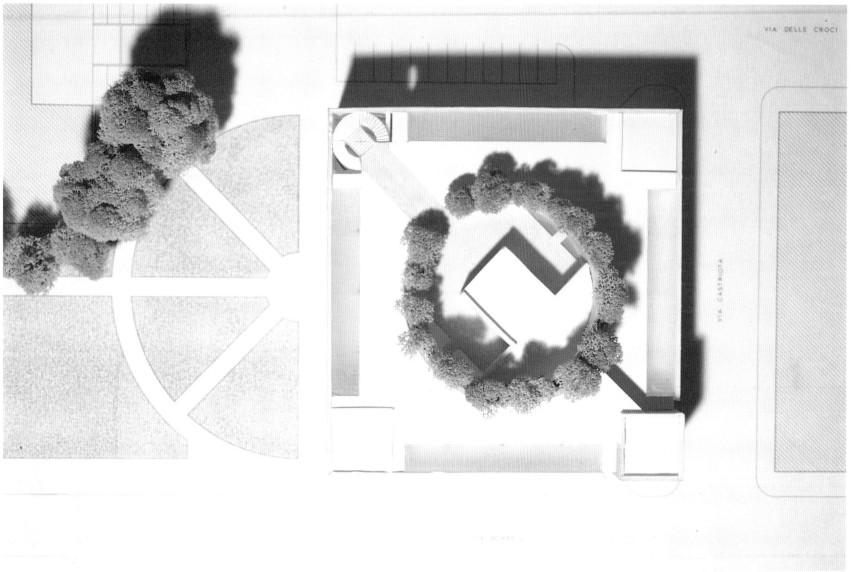

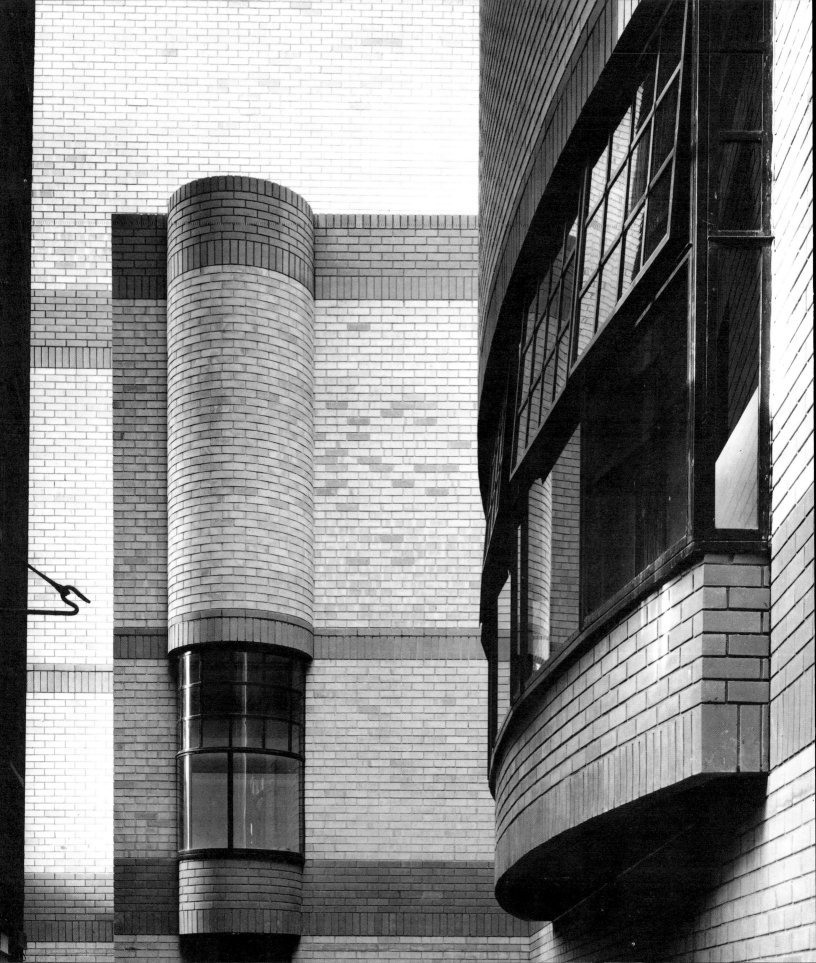

Architects: Alan Colquhoun, John Miller

Collaborators: Richard Brearley, John Carpenter,
Graham Smith

Whitechapel Art Gallery

1982-1985　　**London (Great Britain)**

The plan to remodel and extend the Whitechapel Art Gallery was based on the art gallery designed in 1899 by C. Harrison Townsend, one of the most interesting examples of Art Nouveau in London. The new intervention has consisted of remodelling the existing rooms, creating a new room, enriching complementary services and reopening the interior stair system.

The conceptually clear design is based on a series of key points: keeping the essential parts of the old building, like the facade; insisting on natural light in the rooms; emphasizing the direct and industrial character of the roofs; expressing a radically modern language as in the brick faces, metallic joinery and rational railings all over the building; and insisting on references to Art Nouveau in some new elements of interior design, for example in the joinery.

The museum is based on the clarity and comfort of routes alongside rooms situated at intervals, connected by stairs. The rooms, with wooden floors, white walls, a generous interior height, overhead lighting and the structure of the roof which is also white, are particularly suited to the installation of contemporary works of art with their special characteristics: size, the need for sophisticated technological support and so on.

The bar/restaurant, a new area whose facade looks onto the interior courtyard, is a singular slightly circular volumetric form.

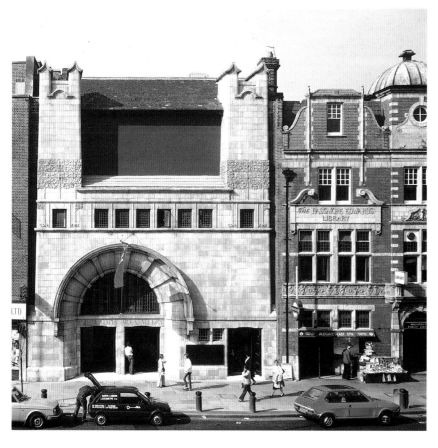

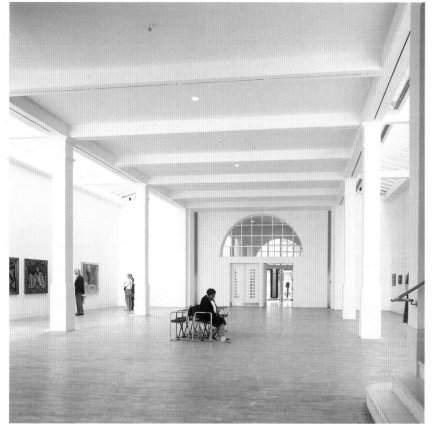
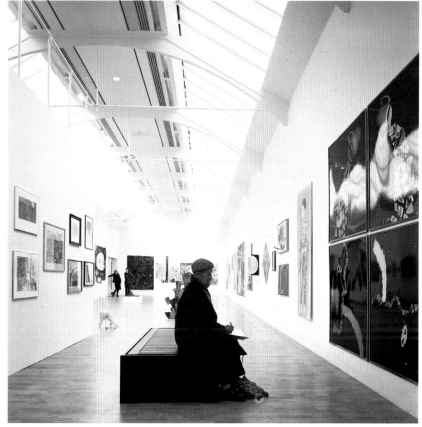

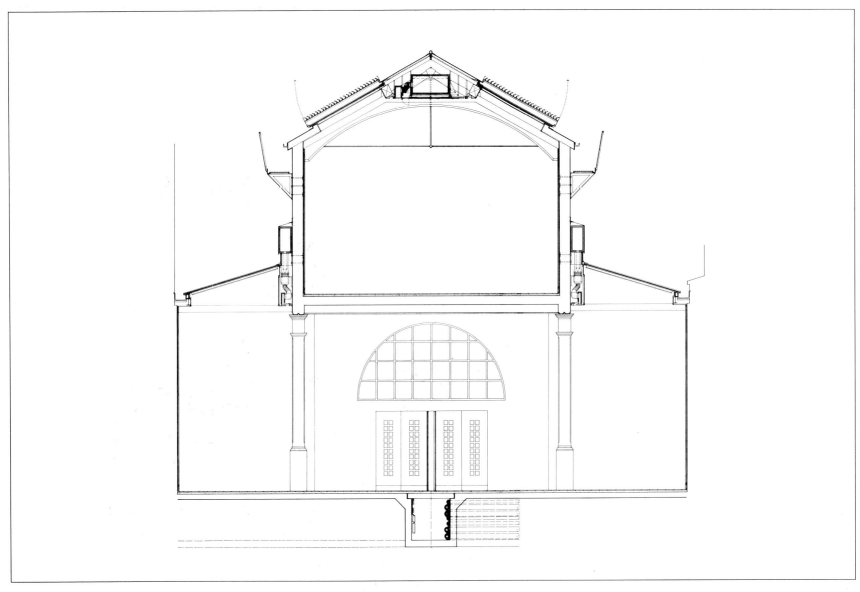

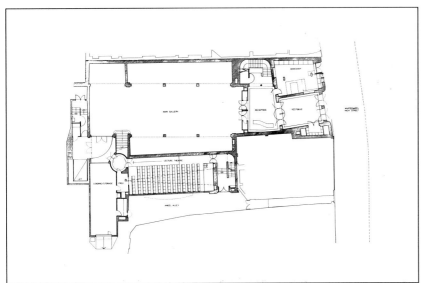

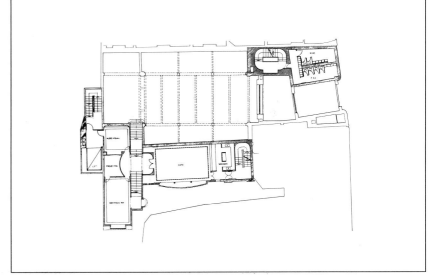

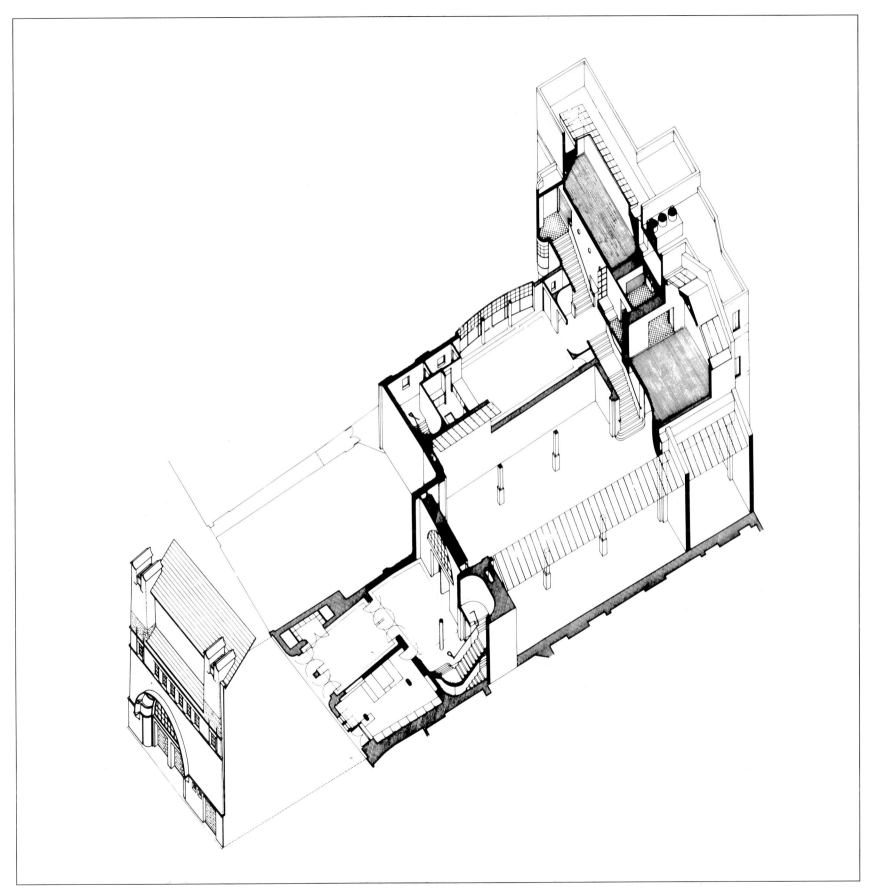

179

Architect: Alvaro Siza Vieira

Galician Centre of Contemporary Art

1988- Santiago de Compostela (Spain)

This is a centre of contemporary art initiated by the Council of Galicia within the historic centre of Santiago de Compostela. The initial plan departs from the typical indeterminacy of these centres of public promotion in Spain. There is an important section for temporary exhibitions plus a series of complementary services – a function room, seminar rooms, a bookshop, café and reception, storage and administration areas. It is a centre of contemporary art dedicated to the presentation of temporary exhibitions and to the promotion of contemporary art, rather than a museum dedicated to permanent exhibitions.

The main concern is the insertion of the building into the urban, topographical and historical context of the area. To express its public nature it has a large entrance porch with steps and a lateral service ramp. The definition of the different areas – exhibition rooms, administrative space and function room – allows a building based on the articulation of the layout and form of each of these fundamental parts. The function room area, the reception and administration area, and the overhead-lit exhibition galleries are autonomous within a unitary and articulate whole.

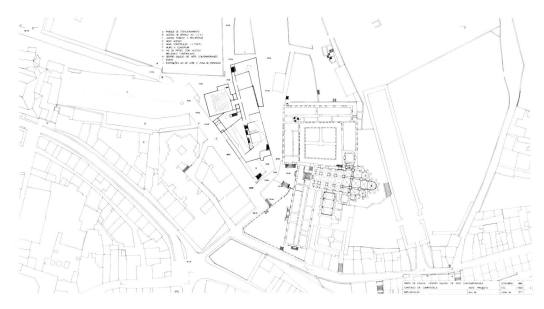

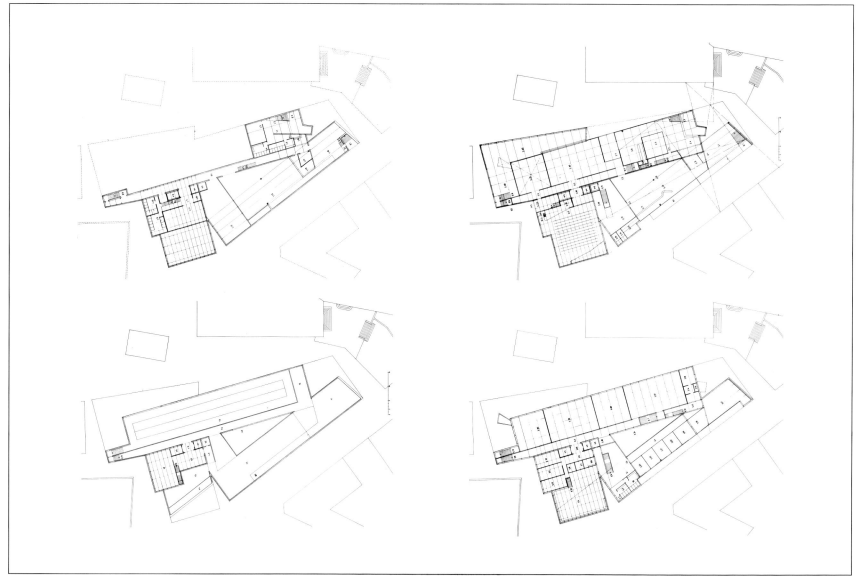

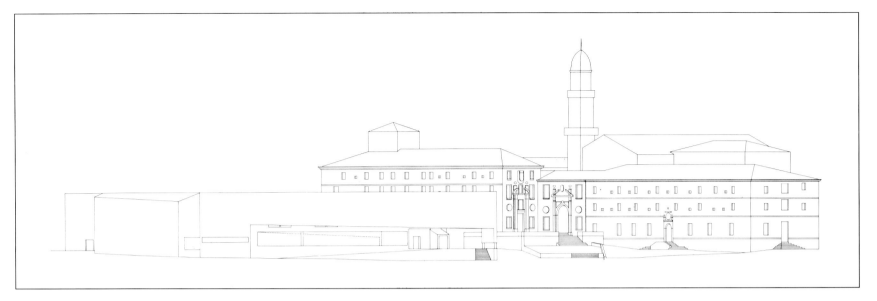

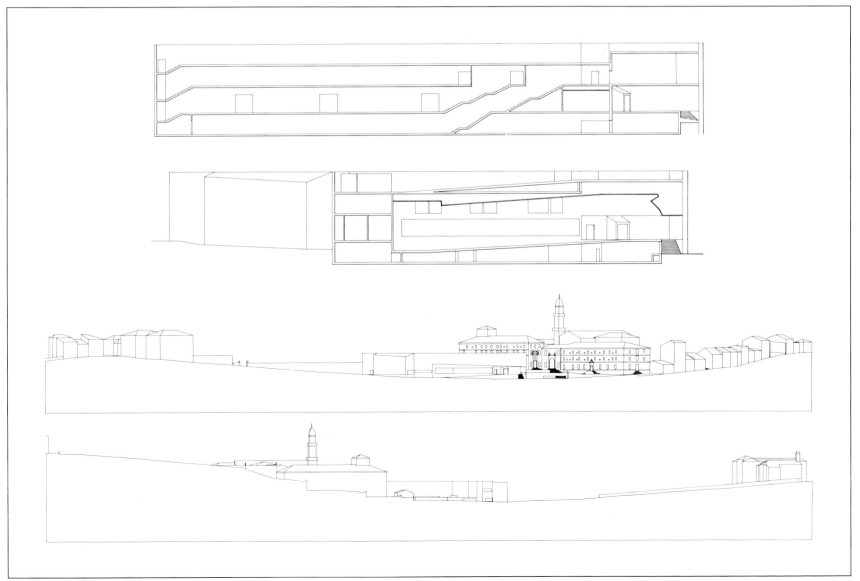

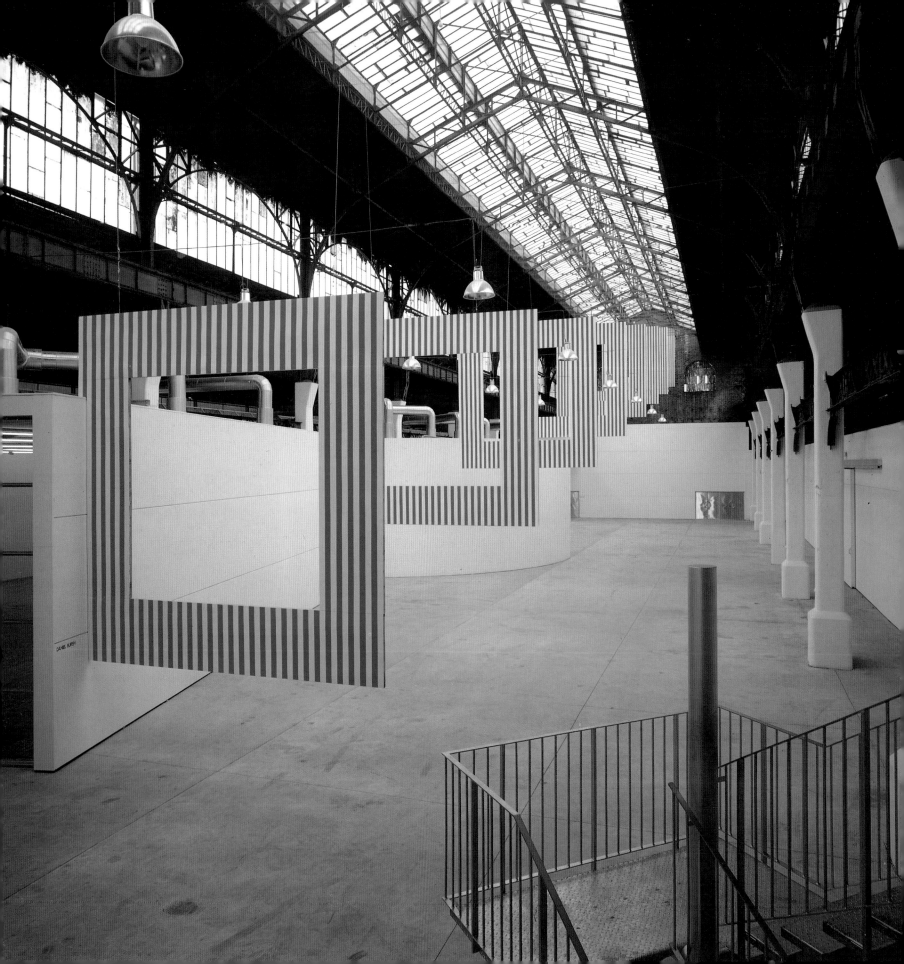

Architect: Patrick Bouchain

Le Magasin.
National Centre of
Contemporary Art

1985-1986 Grenoble (France)

A centre of contemporary art, dedicated to the promotion of artistic creation, has been installed in Grenoble using an old industrial building, a foundry with a metal roof designed by Gustave Eiffel.

The excellence of the enterprise and design relates to the understanding established between a specialist in contemporary art, the first director Jacques Guillot, and the architect, Patrick Bauchain. The architectonic intervention is based on a superficial restoration and introduction of installations to define a wide area for temporary exhibitions and a series of annexed spaces. The central space, changed into a virtual covered street, is not air conditioned; but, the adjoining areas consisting of auditorium, workshops, teaching rooms, library, administration offices, storage for work, are.

The centre is used for experimental creations of great size, conceived in situ. The artists go to the centre to design and realize a large part of their artistic intervention there, in some cases with the help of students participating in seminars. Artists like Sol Lewit, Max Neuhaus, Daniel Buren, Richard Long, Jean-Luc Vilmouth, John Baldessari and Michelangelo Pistoletto – all specialists in artistic installations – have already made interventions, each one radically transforming the character of the interior space.

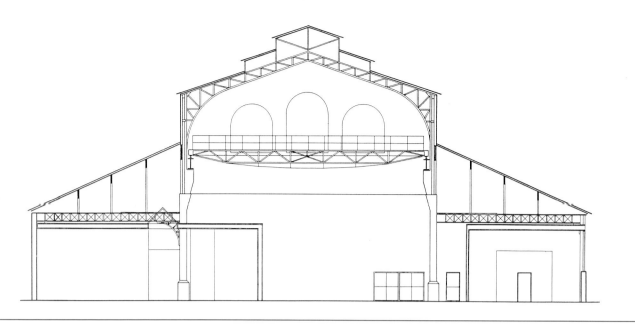

186

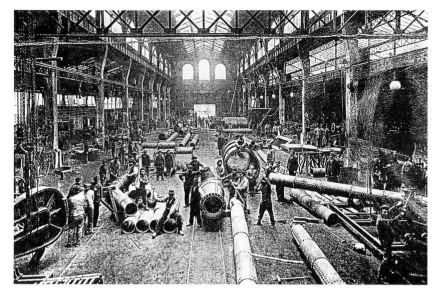
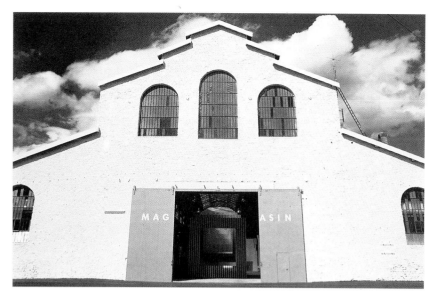
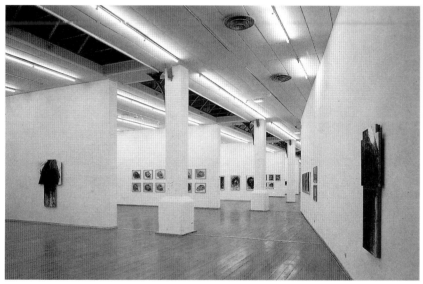

Bibliography

General Bibliography

Aloi, Roberto, *Musei: Architettura, Tecnica,* Ulrico Hoepli, Milan, 1962.

Brawne, Michael, *The New Museum: Architecture and Display,* Praeger, New York, 1965; The Architectural Press, London, 1965.

Pevsner, Nikolaus, *A History of Building Types,* Princeton University Press, Princeton, New Jersey, 1976; Spanish version: *Historia de las tipologías arquitectónicas*, Editorial Gustavo Gili, S.A., Barcelona, 1979.

Thomson, Garry, *The Museum Environment*, Butterworth, London, 1978.

Brawne, Michael, *The Museum Interior, Temporary and Permanent Display Techniques,* Thames and Hudson, London, 1982; Architectural Book Publishing Company, New York, 1982.

Searing, Helen, *New American Art Museums,* Whitney Museum of American Art 8, University of California Press, Berkeley, 1982.

AA.VV. *Museologia. Il Museo nel mundo contemporaneo. Concezione e proposte*, Ed. Scientigiche Italiane. Naples, 1982.

Minissi, Franco, *Il Museo negli anni '80,* Edizioni Kappa, Rome, 1983.

Piva, Antonia, *La Costruzione del Museo Contemporaneo*, Jaca Book Spa, Milan, 1983.

Klotz, Heinrich, *Neue Museumsbauten in der Bundesrepublik Deutschland*. Deutsches Architektur Museum, Frankfurt, 1985.

Flagge, Ingeborg (ed.), *Museums Architektur,* Christians, Hamburg, 1985.

Montaner, Josep M.; Oliveras, Jordi, *Los museos de la última generación. The museums of the last generation,* Editorial Gustavo Gili S.A., Barcelona, 1986; Academy Editions, London, 1986; St Martin's Press, New York, 1986; Karl Kramer Verlag, Stuttgart/Zurich, 1986; Hoepli, Milan, 1988.

Stephens, Suzanne (ed.), *Building the New Museum,* The Architectural League of New York, Princeton Architectural Press, New York, 1986.

Schubert, Hannelore, *Moderner Museumsbau (Deutschland, Osterreich, Schweiz),* Deutsche Verlags-Austalt, Stuttgart, 1986.

Nuvolari, Grancesco; Paran Vicenzo (ed.), *Archeologia, Museo, Architettura*, Arsenale Editrice, Venice, 1987.

Allegrét, Laurence, *Musées*, Electa-Moniteur, Milan–Paris, 1987.

Hudson, Kenneth, *Museums of Influence*, Cambridge University Press, Cambridge, 1987.

Abbreviations of Journals

AA	L'Architecture d'Aujourd'hui (F)	Q Cas	Quaderno di Casabella (I)
Abit	Abitare (I)	CI	Cimal (S)
AD	Architectural Design (GB)	Croquis	El Croquis (S)
AI	Architecture Interieure CREE (F)	DA	Documentos de Arquitectura (S)
AIA	Architecture AIA (USA)	Domus	Domus (I)
AJ	The Architects' Journal (GB)	FMR	Franco Maria Ricci (I)
AMC	Architecture Mouvement Continuité (F)	GA	Global Architecture Document (J)
		GB	Gran Bazaar (I)
A Rec	Architectural Record (USA)	JA	The Japan Architect (J)
TA	The Architect (GB)	L'Ar	L'Arca (I)
A Rev	The Architectural Review (GB)	L'A	Architettura (I)
AV	A & V, Monografias de Arquitectura y Vivienda (S)	LD	Le Debat (F)
		Lotus	Lotus International (I)
AVi	Arquitectura Viva (S)	P	Parachute (F)
Arq	Arquitectura (S)	PA	Progressive Architecture (USA)
Arqu.	Arquitectos (S)	Per	Periferia (S)
A+U	Architecture + Urbanism (J)	Q	Quaderns (S)
AMe	Art in America (USA)	RC	Restauro e Città (I)
Art	Artics (S)	SD	Space Design (J)
Bau	Baumeister (WG)	T&A	Techniques & Architecture (F)
BD	Building Design (GB)	UIA	International Architect (GB)
CAS	Casabella (I)		

Museums Bibliography

Arab World Institute, Paris

Goulet, Patrice, *Jean Nouvel*, Electa Moniteur, Milan, Paris, 1987.

Fessy, Georges; Tonka, Hubert, *Institut du Monde Arabe*, Champ Vallon, Paris, 1988.

Journals: A+U 88/7; AA 88/1; T&A 88/2–3; AMC 87/12; A Rev 87/10; T&A 83/11; Arq 88/11–89/2.

Mediathèque and Centre for Contemporary Art, Nîmes

Benedetti, Aldo, *Norman Foster*, Zanichelli Editore, Bologne, 1988.

AA.VV. *Norman Foster*, Obras y proyectos, 1981–1988, *Works and projects 1981–1988*, Editorial Gustavo Gili, S.A., Quaderns Monografies Collegi d'Arquitectes de Catalunya, Barcelona, 1989.

Journals: AA 84/12; Cas 85/4; Cas 89/5; A Rev 85/5.

Exhibition and Conference Centre, Ulm

Journal: A+U 88/3.

Wallraf-Richartz Museum and Ludwig Museum with the Philharmonic, Cologne

Journals: A+U 87/4; T&A 86/10–11; A Rev 87/10.

Collection of Nordrhein Westfallen Art, Dusseldorf

Sack, Manfred, *Kunstsammlung Nordrhein-Westfallen Dusseldorf*, Verlag Gerd Hatje, Stuttgart, 1986.

Journals: A+U 87/2; T&A 86/10–11.

Museum of the XIX Century in the Gare d'Orsay, Paris

AA.VV. *Orsay 86, Un nouveau musée*. Establissement Public du Musée d'Orsay, Paris, 1983.

Jenger, Jean, *Orsay, de la gare au musée: histoire d'un grand projet*, Electa-Moniteur, Milan-Paris, 1987.

Journals: AA 79/9; Cas 82/7–8; Lotus 82/II; T&A 79/9; Q Cas 87; LD 87/3–5; T&A 86/10–11; A Rev 86/12; AA 86/12; Domus 87/1; AR 87/3; A+U 87/6; Lotus 87/I; GA 88/1.

Museum of Art of Catalonia, Barcelona

Journals: CI 87/10; AVi 88/11.

The Louvre, Paris

Chaine, Catherine, *Le Grand Louvre: du Donjon a la pyramide*, Hatier, Paris, 1989.

Journals: Bau 84/8; BD 83/9; T&A 84/4–5; A Rec 88/5; T&A 88/8–9; A+U 87/4.

Extension of the Guggenheim Museum, New York

Journals: Domus 87/5; Croquis 87/3; A+U 89/4.

Clore Gallery (Turner Museum), extension of the Tate Gallery, London

AA.VV., *The Clore Gallery: an illustrated account of the new building for the Turner Collection*, Tate Gallery, London, 1987.

Journals: Lotus 87/III; AD 87/1–2; Domus 87/7–8; A Rev 87/6; A Rec 87/7; AD 82/1–2; A Rev 81/8; Domus 89/6; Lotus 82/II; Lotus 83/I; AIA 81/7; ED 81/7; T&A 86/10–11; GA 88/1.

Museum of Contemporary Art, Los Angeles

Journals: A Rec 88/1; JA 87/2; AIA 87/2; AJ 87/1; SD 84/1; Croquis 87/3; T&A 86/10–11; PA 86/11; Bau 84/8; BD 83/3; Cas 83/5; GA 83/10.

The Temporary Contemporary, The Museum of Contemporary Art, Los Angeles

Peter Arnell, Ted Brickford (ed.) *Frank Gehry Buildings and Projects,* Rizzoli, New York, 1985.

AA.VV. *La arquitectura de Frank Gehry*, Editorial Gustavo Gili, S.A., Barcelona, 1988.

Journals: A Rev 87/12; PA 84/3; GA 85/1.

Menil Collection, Houston

AA.VV. *Renzo Piano: progetti e architettura*, Electa, Milan, 1986.

Renzo Piano. Obras y proyectos, 1971–1989, Editorial Gustavo Gili, S.A., Barcelona, 1990.

Journals: GA 88/1; T&A 87/11; SD 85/1; Domus 87/7–8; A Rev 87/3; T&A 87/9; AMe 87/6; A+U 89/3; A+U 87/11; PA 87/5.

Municipal Museum of Modern Art, Nagoya

Journals: A Rev 88/9; AA 87/4; JA 88/8; AVi 89/7

Antoni Tapies Foundation, Barcelona

Journal: DA 88/7.

City of Sciences and Industry in La Villette, Paris

Fainsilber, Adrien, *La virtualité de l'espace: projets et architecture,* 1962–88, Electa-Moniteur, Paris, 1988.

Lissarrague, Jacques, *La Cité des Sciences et de l'Industrie*, Electa-Moniteur, Milan-Paris, 1988.

Journals: T&A 86/2–3, GA 88/1; AR 86/12; AA 85/6; AI 80/11–12; AI 84/5–6; A Rev 81/2; Domus 82/7–8; T&A 80/10; T&A 84/4–5.

Civic Museum of the Eremitani, Padua

Albini, Marco; Helg, Franca; Piva, Antonia. *Architettura e design,* 1970–1986, A. Mondadori Editrice, Milan, 1986.

Journal: Cas 77/10.

National Gallery in the Palazzo della Pilotta, Parma

Journals: Domus 87/5; A Rev 88/4; Abit 82/6; SD 83/10; T&A 88/12–89/1; Cas 80/1; RC no. 10; FMR 87/5.

Maffeiano Lapidary Museum, Verona

AA.VV., *Il Museo Maffeiano riaperto al pubblicao*, Comune di Verona/ Direzione dei Musei, Verona, 1982.

Journal: GB 84/6–7.

German Museum of History, Berlin

Aldo Rossi, *Deutsches historisches Museum, Berlin, Milan*, 1988.

Journals: A&V 89/II; AA 89/6.

Hydraulics Museum and Cultural Centre, Murcia

Journals: Arq 83/9–10; Cas 84/1–2; Q 84/10–12; UIA 83/7; AA 84/12; Lotus 86/IV; Arq 88/9–10; Cas 88/12; Per 87/6; Arq 88/3–6; Lotus 88/III.

Ukiyo-E. Museum (Museum of Japanese printing), Matsumoto

Journals: JA 83/2; PA 83/5; AA 84/9; L'A 84/2; Bau 84/11.

Multimedia Space for Contemporary Art, Palermo

Journals: L'Ar 89/1; A+U 89/1.

Whitechapel Art Gallery, London

Eduard Bru, José Luis Mateo, *Arquitectura Europea Contemporánea*, Editorial Gustavo Gili, S A , Barcelona, 1987.

Journals: Cas 84/1–2; A Rec 86–7; A Rev 85/11; AD 84/1; A Rev 84/1; AMC 84/6; Cas 86/4; AJ 85/10.

Galician Centre for Contemporary Art, Santiago de Compostela

Journal: Arqu 89/no.108.

'Le Magasin', National Centre of Contemporary Art, Grenoble

Journals: P no. 46; Art 86/1.

Photographers

Acknowledgements

The figures in brackets refer to the number
of the illustration which appears in the
introduction. The rest of the figures
refer to the page number.

Charlie Abad. (34)

Shigeo Anzai. (24), 100, 101 top, 103

Masao Arai. 166, 168

Aldo Ballo. (46), (47), 136, 141

Quentin Bertoux. (55), 184, 187

Richard Bryant. (21), 90, 92, 93, 95, 96, 97, 110, 112, 113, 116, 117

Mario Carrieri. (48), 64, 68, 69, 142, 145, 147, 148, 149

Lluis Casals. (44), 160, 164, 165

CB Foto. (51)

Stephane Conturier. 132 top

Peter Cook. 177 right

Dan Cornish/Esto. (13), 86, 89

Martin Charles. (56), 174

Marliese Darsow. (4), 50, 52, 53, 56, 57

Richard Davis. (3), 40, 42, 43

Michel Fainsilber. 135

Georges Fessy © IMA. 32, 36, 37

Katsuaki Furudate. 98, 101 bottom, 104, 105

Berengo Gardin. 114 right

Jean-Yves Gregoire. 128, 132 bottom

Leonard Jacobson. (18)

Mario Lasalandra. (45), 140

Dieter Leistner. (53)

Tomio Ohashi. 118, 120, 121, 123

Deidi von Schaewen. (58), 81 top right, 81 bottom, 85

Ben Shutz. 114 left

Alfred Wolf. 78, 81 top left, 83

The author wishes first of all to acknowledge the work of Gustau Gili
Galfetti and Xavier Güell who have been responsible for publishing
the book. He also acknowledges the help of the architects,
contributors and the directors of the museums which are featured,
with particular thanks to Mrs Mariam Ghalayini (Arab World Institute,
Paris), Mr Daniel Giralt-Miracle (Museum of Contemporary Art,
Barcelona), and Mrs Adelina von Fürstenberg (National Centre of
Contemporary Art, Grenoble). Similarly, he thanks Monica Gili, Glòria
Picazo, Mònica Regàs, Enric Franch and Ignasi de Solà-Morales for
their helpful suggestions, and Assumpta Anglada for her help in the
lay-out of the original texts for the book.

Josep Maria Montaner